Navajo Silversmith
Fred Peshlakai

HIS LIFE & ART

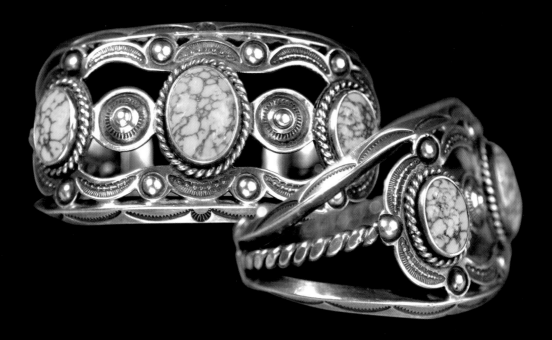

STEVEN CURTIS

Schiffer Publishing Ltd®

4880 Lower Valley Road • Atglen, PA 19310

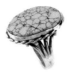

Designed by Danielle D. Farmer
Cover Design by Molly Shields
Type set in Americana BT/Agenda

ISBN: 978-0-7643-4745-0
Printed in China

Published by Schiffer Publishing, Ltd.
4880 Lower Valley Road
Atglen, PA 19310
Phone: (610) 593-1777; Fax: (610) 593-2002
E-mail: Info@schifferbooks.com

For a selection of fine books on this and related subjects, please visit our website at www.schifferbooks.com. You may also write for a free catalog.

This book may be purchased from the publisher. Please try your bookstore first.

We are always looking for people to write books on new and related subjects. If you have an idea for a book, please contact us at proposals@schifferbooks.com.

Schiffer Publishing's titles are available at special discounts for bulk purchases for sales promotions or premiums. Special editions, including personalized covers, corporate imprints, and excerpts can be created in large quantities for special needs. For more information, contact the publisher.

Front cover images: Clockwise from right: Concha belt, ca 1964. Courtesy of a private collection. Fred Peshlakai in Ganado, Arizona. 1924. Vol. 3, p. 153, Ganado Mission Photographic Essay and Oral History Project. Bracelet with butterflies, 1942. Courtesy of the Gloria Dollar collection.
Back cover image: Tooled leather Mexican saddlebags, ca. 1920. Author's collection.
Spine image: Detail of die stamped FP. Courtesy of a private collection.

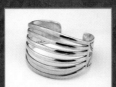

This book is dedicated
to all those who have suffered some
adversity in this world
and have yet still risen;
finding within themselves the
sacred strength
to create something beautiful.

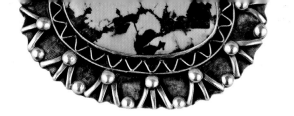

SOME WORKS BY MIDCENTURY JEWELERS STAND OUT because of the designs and the technical prowess of the artist. Fred Peshlakai is certainly one of those jewelers. In addition, he distinguished his work by incorporating high-grade, beautifully matched turquoise stones in his jewelry. Prior to this book, little biographical data has been published on Fred Peshlakai. In the course of Steven's research for this book, he uncovered fascinating information and extensive photographs about the artist, adding greatly to what was previously known.

Fred Peshlakai first came to my attention in 1996 when two colleagues and I had the pleasure of sitting in Sam Vaughn's office in Camp Verde, Arizona, to talk with him about his father's store, Vaughn's Indian Arts. As three cassette recorders whirled, Sam recalled fondly those early years of his father's business as a retailer of American Indian cultural arts in downtown Phoenix. On the walls of Sam's office, several photos of different storefronts chronicled the business as it moved to other and usually larger locations in the town center. We knew that noted Hopi silversmith Morris Robinson had worked as an artist demonstrator at Vaughn's and learned of other silversmiths that Sam's father, Reece, employed in the 1920s and 1930s. By 1929, it was customary for as many as five silversmiths to work in various areas of the multi-level store. It came as a surprise to us to learn that Sam considered Fred Peshlakai's jewelry to be the best that was made in his father's shop. He went so far as to say, "Every piece was a masterpiece."

It appears others have come to appreciate Fred Peshlakai's jewelry in analogous ways. Once his jewelry is brought to one's attention, either through seeing photographs in a book or by admiring jewelry collected by a friend or through another means, all of us seem captured by the beauty and charm of the work. Fred Peshlakai came to Steven Curtis's attention in a similar fashion. Steven's friend, John Strong, spoke fondly of his fourteen-year friendship with the jeweler. But when Steven started researching the artist online or in books, he found very little information.

Steven's search for information about the artist intensified in 2009 when he examined the large collection of the jeweler's work owned by John Strong. Steven set about to find out whatever he could about the artist. He learned that Fred Peshlakai's father, Slender Maker of Silver, sent his children to school in Ganado, Arizona. Steven made contacts in Ganado and discovered that several Presbyterian missionary descendants had photographs that they had contributed to the Ganado Mission Photographic Essay and Oral History Project. With the assistance of the project's curator, it was revealed that among these many photographs were several images of Fred Peshlakai and his siblings. Additional months were spent searching through other genealogical records and historical documents, compiling strands of loose information together in order to form a cohesive thread.

Through this book, Steven Curtis has an opportunity to share his findings as well as extensive photographs of Fred Peshlakai and his jewelry. We are grateful for the opportunity to learn more about an American Indian jeweler whose works have been appreciated and admired by so many.

DIANA F. PARDUE
Curator of Collections, Heard Museum
Phoenix, Arizona

Fred Peshlakai was a Navajo man.

..

IT AMAZES ME THAT THE LIFE OF SO GREAT AN ARTIST could be stated in such a little sentence, but there it is. I've looked at the above sentence and looked at the sentence, pondered the universe, and then gone out and looked over the desert landscape near my home. I've walked around, dithered the toe of my shoe, and returned again to gaze at the sentence once again.

There before me on my computer screen was an acronym, an abbreviated coded rendition of "name yielding meaning" for the entire life of this legendary artist. I was astonished at the truth in this when I first wondered about Fred Peshlakai and who he was as a person. Very little was known about him other than his stunning body of work and a few stabs at placing him in the scheme of things by a modern audience. This, perhaps, was understandable when I considered the society into which he was born. With my usual grasp, I acknowledged to myself that at the turn of the twentieth century, American society was prejudiced in the extreme. In 1896, when Fred was born, his people had been sequestered to reservations for twenty-eight years.

The early Navajo people themselves didn't keep written records about family. Most of them couldn't write in the same way as the white record keepers did (or they chose not to), and their traditions and family ties were remembered in other ways. Cosmology and clan ties were passed down orally or through long-chanted stories and songs of evocation.

What written records we can find are the biased remains of early Anglo chroniclers or well-meaning missionaries. Here and there is an occasional blurb about some individual or group of individuals. But names were written phonetically at the white man's institutions or changed altogether so that the white domesticators could keep the individuals organized in their minds. In the late twentieth century, the Navajo people were once again engaged in the struggle against assimilation as their children were being forced into white schools to try to force the Indian out of them. And it was into this world that Fred, a tiny Navajo child, found himself placed. Today we are left to imagine the modern comparison of parents being forced to send their child, a little Alexander Istanborg, for example, to board at one of these odd and faraway places of indoctrination and having him eventually wander home with a nametag pinned to his shirt that reads "Joe Smith." The look on his mother's face would be something to write about indeed and her expletives would, no doubt, still be censured from any historical treatises.

The tragedy of this truth is, of course, that the Navajo as an entire people were powerless over these chains of events. They had endured centuries of this abuse from these intruders who had finally become their conquerors. They had been subjugated by violence—physically, mentally, and emotionally. The little paper nametag was just another indignity in a long list of ways the Navajo had been suppressed.

However, something powerful occurred as a result of these challenges: the indomitable spirit of the Navajo began to rise. The Diné (as they call themselves, and which means "The People" or "Children of the Holy People") credit their survival as a culture to one primary attribute: They are inherently adaptable and, as such, their beautiful culture has survived to this day.

Fred Peshlakai's father was in his own right a very famous man, both among his own people and among many outside of the Diné community. His name was Besthlagai-ilth'ini Althts'osigi, and he had four wives, three of whom were Diné sisters. Besthlagai-ilth'ini Althts'osigi was a proud and progressive man who knew how to endure and guarantee a dignified survival for his people and his family. He knew that he wanted all nineteen of his children to have an education in order for them to be able to thrive in this new world in which they found themselves.

Among the children he had with Bil-ki jizbah, his second Diné wife, was a daughter whose nametag read "Alice." Also among his extended family "outfit" was a son whose nametag read "Fred." Well, Alice assumed the job as caretaker of Fred when he was a very young boy, and that's where his personal life's story begins, although certainly not the story of his people.

I doubt seriously that Besthlagai-ilth'ini Althts'osigi and his fourth wife named their son Fred, and his sacred names are, sadly, lost to time. But Fred was sent to Anglo schools at a very young age and came to know himself as Fred as a result of it being shouted at him, and following Fred's lead, under the circumstances, we must learn to be adaptable.

Here I must do one of the things I do best, and that is to digress. Before embarking on Fred Peshlakai's story, I need to make some short personal confessions: You see, I am, after all, just a regular guy, and it's important that readers know I thoroughly admit it. I am, however, truly passionate about art, specifically Native American art, and those immensely creative people who can rise above adversity to express the "Beauty Way." They have all my respect, and I am humbled at the sacred opportunity to write about them. I am grateful for this opportunity to purvey such a worthwhile and long- overdue project to a wider audience. It remains mystifying to me that this task has been apparently just handed to me, much as several rumpled Ziploc bags containing a dazzling array of Fred Peshlakai jewelry were handed to me only several short years ago. I feel that a Power quite outside of me has guided this project every step of the way, and, in that spirit of things, I intend to refrain from controversial theories or drown my readers in too much conjecture.

My intentions for this book are to direct it toward every available type of reader. My intuition tells me that this is what Fred would have wanted. He was a compassionate man. He was worldly, yet unpretentious, and his art was meant to belong to all of us. Fred Peshlakai has deserved this for a very long tim and, for me, writing this account is an honor and a gift.

This book is meant sincerely as an offering and another small stepping stone to the great bridge of healing and understanding that stretches ahead of us all through the long expanse of time.

THIS BOOK COULD NOT HAVE BEEN BEGUN, LET alone accomplished, without the help of the many kind people who have so generously contributed their time and expertise to this project. It has been a labor of love, and this final work has been made possible only due to their unfailing support.

Special thanks go to the collectors, galleries, and institutions that have generously contributed so many of the beautiful images in the book and also for their undying advocacy for the work of this legendary artist. Among those deserving special mention are: Brown's Trading Company, Turkey Mountain Trading, and Waddel Trading for opening their archives in order to enlarge upon this study.

Particular thanks go to Kenneth Douthitt for his research and organization in compiling the Ganado Mission Photographic Essay and Oral History Project. Much of Fred Peshlakai's early life would have remained in obscurity without Mr. Douthitt's gargantuan efforts to help preserve the memory of those kind people who labored to uplift the lives of so many at the turn of the twentieth century.

Many thanks are also due to Fred Peshlakai's close friend John Bonner Strong for his invaluable insight into the character of Fred Peshlakai and for information about who Fred was, not just as an artist but also as a person. Mr. Strong was the pebble that started a landslide, and I am grateful for his friendship and humor. Thanks also to Mr. Art Tafoya of Albuquerque, New Mexico, for his unwavering enthusiasm, profound insight into the silversmith's art form, and for his friendship. He has spent many long years studying the art of Fred Peshlakai, and his counsel has been greatly appreciated. Particular thanks are due to Mr. Jonathan Batkin and the Wheelwright Museum for their inclusion of important examples of the work of Fred Peshlakai from the James and Lauris Phillips collection. Lauris Phillips championed Fred during her lifetime and no presentation of the artist's work would be complete without her contributions being recognized.

Thanks to Ms. Diana Pardue for her many, many kindnesses, encouragements, and literary advice. Also thanks to Mrs. Gloria Dollar for her relentless sense of humor and her resplendent emails, without which I might have thrown my computer tower off the roof. And of course thanks to Ms. Brittany Meadows for her astonishing ability to help digitize my stubbornly pervasive right brained perspective. These three fine women have helped me more than they likely realize.

Sincere praise and gratitude are also due to Pete and Nancy Schiffer, Catherine Mallette, and everyone else at Schiffer Publishing for their belief and hard work on this project. Their strong dedication to bringing enlightenment to the world of Native American art cannot be overstated.

Thanks and gratitude to Mr. John Leo Skinner for being such a rock. I couldn't have written this book without his persistent calm and inexhaustible encouragement.

A Place in History

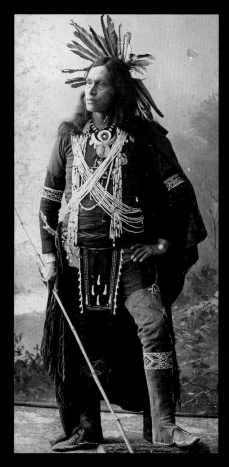

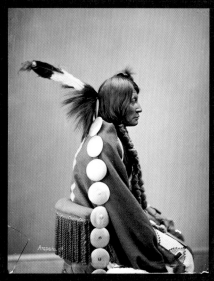

From the reed emerged the
Ni'hookaa Diyan Diné.
The Holy Earth People,
four footed, six and eight
The Sacred Yei.

Altse Hastiin and Alse Asdzaa.
First Man. First Woman.
From clouds of black and white,
yellow and blue;
The Black World ones to teach The Way.

Glittering World.
Sacred songs.
Haashch'eelt'i taught them;
The Talking God.

And from the first sacred Hogan
The Holy People arranged the world.
Dine'tah; the Homeland......
Four Mountains they set down
Shells and stones guiding Moon and Sun.

And in the south rose tall Tsoodzil,
An edge for all that looked that way.
This great mountain they set with
Turquoise
Calling Gendered Rains
Stone of the sky........

—AARON BEGAY, 2004.

THE EARLY HISTORY OF THE AMERICAN SOUTHWEST

IT IS POPULARLY BELIEVED THAT THE ANCESTORS OF today's indigenous peoples entered the Americas sometime during the Pleistocene ice age. During that ice age, which lasted from approximately 110,000 to 8,000 BCE, sheets of ice often a mile high formed over much of the northern hemisphere. This caused a dramatic drop in global sea levels resulting in an exposed 500-mile-wide land-bridge between the present-day upper reaches of the North American and Asian continents. This land-bridge, which is referred to as Beringia by geologists, climatologists, and others of such analytical disposition, subsequently resubmerged at the end of that ice age and the waterway returned and is now known as the Bering Strait. However, during its existence, it is believed that prehistoric peoples crossed over this bridge into the North American continent.

The earliest known lithic evidence believed associated with people crossing over Beringia into the Americas is from the Yukon region in Canada, dating some 22,000 years ago. Although it is accepted that there were many more groups or tribes than those that left these discovered remains, relatively little is known about any of these very early peoples and, as such, specific dates and movements for them are still matters of debate.

It is thought that these peoples moved down out of these arctic northern regions following their herding food sources and they gradually settled all the lands of the American continents. This follows clearly with the much broader evolutionary model for Homo sapiens out of Africa, which is described by Donald C. Johanson in his article titled "Origins of Modern Humans."

In this new world, these early hunter-gatherer peoples found the megafauna: the mastodon and the giant camel, dire wolves, short-nosed bears, and many other terrific creatures, many of which are now, of course,

extinct. They developed a profound knowledge of their surroundings that intelligently followed the seasons in their subsistence. Millennia passed filled with unimaginable migrations on foot. Exactly when humans began to speak languages is not known, but by this stage in time language surely existed. Many of these ancient dialects still survive in evolved forms and countless infinitely patient linguists have exhausted their nighttime candle budget piecing together the similarities that still remain in the words of the modern descendants of these intrepid explorers.

One surviving language group, which includes the Tlingit, Haida, Apache, and others of this same linguistic family, also includes the language of the Diné of the Dinétah. It is referred to as Athabascan and indicates ancient kinship groups linking the Diné to this northern migration model. The Athabascan language group is large and encompasses many modern groups of indigenous Americans. Splinter groups of people sharing this linguistic family exist today relatively in situ to their original settlements, which appear to successively flow in a southerly direction.

Stephen L. Harris, in his paper "Archaeology and Volcanism," which appears in the *Encyclopedia of Volanoes* (Harris, 1301-1314) discusses actual Athabascan oral traditions and remarks there that "these traditions refer to fiery explosions and a collapsing mountain" as the cause for the splintering of this linguistic group, which in "small bands" began to "drift westward or south to their present locations." These oral traditions are reinforced by the existence of additional documentation that there was a volcanic eruption in the Yukon around 750 AD that can perhaps be associated with this study.

This approach is classically plausible and results in the linear conclusion that the subsequent arrival of the Diné in the Four Corners region

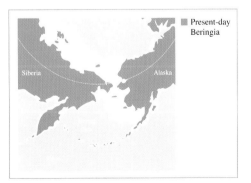

Cartography courtesy of Jesse W. Byrd, Albuquerque, New Mexico.

of the modern United State is thought to have occurred around 1400 AD, not long after its abandonment by the Ancestral Pueblo.

Navajo traditional beliefs dismiss these ideas, stating there is no evidence in their oral tradition of this movement. Instead, their cosmology teaches that they traveled through three previous worlds beneath this one and emerged onto this level of existence in the area of Southwest Colorado and Northwest New Mexico. Their cosmology relates that the Holy People traveled to the four sacred mountains: Mount Blanca in Colorado in the east, Mount Taylor in New Mexico in the south, the San Francisco Peaks in Arizona in the west, and Hesperus Peak in Colorado in the north. They laid offerings for the prosperity of the people and also created the sacred boundaries of the Dinétah. The gods also established four rivers to serve as defensive markers whose intrinsic energies offered further protection. These rivers functioned as clear boundary lines between the Dinétah and other tribal areas and are believed to be guarded endlessly by the Yei of the Diné, who are also known as the Diyen Diné-e or the Holy People of the Diné.

The traditional Diné way of life has no conception of religion being separate from everyday living. They believe all things here on this plane of existence are related and each has its own spirit or inner essence that gives it resonance and intent inside a sedulous and interrelated cosmos. This interfamiliarity is maintained daily through prayer, symbolic offerings, and ceremonies designed to maintain balance, or what the Diné call "Hozho," in the ethos of the celebrant. The very purpose of life to the Diné is to maintain that balance and live in harmony and Hozho with the world and the Creator Spirit. To this end, the Diné must consummate their rituals at specific times and at the sacred places where they reside. To practice their rituals elsewhere, to them, is to die.

Here then, in the Four Corners region of the southwestern United States, have they made their homeland, the Dinétah or Land of The People. Although Diné cosmology indicates their presence has always been upon the Dinétah, they have lived there at least since sometime around 1400 ACE when perhaps several wandering clans of related proto-Diné groups coalesced and consolidated into the distinct tribal group known as the Diné. It is interesting to note that the Diné encountered the abandoned places of the Ancestral Puebloan peoples who had inhabited this region and referred to these peoples as the Anasazi or Enemy Ancestors. The use of this term by them implies that they

acknowledged these places as likely being the ancestral homes of the contemporary Pueblo people who they knew resided to the south, southwest, and southeast of the Dinétah. There is room, too, in the term that perhaps indicates encounters with these early Pueblo ancestors.

The most powerful tribal groups in the area were the Diné, the Ute, and the Pueblo peoples. There were raids back and forth, and they also traded with each other. The Ute were hereditary enemies of the Diné, which is not surprising if we refer to either of these migration models. If the Diné did travel south along the Rocky Mountains, then they traversed the homelands of the Ute to get there. If they emerged, then they did so in the region where their appearance overlapped that of the ancestral Ute. As these groups expanded, conflict would have resulted from trespass by one group on another's food resource areas and would have eventually required boundaries of demarcation in order to coexist. If an area did not provide sufficient food resources naturally, then these groups were forced to develop at least some sort of marginal agriculture or to become raiders upon each other's territories. Since the hunter-gatherer modalities of both the Diné and the Ute were ingrained culturally, the latter option was the one they chose until forced into capitulating this behavior late in the 1800s due to Anglo encroachments.

The Pueblo people of the period had by then primarily consolidated along the waterways of the Rio Grande or scattered into various branches, and their sedentary tradition kept them in sodality with their various kin and separate from the nomadic Diné. The Ancestral Pueblo knew how to cultivate maize and built many multistoried structures of adobe to augment their agrarian society. When exactly their culture first developed is still debated, but it is generally agreed that, based on the Pecos Classification, that they emerged or consolidated into a distinct culture around the twelfth century BCE.

Although one of the Pueblo people's early formative periods, known as the Basketmaker era, shows that many came to a violent end, and while the placement by later members of their culture of stone houses high in rock shelters within cliffs walls indicates a defensive posture, the Pueblo people themselves remain aggregated into a culture quite famous for their peaceful disposition.

They did encounter the Diné on occasion during this early period, and their relationships were varied, sometimes hostile, while at other times trading and coexisting in close proximity. Primarily, however, they remained apart due to

a general distrust. The word Navajo is actually an evolved word from the Pueblo Tewa linguistic group word "Navahu," which loosely means Raiders of the Cultivated Fields.

The Diné and their neighbors lived for several hundreds of years in their own homelands and developed their own distinct cultural traditions. They built unique shelters and hunted the wild world for food and tools to

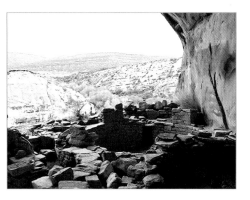

make their lives easier. Wild variances in geological environs made the Diné travel throughout different regions of their lands, following the seasons. Hozho was diligently sought and maintained or rectified by the many ceremonial chant-way ceremonies, and great shamans arose among them ,gifted in powerful memory. Clans evolved as extended family groups sought distinction one from the other and to measure ownership and lineages. Matrilineal hierarchies directed the ebb and flow of daily life while male prowess engaged the natural world. And so it was for many long changes of the season.

Other groups became known to the Diné: the Comanche from the eastern plains, the fading Salado in the far west, and the Hopi on their long flat mesas. It was a large world, which over time became increasingly inhabited and, despite occasional frictions between the Diné and their neighbors, their lands (which for all these groups covered barely 100,000 square miles) were enough and all that mattered in the minds of the inhabitants.

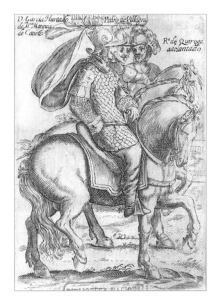

But all this was about to change.

There were other powers moving into this place of habitation. Unexpected visitors were about to come up the Rio Grande searching for what the Incas of South America had referred to as "The Sweat of the Sun" (Lourie 1991). They came looking for gold. Men with pale skin, and beards, carrying lightning rods came up the sacred river. They rode on giant beasts that were rumored to feed on children and that pulled small houses

that floated across the sands on spinning discs. In their hands were tiny glittering beads and wooden figures of their gods to whom they murmured and bowed. These were the Spaniards who were called "El Conquistadors" and who, after tiring of their sacking and subjugation of lands to the south, had turned their will upon these northern reaches of the American continents, seeking the fabled land of Cibola and the Seven Cities of Gold. With them came the Franciscan friars from the Motherland who hoped to bring the word of God to the lost souls living in the wilderness. They had a holy mission and believed their will was the will of their God.

The first of these Spanish explorers was Fray Marcos de Niza, accompanied by his Moor servant and a small reconnaissance party. They arrived near the lands of the Dinétah in the year 1539, but didn't get all that far before becoming intimidated by their arduous task. The frightened Marcos returned to Mexico where he fabricated fantastic tales of enormous cities that contained fabulous wealth. The Spanish Viceroy in Mexico who heard these stories was Antonio De Mendoza. The famous Hernan Cortes (of South American reputation) applied to Mendoza to command the subsequently proposed and more intriguing second expedition, but Mendoza's political inclinations caused him to grant the task to Francisco Vasquez de Coronado instead.

With fame and fortune apparently assured, Coronado sallied forth with a much larger army and in 1540 came upon the Zuni town of Hawikuh. The natives came forward and drew an energetically symbolic line of cornmeal in front of the advancing force telling them not to cross. Unfortunately, the magical spell failed and the conquest of the region by Spain officially began.

The Chiefs of the Hawikuh area were summoned by Coronado, and one, called Begotes, hoping to be rid of these intimidating strangers, told Coronado

Top: *Ancestral Pueblo ruin.* Grand Gulch Primitive Area, Southeastern Utah.

Bottom: 1646 engraving of the Conquistadors by Alonso de Ovalle.

of trails to the east, cities on a great river, mountains and plains. Sending his captain, Alvarado, to investigate, Coronado renamed Hawikuh "Granada" and settled in for an extended stay.

After extensive fruitless searching of the area, the Spanish explorers had to relay the news of the dearth of wealth in the upper Rio Grande area back to the authorities in their capital of Mexico City, and the Spanish Crown was reluctantly forced to abandon its quest for the fabled Seven Cities of Gold in the American Southwest. They did, however, remain in the upper Rio Grande area, primarily out of their fear of French interests in the New World, and also due to the undaunting zeal of the Franciscan Order of Catholic Missionaries desiring to bring the True Faith to the heathen inhabitants. Only once in 1680, when the subjugated Pueblo people organized a revolt, did the Spaniards briefly lose their grasp on the region prior to the middle of the nineteenth century.

The Diné were profoundly affected by the settlement of the Spanish along the Rio Grande waterways and were decimated by Spanish diseases. Spain made repeated sojourns into Diné territories wreaking great havoc on the eastern Diné communities who withdrew to mountain and hill areas of the west to avoid devastation and Spanish acquisition of Diné slaves for their burgeoning slave trade. The Diné, on the other hand, did gain sheep and horses by raiding the Spanish settlements.

The first 'Entrada' alone from Spanish Mexico City by Coronado and his conquistadors to the Northern Rio Grande included some 552 horses and 5,000 sheep, 500 head of cattle, and 600 pack mules (Horgan 1954). All of these types of domesticated stock vastly changed the Diné lifestyle, giving them enhanced mobility and more readily woven fiber. The native populations began breeding herds of horses, relying on stolen animals and those found on the plains that had escaped captivity. The Apache were

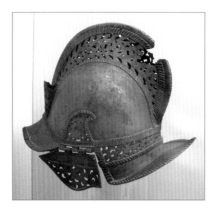

particularly known as plunderers on these early herds. Use of the horse soon spread widely among all the native tribes of the American plains and Southwest.

There's still more to think about and delay the reader before getting to the discussion of Fred Peshlakai. The landscape of the Diné in the late sixteenth century was on the threshold of even greater change. These changes would form the world into which Fred was born and have meaningful influence on his artistic expressions.

Several other European nations followed Spain in their rush to the New World. Colonists arrived on the East Coast much to the dismay of the Native residents who occupied the region. These Europeans did not just stay put but expanded their reach exponentially over the next several hundreds of years, eventually inundating the American Southwest.

The powers of Europe had arrived and were busy divvying up the native lands as opportunity presented itself. England's American Colonial population grew from 980 in 1625 to 2,400,000 in 1775. (U.S Bureau of the Census, 1909).

These figures do not include other European holdings on the continents; the number of Spanish people alone were estimated in the range of 740,000 by the end of the seventeenth century. Spanish estimates also include a 90 percent drop in native populations by that time in areas under their control due to European diseases and violent assault.

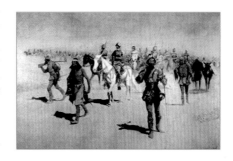

In 1534, the French, led by Jacques Cartier entered the Americas via the Saint Lawrence River area of modern Quebec and claimed for France an enormous area of the North American continent. Although regions were loosely interpreted for several hundred years, the map inset gives a fair idea of the reach of European interests during this period. The main business enterprises in these northern regions was the

Top: *Spanish helmet*, ca.1600. Exhibited: The Museo de América. Madrid, Spain.

Bottom: *Coronado Sets Out to the North* by Frederick Remington, 1861-1909.

harvesting of unplundered fur-bearing creatures of virgin forests. Immigration by simple Europeans hoping to escape European complexities also increased as the native populations retreated or were destroyed and the Anglo presence in the eastern regions burgeoned. The French eventually lost their land holdings in 1760 when England seized French interests east of the Mississippi River. These were called the French and Indian Wars, and they eventually consolidated England's control over the eastern portions of the North American continent.

The American Revolutionary period of 1763 to 1776 was finalized in 1783 by the Treaty of Paris and created a new power called the United States of America. This ousting of England from Colonial America and the creation of this new independent entity would create a new power base of Anglo interests concerned with nationalism, security, expansion, and wealth.

It wasn't long until the discussion inside America's government halls began to focus on the land that lay to the west and its relatively uncharted borders. The Louisiana Purchase of holdings still officially belonging to France was consummated in 1803 and expanded United States' holdings by 828,000 square miles for the tidy sum of $11,250,000. Soon after, from 1804 to 1806, came the Corps of Discovery Expedition by Lewis and Clark, commissioned by the American president Thomas Jefferson. Its purpose was to find a direct waterway route to Oregon Country and the Pacific Northwest. Fur-collecting interests in the Oregon Country had long been held primarily by Russia, England, and France, but by 1820, Americans began to settle there in large numbers. It wasn't long until fur stocks were depleted all across the Americas, prompting even John Jacob Astor, owner of the largest fur company in the Americas and whose great-grandson J.J. Astor IV would later sink with the *Titanic*, to retire from that business in 1834 and continue building his fortune in real estate.

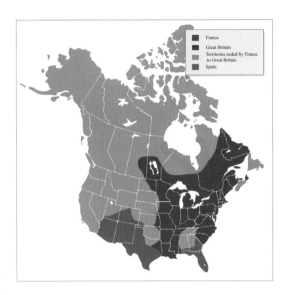

Revolution was also happening to the south, in Mexico. From 1810 to 1821, the Spanish people in Mexico and some of their remaining indigenous populations had also risen up and procured for themselves an independent country from the Spanish Crown, formalized on August 24, 1821 by the Treaty of Cordoba. The new country was called New Spain.

This Mexican War of Independence resulted in the formation of a Federal Republic consisting of nineteen individual states, which included the Coahuilla y Tejas (later Texas) and Nuevo Mejico (New Mexico Territory) as individualized regions. It was originally hoped that these states could enjoy some semblance of local control while still remaining under a republican national umbrella. This concept was, unfortunately, short-lived. After the dust had settled, a certain Colonel Augustin de Iturbide demonstrated his previous royalist leanings by having himself declared Emperor Augustin I one year later. Although supported by the Church, this act was not smiled upon by the original republican reformists among the new government's hierarchy.

Antonio Lopez de Santa Anna, a regional governor at the time, and several others of influence took advantage of Iturbide's inability to pay his military and inopportune censuring of the press to march on Mexico City and force Iturbide's abdication on February 23, 1823. After Iturbide's exile, there followed ten years of political posturing among Mexico's elite, which eventually ended in Santa Anna's election to Mexico's presidency in 1833 (Horgan 1954).

Beginning back in 1824, the new government of Mexico had begun inviting United States citizens to settle in and among the large expanses of the state of Coahuilla y Tejas using large land grants as incentive. They asked in exchange that these new settlers provide the citizenry with protection against the indigenous Comanche of the region, who were doing their best to harass and drive away the trespassers setting up their little wooded

European regional holdings map of the North American continent, ca. 1750. *Cartography courtesy of Jesse W. Byrd, Albuquerque, New Mexico.*

structures all across the open plains and ancestral Comanche hunting grounds.

The Texans got rather tired of having all the responsibility for performing these tasks while not getting much, if any, cooperation from the struggling Mexican leadership to the south. Responding to the complaints of the Texans and other Mexican states increasingly unhappy with the central government, the newly elected Santa Anna dissolved the state legislatures, disarmed their militias, and even abolished the 1824 Constitution in 1833, hoping disempowered complainers would be less likely to bite.

This was the beginning of the Texas War of Independence, wherein Stephen Austin, Sam Houston, and others of famous name rose up and proclaimed the region as the independent Republic of Texas, this time with United States of America affiliations. They elected their own president and governing officials, thereby thumbing their noses at the Mexican national government far to the south.

Santa Anna saw a problem in all of this and, riding forth, trounced the Texans at the Alamo and then rode south again over the border, leaving the infuriated Texans to run roughshod over the Mexican populace left behind. The Texans were determined now to run off any show of Mexican authority and began systematically eliminating any strongholds of the Mexican government. The Texans surged forward and were making great inroads toward their ultimate goal of seceding from the Mexican nation when up from the south the Mexican forces regrouped themselves and returned to engage in the conflict.

President Santa Anna of Mexico personally joined the melee, traversed indiscreetly into unsecured areas held by the Texans, and was ingloriously captured in The Battle of San Jacinto, which lasted a blistering eighteen minutes. To procure his release, Santa Anna signed documents promising to withdraw his troops and offering an agreement of peace between the Texans and the Mexican officials (later referred to as The Treaty of Velasco) that granted autonomy to Texas.

The Treaty (although not really a treaty as was pointed out later to President Polk by none other than Congressman Abraham Lincoln) was signed, but not without some confusions. Apparently, Mexico had intended the border of this newly recognized entity of Texas to begin at the Nueces River, which basically runs diagonally across the center of what would eventually become the U.S. state of Texas. Texas, on the other hand, had interests (and American citizens) west of the Nueces, and they claimed all the lands east from the Rio Grande instead, including its delta in the south at the Gulf of Mexico, and then north to the Rio Grande's headwaters in what would later become the state of Colorado. This left an enormous area of valuable land still in dispute. This dispute would continue for ten additional years and enflame politics in both countries. The United States government finally intervened and defiantly officially annexed The Republic of Texas in 1845, with final ratification scheduled for December 29, which included admission to statehood scheduled on the same date. Needless to say, the Mexican government was not pleased with this action on the part of the U.S. Government and refused to recognize the independence of Texas and its claims to the Rio Grande territory and broke off diplomatic relationships with the Americans.

It is interesting to note here that in this same year, while the U.S. government was filibustering over Texas, Mr. John O'Sullivan wrote an article in *The United States Democratic Review* entitled "Annexation," which used the term "Manifest Destiny. " The phrase would come to be a motto for those Americans dedicated to the interests of expanding the United States to the western sea-board (O'Sullivan 1845).

The phrase created the notion of a "divine destiny" for the Anglo population of the United States "to establish on earth the moral dignity and salvation of man." Once again even God was on the side of the expansionists, and popular opinion swayed in favor of plundering the poor souls who apparently also needed moral guidance.

James K. Polk, as the incoming United States president in 1845, had long held expansionist views for the American nation, including the idea of a transcontinental railroad. Casting his interested eye upon the enormous expanse of land that lay between the east and west coasts, Polk saw all the uproar with the indignant Mexican government as an opportunity, and he took it. Citing Mexico's resistance to acknowledging United States sovereignty in Texas, Polk began the Mexican American War in 1846, hoping to remove Mexico's obstructive presence in the upper North American continent.

United States forces thoroughly clobbered the disorganized Mexicans in the Texas region and even marched on Mexico City itself, prompting some in Washington to clamor for annexing all of Mexico into the United States as well.

Instead, the two sides signed the Treaty of Hidalgo, wherein Mexico ceded to the U.S., along with agreeing on the Gasden Purchase, all the territory in dispute and created the border between Mexico and the U.S. that exists today. The Treaty of Cahuenga in California finalized these conflicts, and in 1848, the war ended. None too soon either for the Americans, since gold was discovered in California on January 24, 1848, and some 300,000 U.S. citizens rushed to the area to find their fortunes.

But wait, there's more!

Back east, the United States now had other problems looming. Slavery in the United States was becoming a divisive issue. Intending to resolve the matter for the western regions of the U.S. continent, the Compromise of 1850, penned by Henry Clay and Stephen Douglas, claimed California as a free state and noted that Utah and New Mexico territories would be able to decide the issue on their own by popular sovereignty. Texans, who were long-time slave holders, sided with the South. What eventually became known as the Civil War began, and the years 1861 through 1865 saw the deaths of some 750,000 U.S. citizens. During this period, slaveholding Texas claimed lands extending to the east bank of the Rio Grande and free New Mexico claimed to the 100th parallel, while southern New Mexico held allegiance to the Confederacy.

What specifically followed in the New Mexico Territory was not all that dramatic compared to the devastation back east. Soldiers sympathetic to the Confederacy were in short supply in the American Southwest. Most were called to fight their battles back east and elsewhere, so other than some small chasing of each other back and forth across the hills east of the Rio Grande, not all that much happened.

Since those Anglos posted to the territory had little to do for the war effort, the Union military commissioned Christopher Houston Carson, otherwise known as Kit Carson—intrepid explorer and later demon to the Diné—to assemble the 1st New Mexico Calvary during this period. Military thought turned to addressing what they called "The Indian problem." It was a solution that leaders thought would boost the morale of the idle Union soldiers and also remove the obstructive presence of the Diné, whose lands lay astride the nationally proposed routes of westward expansion.

This was not a favorable turn of events for the Diné. They stood in the way of President Polk's railroad and the trails to the gold fields in California, and so began the first authorized dedicated attempts of cultural genocide against the Diné upon their Dinétah by the United States government. If physical genocide was a byproduct of Anglo ambitions of the times, then that was of little consequence. Manifest Destiny forgave all methods and means to the end.

According to the 1850 U.S. census, there were 61,547 persons in all the land of the New Mexico Territory. Another estimate for population posted in 1842 stated there were 47,000 Spanish, and 16,500 Pueblo people living in the region. These last figures do not apparently, or specifically, include the Diné or other native populations present. Common sense would conclude that these figures are inaccurate as the ability to correctly count populations was limited due to the region's remoteness.

Suffice it to say that, during the American Civil War, the overall population of U.S. citizens living within the New Mexico Territory could not have been very high. Comparatively, Native American populations had declined by upwards of 90 percent by this time due to European diseases and conflicts with these invaders.

The sequential subjugation of America's Western indigenous populations can be broadly illustrated using a map that demonstrates the official protocol for the United States requiring a region to be first officially designated as a territory before it could be recognized as a state. The table demonstrates the recognition of those regions by the United States (see page 20).

The implications were clear for each region's indigenous people.

It can easily be surmised that, while watching all of the events that were unfolding around them, the Diné elders who were looking on from their mesas and lowlands considered the Bilagáana out of Hozho with their lives very much indeed.

Formation of Territories by the United States

Oregon Country...1818-1846

Oregon Territory..1843-1849

State of Deseret (Utah)......................................1849

Territory of Washington.....................................1853-1889

Territory of Nebraska...1854-1867

Territory of Dakota...1854-1889

Territory of Idaho ..1863-1890

Territory of Montana..1864-1889

Territory of Wyoming ...1868-1890

California StatehoodSeptember 9,1850

New Mexico Territory...1850-1912

Arizona Territory...1863-1912

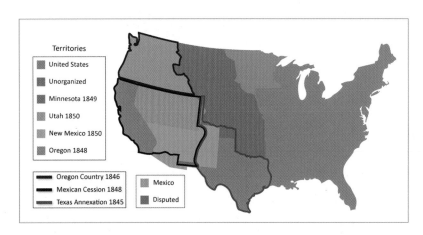

Cartography courtesy of Jesse W. Byrd, Albuquerque, New Mexico.

I awoke.
And the earth was weeping for the coming
Bitter Moons.
New strange men
Set the crow running for the setting
Western sun.
The Sacred Ones blew sands of grief
And poured them on their council fires.

Evil storm.
And the rain was pleading for the failing
Many Suns.
New strange men
Set the earth crying for the mighty
Wailing winds.
The Peaceful Ones sang songs of tears
And poured them on their dreams of ash.

Scattered days.
And the maiden longed for her broken
Spider's net.
New strange men
Set the rivers flowing for the fated
Barren days.
The Old Ones spoke their words of stone
And poured them on
The child of time.

—AARON BEGAY, 2008

BITTER MOONS
FOR MANY SUNS

THE NINETEETH-CENTURY WAS A TIME OF GREAT change for the Diné people who had lived relatively peacefully within their Dinétah. One of the most readily associated persons from that time period—especially regarding the evolution of Navajo silver art and the family origins of Fred Peshlakai—is remembered by the name of Atsidi Sani. His Diné name, Atsidi Sani, roughly translates into English as Old Smith. He was born sometime around 1827 to the Dibélizhiii Dinéé, or Black Sheep People Clan, at To' Dzis'a' on the clan holdings of his people in the Chuska Mountains of the Dinétah (Navajo Nation Museum exhibition, 2012). It was a time of peace for his family. They were relatively safe, deep in their homelands where the Ute and Comanche struggled to find them on their raids into the Diné lands.

It was a time when the presence of the Anglo Mountain Men from the east was beginning to wane. These men had long been a source for guns and other trade goods, which they had brought to the Diné in exchange for being able to hunt the fur-bearing animals at the headwaters of the rivers across the Dinétah. The presence of the Spanish soldiers had begun to diminish as well. The Mexican people had separated from their king in 1821 and their new government was busy with their own reformation issues and had considerably retreated from the American Southwest.

Atsidi Sani was about eight years old when he likely first saw the man whose colorful life would come to be known synonymously with what would befall the Diné in the nineteenth century. This man was called Ash kii Diyinii, or Holy Boy, by the Diné. Holy Boy was the son of Cayetano, the leader of the Bit'aa' nii, or Under His Cover clan, and he would soon marry the daughter of the famous war leader Narbona (Diné Education Web). This marriage placed him in the position to become a great leader of the Diné people, a position also shared by the clan family of Atsidi Sani.

In the years around 1846, a new type of American began to appear in the Chuska Mountains. These New Men arrived from the east, thanks to the Mexican American War of 1846 to 1848. Commanded by Stephen W. Kearny, the Army of the West arrived, with interests in both the Rio Grande area and the California area of the west coast. Other American leaders followed, such as the noteworthy attorney and soldier Alexander Doniphan and Colonel Stephen Price. This latter figure proclaimed himself the Military Governor of New Mexico, marking a turning point for white occupation of the region. These New Men Americans had entirely different intentions for the region than their Spanish predecessors had had. Their intentions represented the relentless will of their government back east, which wanted not only to be a presence in the area but also to intricately manage these vast lands and the people who lived there as well.

After the Americans won the war with Mexico in 1848, they began occupying the land. It was in this capacity in 1850, just after the region was named the New Mexico Territory by the United States, that their Military Governor, John M. Washington, met with the famous Diné leader Narbona in order to sign a treaty with the Diné regarding the region in which Atsidi Sani lived.

It was at this treaty signing in the Tunicha Valley at the eastern Chuskas that an infamous event occurred. Reportedly, a Diné man was accused of stealing a horse from one of the American soldiers, and the Americans fired upon the treaty gathering, mortally wounding the famous Narbona. This enraged his son-in-law Holy Boy and crystallized Askii Dihin's stance of resistance to the American occupiers.

In 1851, Fort Defiance was established in the area north of the modern town of Window Rock, Arizona, in order to provide an American military presence in the region. In 1855, a treaty was signed between the Diné people's leader, named Largos, and the U.S. Governor of the New Mexico Territory. This treaty was intended to grant exclusive use of the lands that lay outside the American fort solely to the Diné. After the treaty was signed, Largos resigned due to advancing age, and Holy Boy was named his successor. It was at this time that his name begins to

appear on signed treaties as Manuelito, or A Little God Among Us, in the manner in which it was translated by the Mexican interpreters.

It was in this capacity that Manuelito met with Commander William Brooks, who was the commander at Fort Defiance, regarding the demand that the Americans be allowed to graze their livestock on the lands surrounding the fort. Manuelito refused this, based upon the Largos Treaty, and subsequently Brooks sent troops onto Diné land holdings and slaughtered their livestock in retaliation. In 1856, Manuelito and an estimated 1,000 Diné warriors attacked Fort Defiance in their own response, compromising the American operation there. This action caused Manuelito's party to be considered dangerous renegade fugitives to the United States military, which then pursued them relentlessly across the region.

In 1861, the American Civil War broke out and Fort Defiance was temporarily abandoned due to the exacerbated situation with the Diné as well as increased internal conflicts among American factions. General James H. Carleton with the Union army came east from California and joined forces with General Canby. After the issues of the Confederacy's ventures into the area had been settled, it was Carleton who then took charge of the New Mexico Territory.

Carleton immediately turned his attention to the inconvenient presence of the indigenous populations in the area. He selected a place in the southeast desert region of what is now the state of New Mexico along the Pecos River where, with the government's approval, he established a reservation area intended for the sequestering of all the different native inhabitants of the area. It was a long narrow valley of about forty square miles, and into it he planned to confine all of the Diné, the Mescalero Apache, the Comanche, and all the Kiowa tribal members who lived within the New Mexico Territory. Here he built Fort Sumner, which was named after the original builder of Fort Defiance, Colonel Edwin V. Sumner.

It was an altogether wretched place despite its cottonwood tree-filled basin. Its enclosing hillsides suited the brutal Carleton perfectly. He selected the notorious Kit Carson to perform the task of rounding up the indigenous populations, a decision he based largely on Carson's familiarity with the areas as well as his reputation for intense ferocity against all nonwhite peoples. This task perfectly suited Kit Carson's penchant for cruelty, and stories abound regarding the horrific methodologies Kit Carson inflicted upon the Navajo people in the course of his calling. If the Diné did not come voluntarily, Carson and his men burned their fields, destroyed their homes, and murdered them by the hundreds, forcing most of those who survived to capitulate. Those who didn't go willingly were dragged in chains to holding areas before their relocation.

In 1864, Atsidi Sani was among the people from the land holdings of the Dibélizhini, or Black Sheep Clan who surrendered to the Americans at Fort Wingate (Lapahie 2009). It is here, too, in the Gorman family lore, that Althts'osigi, or Very Slim Man (and later known famously as Slender Maker of Silver), is mentioned as a participant in what was befalling the Black Sheep Clan. It states, referring to Carl Gorman, Fred Peshlakai's nephew, that, "Carl's own grandfather, Peshlakai, had the opportunity to escape, but he chose to stay with his family. He had seen his father and mother taken in fear, along with his brothers and sisters. He went with them. He was young and strong, and he would take care of them, he said" (Greenberg 1996). Althts'osigi was born c. 1831 and would have been about thirty-three at the time. It is interesting to note that Fred Peshlakai remarked with equal pride in 1964, that his father and other members of his family had escaped sequester and had hidden out in the mountains and had not been incarcerated at Bosque Redondo. (John Bonner Strong, pers. comm.). There are currently no known official records of Althts'osigi for this period to verify either versions of this family lore. What is apparent is that both versions place a great deal of pride in the character of Slender Maker of Silver.

From Fort Wingate, they were forced to walk the 450-mile, eighteen-day journey to what the Diné called "Hweeldi" at Fort Sumner in the barren desert far to the south and far from their sacred Dinétah. This event, which was part of the "at least 53 separate episodes of removal" (Ackerly 1998, 3) is remembered by the Navajo as "The Long Walk." The people were starving, and it is related that at least 200 of them were left unattended as they lay dead or dying along the trail that led them far from their homelands.

Hweeldi was crowded and exceptionally dismal. There were no shelters prepared for the arriving Diné, and they were forced to improvise as best they could. The Americans had planned on a total of about 5,000 people being sequestered, but by the end of 1864 there were more than 8,000 people huddled together in the bottom of the little valley (Ackerly 1998, 2). There was not enough food or adequate makeshift shelters, and the winters were bitterly cold. To make matters worse, 500 of the captives

being held in the little valley were Mescalero Apache tribal members whose tribe had long been considered hereditary enemies by the Diné. Still, they were expected to cohabitate and share the meager provisions provided to them by the soldiers, who resolutely stood posted around the rim of the canyon.

Complicated, too, was the fact that this small round valley, called "Bosque Redondo" by the Mexican servants of the soldiers, was situated hard by the lands of the Comanche people, whom the Americans had been unable to subdue. These Comanche handily raided Bosque Redondo, taking provisions from both the destitute captives and the white men indiscriminately. Diseases swept through the camps of the captives. The old and the young began to die at a terrible rate.

In 1865, the Mescalero Apache people interred at Fort Sumner instigated a successful escape which eased some of the tensions. Still, the situations of the Diné grew steadily worse. The soldiers forced the Diné to cultivate fields in order to try to make up for some of the food shortfall, but the area was stricken by drought and the crops failed.

In 1865, even the great Manuelito ended his resistance to being held prisoner at Bosque Redondo after being wounded in a skirmish with a Zuni and Ute war party that had banded together to assist the Americans.

Despite the ending of the Civil War in 1865, it took three more years before the Americans would admit that the internment of the Diné at Bosque Redondo was a failure.

The Treaty of Bosque Redondo was finally signed on June 1, 1868. Atsidi Sani was the sixth signer of that treaty and is listed on the document as "Delgado" or Slim Man, called elsewhere in the same capacity as "Hastin Besh lini," (Navajo Nation Museum exhibition, 2012), where he signed the treaty with his mark as the letter "X." The treaty granted back to the Diné their ancestral Dinétah to which they could finally begin their long walk home. It was the place where the Diné felt they belonged, but it would take years to recover any measure of its productivity and in so many ways would never be the same as it had been only one generation earlier.

THE FAMILY OF FRED PESHLAKAI

VERY EARLY HISTORIES HANDED DOWN BY THE NAVAJO people, which include important members of their culture, spring from their cosmological Story of the Emergence, called the Hahdenigai-Hunai. One compilation of these sacred beliefs was beautifully recorded by Mary Cabot Wheelwright in her translations of the words of the well-known Diné artist and medicine man named Awéé askii', also known as Hosteen Klah, who was born in 1867 (Klah, 1942). The final pages of this particular translation bring the story of the Diné people forward to the Dinétah, establishing it as their homeland.

Out of deep respect, that story is not elaborated on here, but is highly recommended to those who seek a deeper understanding of these noble people. There are also interviews with Hosteen Klah by Franc Johnson Newcomb that bring the history of the Diné into the eighteenth century. Here their own recorded histories begin to merge with those of early-contact Anglo chroniclers. Recommended too is an elucidation by William B. Tsosie titled "Clans and Their Origins," which speaks to the presence of these early people and their places in history (Tsosie).

These texts have only relatively recently been able to be coalesced and contain very large disparities, largely based on individual viewpoints and biases, as was typical for their times. An example of this is a reference to the last half of the seventeenth century that states:

> At that time a Spanish informant advised the Spanish Governor that the Navajo tribe consisted of about 700 families numbering 3,500 people. The informant also states that this tribe owned 500 horses, 600 wild mares, 700 black ewes (he does not list the white ones), 40 cows and their bulls, and many short-haired Mexican goats. Klah's estimate of the number of people and their stock does not agree with this in any detail excepting perhaps (sic) the number of black ewes. He gave me a higher estimate of around 1,200 families with twice as much live stock as the report stated. (Newcomb 1965)

These disparities in accounts are relatively standard in the early recorded histories of the Diné, and it has only been in recent times that these disparities have been more seriously reevaluated for some semblance of the truth—a truth that has been found to lie most accurately on the side of the Diné and their accounts of what befell them.

Somewhere in all of these accounts lies the earliest family history of Fred Peshlakai. Most of these records have been hitherto examined rather cursorily, except perhaps by his relatives and descendants. Nevertheless, much has been theorized about Fred's life. Perhaps there is little blame to be placed on these well-meaning individuals. It has only been recently, with the advent of digitalized information, that these histories can be better evaluated. Unfortunately, many misnomers still prevail.

What is known is that Fred Peshlakai's forebears lived in the Chuska Mountain regions of what is now northeastern Arizona and northwestern New Mexico at the beginning of the nineteenth century. An early description of the people of the area is found in a letter written by the Spanish Provincial Governor at the time (1794-1805), named Lieutenant Don Louis Chacon. In it he writes:

> The Navajos, whom we suspect have sided with the Apaches in their invasions, have since the death of their leader, Dinnae-ihil-kish, (Spotted Man) who met his death at the hands of the Apache, been irreconcilable enemies, to such a degree that with us they have observed an invariable and sincere peace. These Indians are not in a state of coveting flocks (sheep and goats) as their own are innumerable. They have increased their horse herds considerably; they sow much and on good fields; they work their wool with much more taste and delicacy than the Spaniards. Men as well as women go decently clothed, and their Captains are rarely seen without silver jewelry. (Newcomb 1965)

Although there is a disclaimer by Newcomb that she felt this was in reference to a southern group of Diné people near the Bear Spring area southeast of Zuni Pueblo, she goes on to say that, "The same description was equally true of the Navajos living along the eastern slopes of the Tumecha Mountains." These mountains are now considered part of the Chuska mountain range.

Of interest in this letter, too, is the mention of silver jewelry worn by the "Captains" of these people. Although it is agreed that the advent of Diné manufacture of these kinds of ornamentation was not to occur until several decades later, its position inside the Diné aesthetic is clearly mentioned at this early date and implies it was in place for some time prior to the turn of the nineteenth century. Certainly, the forebears of Fred Peshlakai shared this aesthetic, and its inclusion as a measure of wealth and status is demonstrated early on in Diné history.

One of the least agreed upon topics in the evolution of Navajo silver art is regarding which specific Diné artisan it was who first created a silver ornament and could be therefore be considered the progenitor of the craft. This question is a pertinent one when considering the familial connections to Fred Peshlakai as well as the overall evolution of Navajo silver as an art form.

This debate first reached a larger audience in 1938 when Arthur Woodward published his *Bulletin No. 14* for the Museum of Northern Arizona entitled "A Brief History of Navajo Silver." In this publication, the subject is examined in such detail that it can be concluded that the answer to the question cannot be determined irrefutably. Woodward did however state that "the man who is indicated as being the first silversmith, known to the Navajo as Atsidi Sani (the Old Smith) and to the Spanish as Herrero Delgadito (Little Lean Iron Worker), acquired his knowledge of silversmithing between 1853 and 1858" (Woodward 1938,14). He went on to conclude that, "At any rate, both traditional and documentary evidence point to the 'Old Smith' as being the 'daddy of the silversmiths' and in the light of subsequent testimony of Herrero himself, there seems to be little doubt as to the accuracy of this statement" (Woodward 1938,15). These conversations were added to when in 1944 John Adair wrote *The Navajo and Pueblo Silversmiths*. In Adair's book he writes that Atsidi Sani, at the age of "about 25" years old, began his association with the Mexican blacksmith Nakai Tsosi, who lived in the region of Mount Taylor, which lay to the south of the Chuska Mountains (Adair 1944, 4). It is reported that this man agreed to teach Atsidi Sani the

handling of what the Navajo called "Besh," which was their word for the metal they knew as Dark Iron.

Adair goes on to state that, "One of these 'few,' a silversmith who was well versed in the craft, was a man by the name of Beshthlaigai-ithline-athlsosigi (Slender Maker of Silver), who was the younger brother of Atsidi Sani and lived near Crystal, New Mexico" (Adair 1944, 22). He then remarks that "I have met the son of Slender Maker of Silver; he lives at the present time in Los Angeles, where he makes Navajo silver for the tourists who visit Olvera Street. His name is Fred Peshlakai, and he said he learned the craft from his father over twenty-five years ago" (Adair 1944, 23). Adair then adds a disclaimer to the quote from Fred Peshlakai as a footnote to that page that reads:

> *It is quite possible that this man is the nephew and not the son of Slender Maker of Silver. According to the Navajo method of reckoning kinship, that father and the father's brother are called by the same term. In this case he would be the son of Slender Old Silversmith, the brother of Slender Maker of Silver, who was also the brother of Atsidi Sani. (Adair 1944, 23)*

This footnote has caused no small amount of confusion among scholars studying this era. It has also provoked endless misnomers within the subsequently purveyed commentaries regarding the interrelationships of these famous figures. So much confusion abounds in what is readily available to the inquisitive that it could be suggested that everybody get together and just release a universal 'Ohm' of forgiveness and wait for digital science to fill in all the gaps in common knowledge. In the interim, although the broader question regarding who was the progenitor of the iron work that evolved into Navajo silversmithing must be left to posterity, the questions regarding the familial relationships between these famous figures can be further clarified.

It is important, for the purpose of this biography on Fred Peshlakai, that the placement of his direct bloodline in these historical events be considered in order to better understand how he was profoundly affected by his family's history. Also, since his genetic lineage was famous in its own right, this perhaps explains something of the origins of Fred's brilliance.

Seeing him within the context of his lineage certainly helps to understand his inclinations.

Past confusions have been pervasive, with linguistics largely to blame. Even today many of the Diné don't understand what is meant by words written in English orthography and must hear the word out loud in order to know what it means. There is little wonder discrepancies abound in the correct format for writing out the Diné language. Names recorded for different Diné members were often written phonetically, and so individuals often appear as different persons on differing documents. Cultural predilection also complicates things when the giving of a person's name is often associated with their personal traits and prone to change over time when the name-giver sees changes in the one observed. It can be concluded with near certainty that most linguists studying the Diné language have been tempted at times to go lie on an enormous fire-ant mound in order to 'end it all' when confronted with the variables in how the Diné word is represented.

Consideration, too, must be given to the individuals who were being interviewed and their interpretations of kinship translated into English equivalents by the one doing the interviewing. There are three types of kinship at work here. The first is 'consanguinal' or kinship by bloodline. The second is 'affinal' or kinship through marriage,,and the third is called 'fictive' kinships, which are expressed as a social tie.

These variables in how the interviewee and the interviewer were interpreting the kinship are very important to our study, especially in light of the fact that the Diné culture and the Anglo culture have different meanings for differing titles that they assign to certain individuals. A simple example of this is the Diné use of the title of aunt, which can be used as a title of respect for any older woman of their tribe with whom they are interacting. Other similar fictive titles such as brother, father, cousin, uncle etc., are given to family members and others by the Diné quite differently than by the typical Anglo. As such, the historical record has become increasingly blurred over time.

As mentioned earlier, even John Adair expressed concern in his book that perhaps the terminology used by Fred Peshlakai regarding his "father" had the potential to be misinterpreted. This potential has certainly increased with the republication and reinterpretations of those early interviews of all these early historical figures.

Atsidi Sani is a fairly well recognized and documented historical Diné figure from the nineteenth century and can be used here as a pertinent example. The Navajo name "Atsidi" (which specifically means 'to pound' in Diné and is often used by them humorously in a tongue-in-cheek fashion) is similar to "Smith" in English, referring to a worker in metals. This Diné word is also spelled as Etsidi by some, while using the word '-ilthini' within a name also translates as "A maker of." Diné language structure places the noun in front of the descriptive in certain names, and so Atsidi Sani translates directly into Smith Old.

The Diné's use of associative names for individuals, like Old Smith, as an everyday description for tribal members likely results then in there being several Old Smiths across the breadth and width of the Dinétah. Their sacred names were private and not generally used outside closed ceremony or intimate association. More common names that were also used for Atsidi Sani and found within a dizzying myriad of sources are: Hashke Naat aa, which roughly translates into War Chief or Fierce/Angry-Talker/Maker; either Hastin or Hosteen Atsidi Sani, which means Respected Man Old Smith; Delgado, or Slim Man (Navajo Nation Museum exhibition 2012); and Beshiltheeni or Beshilthini, which translates as Dark Iron Smith or Iron-worker. Atsidi Sani was also called Herrero, the Spanish word for Smith; Herrero Grande, Big Smith; Delgado, Thin Man; and Delgadito, Spanish for Little Thin Man.

It is wise to acknowledge here, too, that perhaps some of these names have been misapplied to Atsidi Sani. Slender Old Silversmith is, for example, listed as a different person than Atsidi Sani by John Adair who goes so far as to indicate him as a "brother" to Atsidi Sani and so therefore a "brother" to Slender Maker of Silver. There is such a dearth of further information regarding Slender Old Silversmith that it begs the question if there isn't some confusion here since the other two "brothers" are so well documented and their Diné names, when interpreted, are so nearly similar.

The Slim Man is another name that may be misapplied although, here again, there are discrepancies since historical records indicate that Atsidi Sani signed the treaty of 1868, yet his name listed in those documents is rendered as Delgado or Thin Man. This name subsequently also translates from the Spanish language into Diné as Diné Ts'ozi. Currently, there is insufficient evidence to throw out the possibilities that these names could be in reference to Atsidi Sani and not some other figure.

This illustrates clearly why there exists such a challenge to researchers, especially since those names listed above are only Atsidi Sani's well-known common names and don't include others that may have been used for him on occasion to say nothing of his family names. (Is anyone else looking for that ant hill yet?!!) Fortunately, there are dominant versions of names for these more famous individuals, and for our purposes we can focus on those.

Diné family ancestry is determined through the use of familial clan names that represent distinct groups of persons within the Navajo tribe. The Diné clan system is matrilineal, meaning the bloodline of the women is considered socially dominant over that of their male counterparts, even though the clan affiliation of the male partner remains important within the dynamics of the Navajo nuclear family unit. Children are considered born 'To' the mother's clan and born 'For' the father's clan. In other words "To" means the child belongs to the mother's clan but there are still familial deference obligations 'For' the father's clan family. The result of this is that the clan name of the female is the most dominant association to prevail over time and therefore the one most likely to be remembered by later generations. It is some assistance to the genealogist that the Diné clan system includes a strict observance against intermarriage between members of the same clan as part of their longstanding traditions and is closely observed. However despite this clarity for the governing of social interplay between members of their immediate family, there is still a generational loss of information. The family tree illustrated here demonstrates the loss of male clan information over time.

The table (below) is demonstrative only. Certainly the Diné themselves keep better memories of their clan histories but by the fourth and fifth generations it explains why, as a result of this social delineation, combined with all the cataclysmic events and compromised available record-keeping propensities of the early nineteenth century, there has been confusion among genealogists as well as within the oral record of the Diné.

It was in the Chuska Mountain area that well-recorded historical Diné figures began to appear at this time. As noted earlier, one famous leader of the Diné was named Narbona, who lived from about 1766 to 1849, and interwoven into his story is the famous war leader Manuelito, who was born c. 1818 and whose name would become synonymous with the resistance of the Diné people against their oppressors during nearly all of the nineteenth-century era.

Franc Newcomb records that Narbona was born to the "Yei-ee-Dinnae" clan although Newcomb then goes on to disclaim that this was an unverified clan name (Newcomb 1965, 2). Related elsewhere by sources such as the material published by the "Kiyaa-aanii" (Lapahie) or Towering House

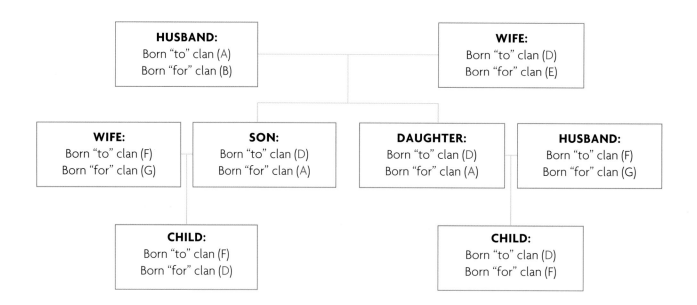

Clan, it is stated that Narbona was born to the Tachii nii or Red Running into Water clan. The Tachii nii clan is considered a very early clan by the Diné and as such Holy People (Tsosie). This belief is clearly echoed in the clan name of Yei-ee-Dinnae given to them in the Newcomb papers, which roughly translates as Holy People of the Diné. This example is given to demonstrate why so many differences exist in the record and why there has been so much confusion in overly conclusive statements made by many historians. Great caution obviously needs to be exercised here.

This is important information, however, for the search for the familial origins of Fred Peshlakai. In Henry and Georgia Greenberg's book *Power of a Navajo; Carl Gorman: The Man and His Life,* there is information regarding Carl's grandfather through his mother Alice Peshlakai Gorman. This man is none other than the famous Slender Maker of Silver, otherwise known as Beshthlagai Althts'osigi of the Ta'chii'nii clan" (Greenberg 1996, 7).

This information tempts the historian to conclude that Slender Maker of Silver is related to the famous Narbona of the early nineteenth century. However, in the book *American Indian Jewelry III, M-Z,* the author states that a highly respected source has revealed that her mother's family history indicates that Slender Maker of Silver was of the "Todichii'nii" or "Bitter Water" clan (Schaaf 2013, 268). This comparison is not intended to prompt an argument but rather to demonstrate the need for additional research before absolute conclusions can be drawn regarding these earlier members of Fred's family. It is entirely possible that both sources cited here may be in some respects right regarding the clan lineage of Slender Maker of Silver since certain clan associations for his individual parents remain currently unavailable to researchable common knowledge.

It has been previously stated that John Adair in his book on Navajo and Pueblo silversmiths mentions that Slender Maker of Silver "was the younger brother of Atsidi Sani and lived near Crystal, New Mexico" (Adair 1944, 22). This is corroborated, with some slight variation, in the Woodward text as, "particularly Slim Old Silversmith of Crystal and a brother, the famed Slim Silversmith" (Woodward 1938). Further intriguing information is again related in the Greenberg manuscript where it states: "In the same group was Atsidi Sani, a clan brother of Peshlakai's," (referring to Carl Gorman's grandfather), "who is considered by some as the first Navajo Silversmith" (Greenberg 1996, 5-6).

According to information at the Navajo Nation Museum, Atsidi Sani is "Black Sheep" clan. (Navaho Nation Museum exhibition 2011) Also, according to the biography on Carl Gorman, the Gorman family genealogy relates that three of Slender Maker of Silver's wives were '"Black Sheep" clan (Greenberg 1996, 7). Information previously discussed describes Slender Maker of Silver as being either Tachii nii/ Red Running in to Water clan or Todichii'nii / Bitter Water Clan depending on the particular descendant and their family lore. This is validated by the fact that Slender Maker of Silver could not be a consanguinal member of the Black Sheep clan in order to marry Black Sheep clan sisters in adherence to strict Diné cultural protocol. Atsidi Sani and Slender Maker of Silver could therefore not be full brothers but they could have been clan brothers, brothers-in-law, or members of an extended family unit.

This affinal relationship resolves many disparities in the historic explanations of the association of these two famous figures. The revelation that Slender Maker of Silver was either Tachii nii clan, with possible connections to the great Diné leader Narbona, or from the equally respected Todichii'nii clan also goes a long way in explaining why three wealthy Black Sheep clan sisters, with ties to the Black Sheep Clan leadership, would choose Slender Maker of Silver as their husband.

Further, it can definitely be stated that Slender Maker of Silver was Fred Peshlakai's biological father and not potentially Fred's "uncle," as was hypothesized by Adair and subsequently others. To do this, we refer to two exceptionally reliable sources. The first of these is the only surviving person known to the author who knew Fred Peshlakai personally, outside of Fred's descendants. John Bonner Strong knew Fred for fourteen years and had a close friendship with him. In the recorded interviews with Mr. Strong for this study, he revealed that Fred Peshlakai had told him that Slender Maker of Silver was his paternal father. Fred was very specific with Strong that Slender Maker of Silver was his true father and that he had learned to be a silversmith directly from him (Strong 2012, CD 2).

The second source of verification for this relationship is contained in the Greenberg manuscript, wherein the subject's mother, Alice, is described as, "one of nineteen children born to the eminent leader known as Peshlakai." "His name was Besthlagai-ilth'ini Althts'osigi" (Greenberg 1996, 7). Further on in the same manuscript is an image of Alice Peshlakai Gorman and Fred Peshlakai and then a comment that "her brothers, Fred and Paul" had been under her auspices (Greenberg 1996, 18). There no longer remains any doubt regarding who was the true father of Fred Peshlakai.

Two other individuals are often confused inside the discussion, and their potential familial association is important to clarify. One of these is the Diné man named Peshlakai Atsidi (spelled alternately as Etsidi), whose own comments regarding the evolution of Diné silver art appear in the book by Woodward as "Appendix No. 4" (Woodward 1938, 67). Although his remarks certainly add to the story regarding the appearance of Navajo silver as an art form, it bears emphasizing that Peshlakai Atsidi is remembered as being a Diné clan leader who lived in the area of the Wupatki region of the Dinétah, which is near modern-day Flagstaff in Arizona. He lived from 1852-1941. Although Peshlakai Atsidi is considered an important figure in Diné history in his own right, it is important to note that, despite the similarities in his name, he is not Atsidi Sani nor is he Slender Maker of Silver, who lived in entirely different regions of the Dinétah. He is not directly related to these figures since they belong to different clans. As such, he is not related to Fred Peshlakai.

Another hypothesis in question pertains to another early Navajo silversmith named Atsidi Chon. Traditional lore states that Atsidi Chon was the first Diné craftsman to have set turquoise stones in a silver jewelry piece. This premise seems reasonable based on recorded oral histories available. However, the hypothesis that he was actually "the" instructor of Slender Maker of Silver remains unverified (Bedinger 1973, 18). The many sources for the historical record also relate that Atsidi Sani taught the art of silversmithing to Slender Maker of Silver. Although there is no hard documentation of this event, the inference of the association of these figures by their familial ties certainly makes the concept plausible. The shared interests of these famous figures would certainly have been increased by their close proximity and appear to confirm those earlier records. There are other suppositions, too, that Atsidi Chon was also a brother to Atsidi Sani and Slender Maker of Silver, but since Atsidi Chon hailed from the "Sanding House" clan, this premise seems, at the moment, unlikely (Bedinger 1973, 18).

These conclusions rectify several large points of confusion within the historical record and their applications to the lineage of Fred Peshlakai. Fred's father, Slender Maker of Silver, would go on to become a great leader among the Diné, even traveling to Washington to address the concerns of his people with the American government.

Slender Maker of Silver, too, would become recognized as the greatest Navajo silver artisan of his era. Fred Peshlakai would follow diligently in those famous footsteps. Fred would become a unique individual dedicated to the independent life of a true artist, following the path his forebears' hearts had blazed.

EARLY NAVAJO SILVER ART

NAVAJO SILVER ART IS A RELATIVELY RECENT phenomenon to appear within the landscape of world art. Appreciation of silver by the Diné began as an acquired element after exposure to neighboring cultures sometime in the middle of the last millennium. This appreciation increased exponentially with silver's increased availability after the end of the Civil War in 1865. The Diné began to modify and reinterpret the silver ornamentation of others according to their own ideas about adornment. From the beginning, Diné craftsmen exhibited a preference for purer varieties of silver over German silver, which was used by the Plains Indian people. This can perhaps be attributed to the Diné's early exposure to Mexican and Spanish silvers. Once the preference was established, it quickly became the standard within the Diné repertoire.

Authoritative studies submit that the earliest design forms depicted on Diné silver were adaptations of design forms seen elsewhere by the earliest Diné craftsmen. Personal accessories such as earrings, brooches, hair ornaments, and belts (all in evolved forms) eventually found their way into the hands of the Diné, and these designs were adopted and diversified by Diné craftsmen.

This very early formative period of Navajo silver work is referred to as First Phase Diné silver and demonstrates brilliantly the transitioning of these very early designs into the immediately recognizable purely Diné art form that exists today. The inverted semicircle of the Najahe, for example, can be traced to Roman times; perhaps its quasi-universal symbolism as a talisman to ward off the evil eye was adopted by the Diné, prompting them to use it in their repertoire.

We can, however, only hypothesize the reasons—psychological or otherwise—why the Diné were attracted to certain forms and designs. The propensity of observers to infuse their own design associations onto indigenous art is likely to lead to faulty conclusions. Art is an expression of the individual, and although some representations become standardized by cultural traditions, it is best left to that individual or culture to verify their meaning.

We also must consider the reality that, as the craft evolved, artist decisions may have been determined by market forces—by what the artist could sell. For example, in the early twentieth century, Navajo-style jewelry was beginning to be made expressly for the tourist trade and was mass-produced in alarming quantities by companies catering to the demands of these overly romantic tourists. Things were made worse by some of these companies producing Navajo items that were made by non-Navajo factory workers. These establishments were bent on profiting from early white travelers and their appetite for charming kitsch. Such things, while appealing to amused consumers, certainly do not represent the Diné aesthetic and must be sequestered as such when considering the evolution of the art form.

SPANISH COLONIAL NEW MEXICO

Diné silver art, as we know it today, finds its roots in a synthesis of the history of its people. It has evolved as a visual combination of the Diné's own cosmological and artistic aesthetics and the influences of the cultures to which they were exposed. However, unlike the art forms of many other cultures, the appearance of silver art made by the Diné occurred relatively abruptly and, as such, many of the influences upon its stylistic identity can be readily recognized.

One of the earliest influences was the art of the Spanish Colonial people who occupied the Upper Rio Grande area of modern New Mexico. Beginning in 1539 with the arrival of Coronado, the artistic styles of Spain were indelibly stamped on the American Southwest. The colonists used Spanish design motifs in their religious and secular art, architecture, and decor.

Spain itself was influenced by outside design sources before attaining its own voice. There were Mediterranean influences. as well as classical motifs from Greece and then Rome. The Roman Catholic Church, too, was extremely influential with its standardizations for religious representations, although even these were eventually manipulated into purely Spanish expressions.

Spanish metallurgy and its embellishments can be most readily associated with the Islamic Moors who conquered Iberia in 711 AD and lingered in digested form until 1614 before they were expelled by the Catholic Inquisition and Spanish government. They, too, left a lasting impression on Spanish art.

As the Spanish moved north into the Upper Rio Grande area of the American Southwest, the Diné were exposed to their decorated iron and horse gear, as well as textiles, attire, and jewelry. Decorated or stamped and tooled leathers were also in fashion on a myriad of personal devices in Colonial Spain. These designs were then seen on creations from Spanish-liberated Mexico, which were also reinterpreted in the Diné's silver art. The ability to impress or incise decorative motifs onto metal was slow to arrive among the Diné in their early years of silversmithing. Early craftsmen were limited to simple chisel and mallet. However, by the late nineteenth-century, the myriad of stamped designs now readily associated with Diné silver became much more common.

Top: Part of the alter screen at the San Jose Mission Church at Laguna Pueblo, New Mexico, ca.1808. By The Laguna Santero, 1776-1815. *Photograph by Andrew Johnston who was a conservator there ca. 1945.*

Bottom: Antique Islamic overlay and engraved tumblers. Syria, ca. 1750. Height: 7"and 5". *Author's collection.*

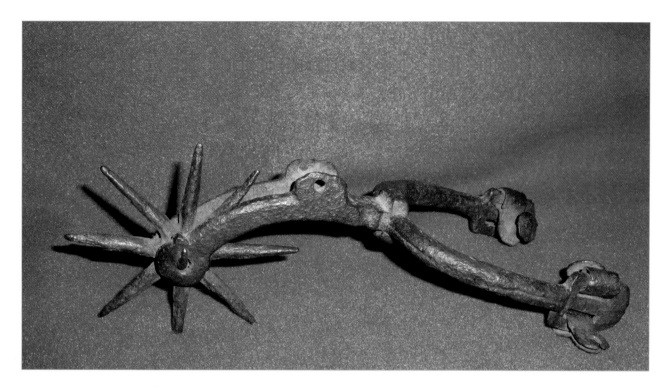

Hand forged Spanish Conquistador spur, ca. 1575-1630. *Inset:* rowel detail. Author's collection.

Bottom left: Spanish Colonial engraved silver mug, ca. 1700-1750.
Height: 4.5". *Courtesy of Berta Perez Uria.*

Bottom right: Spanish embroidered panel. Silk on silk with
gold-wrapped thread, ca. 1725. *Courtesy of The Carolyn
Forbes collection.*

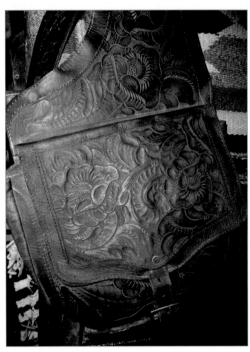
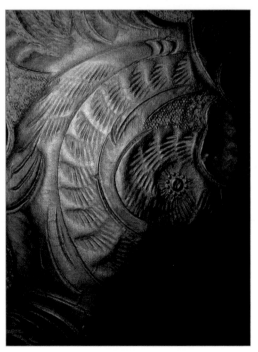

Top: Spanish Colonial horse bit, ca. 1780. Hand forged iron with original chains. Chisel incised decoration. *Author's collection.*

Bottom: Tooled leather Mexican saddlebags, ca. 1920. Die-stamped embossment. *Author's collection.*

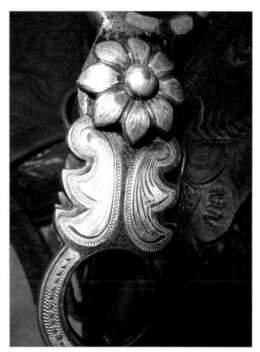

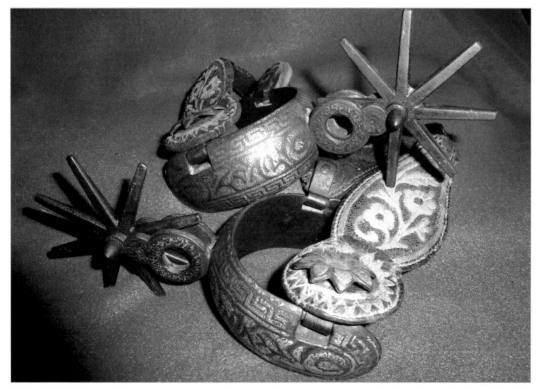

Top left: Spanish-influenced New Mexican tin mirror showing turquoise inlaid reverse, ca. 1910. *Author's collection.*

Top right: Spanish Colonial-style horse bit, ca. 1940. Rocker engraved and point-engraved bridle mounts by E. Garcia; Viejo California. *Author's collection.*

Bottom: Silver inlaid iron Vaquero spurs with embroidered pitiado heel straps, Mexico, ca. 1880. *Author's collection.*

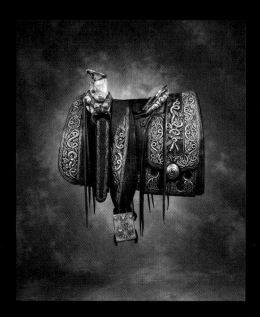

PONCHO VILLA'S LAST SADDLE

Considered a tour de force of early twentieth-century Latin American design, this saddle exhibits many Spanish Colonial influences. Floral motifs in running panels rendered in raised pitiado silver threads exhibit thriving ancient Islamic stylized depictions of life elements popular with the Moors during their occupation of the Iberian Peninsula. Undeniably Mexican in its overall evolution, this piece exhibits clearly the design influences that would have been perceived by the Diné in their exposure to the Spanish Colonial aesthetic prevalent in the American Southwest. Molded concha elements, as well as cast silver mounts over a heavily tooled leather background, complete the display. Although it is unlikely there were very many pieces of this outstanding quality of horse gear produced, the sheer exuberance of design was often repeated in varying degrees based on the individual's wealth and status. It's easy to comprehend the impact these ornaments would have had on the observant Diné and how the association between status and wealth and silver ornamentation might be carried into their own repertoire.

INFLUENCES OF THE FRENCH AND ENGLISH FUR TRADE AND THE PLAINS NATIVE AMERICANS

Influences of the French and English fur-traders reached the Diné via the Southern Plains tribes, like the Comanche and Kiowa, as well as the Ute peoples of the Rocky Mountains. The fur traders' influences began far to the east, where the early fur traders used silver objects to befriend and seduce the native peoples. These objects remained in use even after the fur supplies had radically diminished. Early eastern natives recognized the decorative as well as the trade value of silver objects and used them extensively during their dealings with the traders. Furs obtained in the east were typically purchased from native trappers in that region, and silver objects were prized as a currency that could be traded back and forth.

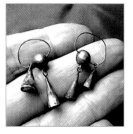

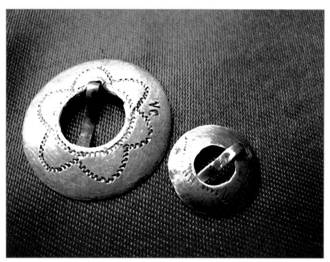

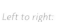
Left to right:

Roller impressed silver bracelet, ca. 1810. *Courtesy of The Robert Bennett collection.*

Fur trade earrings on wire hoops. Hollowed conical pendants and beads from joined half-domes, ca. 1785. *Courtesy of The Robert Bennett collection.*

Early fur trade brooches. Rocker engraved. ca. 1790. *Courtesy of The Robert Bennett collection.*

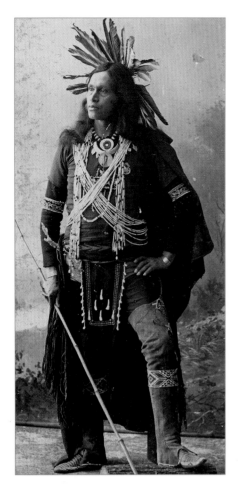

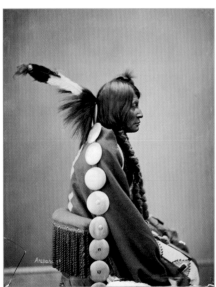

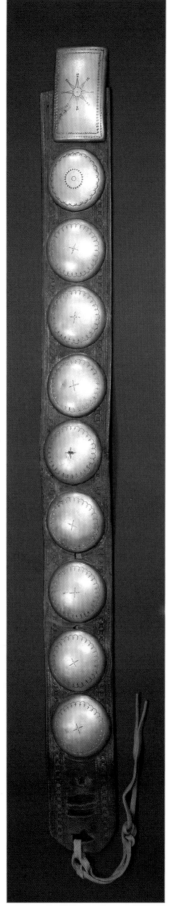

After depleting fur resources in the east, traders moved westward and discovered that the Plains people were not traditionally fur trappers, so the coercive power of high-grade silver waned. The native Plains people did, however, have an acute appreciation for the decorative potential of the white metal, and German silver satisfied their tastes for personal adornment. Old French and English designs remained entrenched on items used by the Plains tribes and were then picked up by the Diné in their associations with those tribes. Large round discs, worn as hair decorations and also attached to belts, were favored; brooches and earrings also made their way into early Diné fashion. Although the crucifix was a standard form, there is little reason to make typical religious associations to it among these early wearers of trade silver. These items were passed around extensively and no emotional or psychological implications can be made about their meaning to the Diné beyond a personal admiration for an item. Later on in the late nineteenth century, there emerged design forms with more clear associations for the Diné in their silver work.

GREAT LAKES WARRIOR. Cabinet card, ca. 1894. German silver ornaments shown as an integral part of regalia. *Photo by J.F. Barta.*

BIG MOUTH HAWK; *Arapaho.* German silver discs worn as hair ornament, ca. 1872. *Photo by Alexander Gardener.*

PLAINS INDIAN CONCHO BELT. German silver with engraved designs, ca. 1890. *Courtesy of The Cochrane Collection, Florida. Mark Sublette Medicine Man Gallery. Tucson, Arizona, and Santa Fe, New Mexico.*

EARLY DINÉ SILVERSMITHS AND THEIR WORK

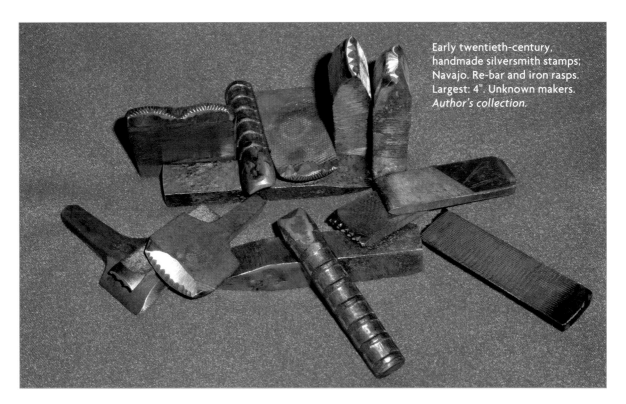

Early twentieth-century, handmade silversmith stamps; Navajo. Re-bar and iron rasps. Largest: 4". Unknown makers. *Author's collection.*

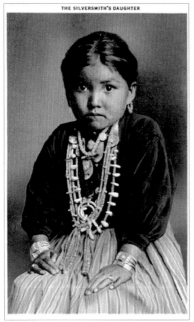

THE SILVERSMITH'S DAUGHTER. Postcard, ca. 1890. Produced: 1935. *Courtesy of Lake County, Illinois Discovery Museum. Curt and Teich Postcard Archives.*

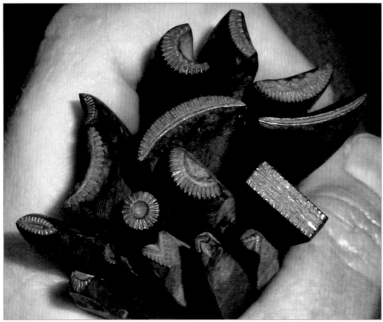

16 silversmith stamps made by Fred Peshlakai, ca. 1965, and purchased by John Bonner Strong. *Author's collection.*

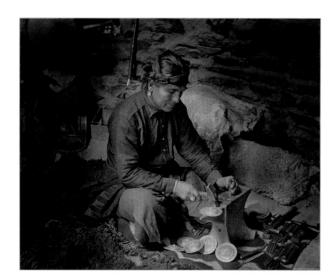

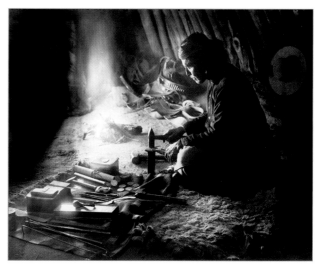

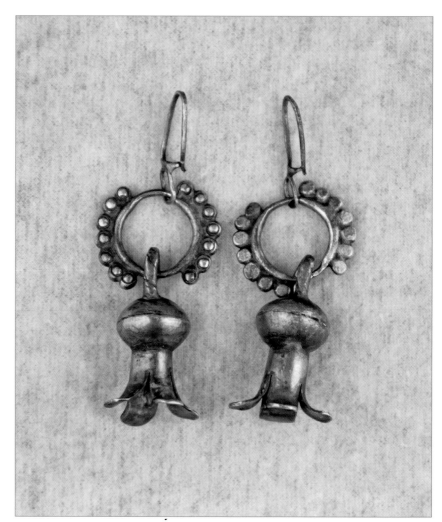

Top left: Navajo Silversmith, ca. 1910. This photo influenced the painting of Slender Maker of Silver by Vic Donahue *(see page 49). Photo by William Pennington.*

Top right: A Navajo Silversmith, ca. 1915. *Photo by William J. Carpenter.*

Bottom: First Phase Navajo earrings, ca. 1880. Ingot silver. *Author's collection.*

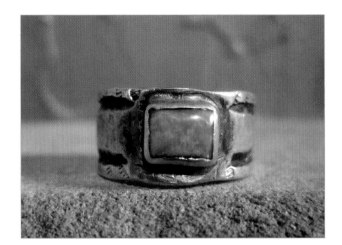

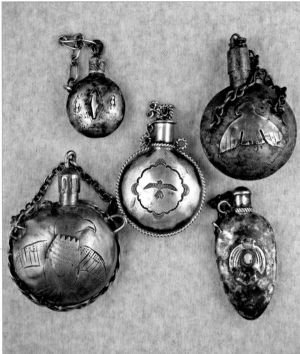

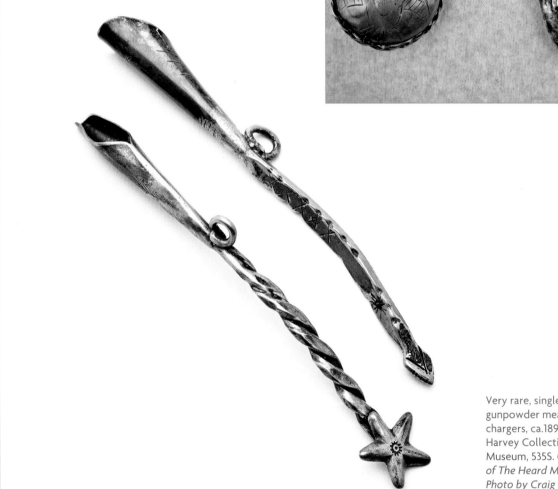

Very rare, single shot gunpowder measurers or chargers, ca.1890. Fred Harvey Collection; Heard Museum, 535S. *Courtesy of The Heard Museum. Photo by Craig Smith.*

Top left: Early ingot silver ring, ca. 1910. *Courtesy of The Harriet Callahan collection.*

Top right: Early Diné tobacco canteens; earliest: top right, ca. 1880. *Author's collection.*

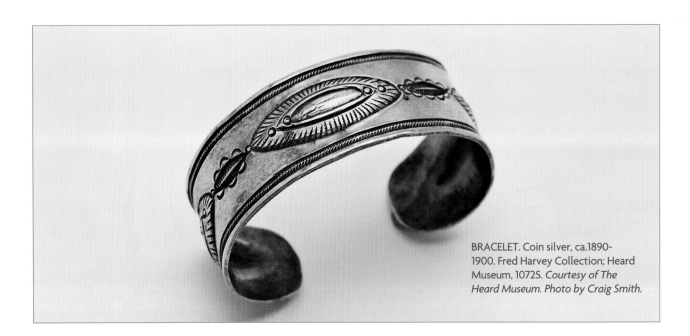

BRACELET. Coin silver, ca.1890-1900. Fred Harvey Collection; Heard Museum, 1072S. *Courtesy of The Heard Museum. Photo by Craig Smith.*

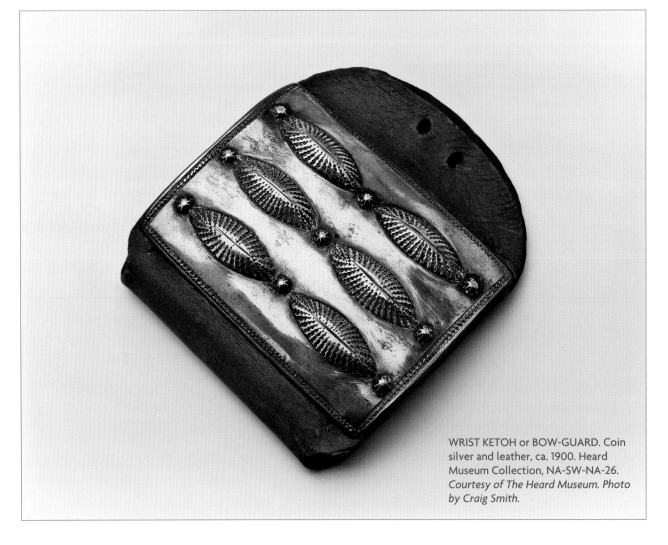

WRIST KETOH or BOW-GUARD. Coin silver and leather, ca. 1900. Heard Museum Collection, NA-SW-NA-26. *Courtesy of The Heard Museum. Photo by Craig Smith.*

Part I: A Place in History

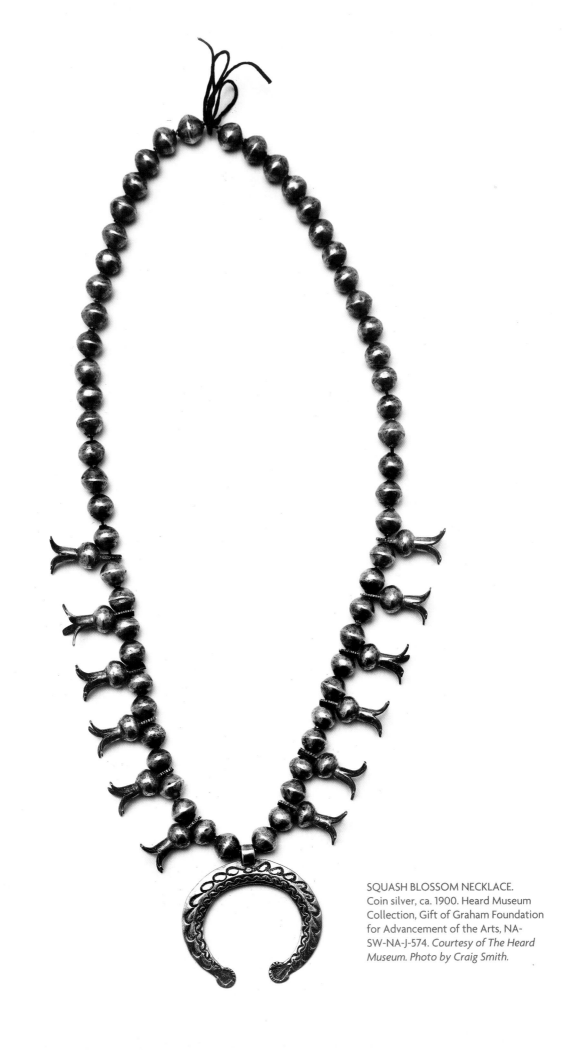

SQUASH BLOSSOM NECKLACE.
Coin silver, ca. 1900. Heard Museum
Collection, Gift of Graham Foundation
for Advancement of the Arts, NA-
SW-NA-J-574. *Courtesy of The Heard
Museum. Photo by Craig Smith.*

NAVAJO HORSE HEADSTALL, ca. 1885. Ingot silver and Cerrillos turquoise mounted on braided rawhide. Spanish Colonial bit, ca. 1800. Although the brow pendant, or "najaje," may be a replacement, the resplendence of the accoutrements that the Diné lavished on their horses is clear on this beautiful example. *Author's collection.*

CONCHA BELT. Coin silver and leather, ca. late 1800s. Fred Harvey Collection, Heard Museum, 1152S. *Courtesy of The Heard Museum. Photo by Craig Smith.*

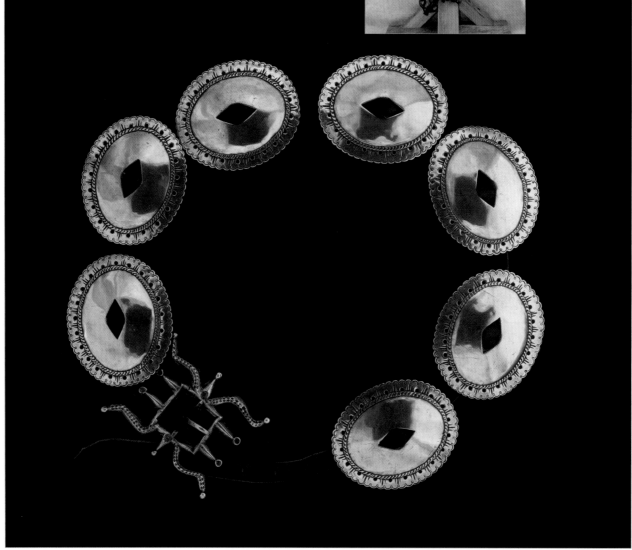

MASTERPIECES IN WHITE IRON

FRED ROAN PESHLAKAI WAS BORN ON THE 27TH OF November, 1896, in Lukachukai, Arizona. His mother was the fourth wife of the famous silversmith Besthlagai-ilth'ini Althts'osigi. He had two older full siblings, Rose and Paul, and eventually a younger brother, Frank, who was born in 1903. Their father had a large family that would eventually yield nineteen children from his four concurrent wives. The very wealthy men of status among the Diné commonly had multiple wives and many children, although not all of the children, of course, survived. Three of the wives of Besthlagai-ilth'ini Althts'osigi were sisters of the Dibe'lizhiii Dine'e', or Black Sheep Clan people, of the eastern Diné. Land and property is matrilineal in Diné perspectives and thessisters held good land in a temperate region that supported many livestock assets.

Fred's mother was not Diné. Her name and how she came to know Besthlagai-ilth'ini Althts'osigi and be married to him are details lost in time. Fred recounted that his mother had come from Taos Pueblo (Strong, pers. comm.), that she was unhappy living among the Diné, and that she had returned to her Pueblo people in about 1904, when Fred was about eight. John Bonner Strong remembered that the only time in his fourteen-year association with Fred that he had ever seen Fred sad was when he recalled his mother's departure. It was obviously a painful memory for Fred and would be intrinsically influential in who Fred Peshlakai would become as a person.

It can well be imagined how Fred's Taos mother would have been challenged living among the Diné society at that time. That she would have been viewed as an outsider by Besthlagai-ilth'ini Althts'-osigi's

other wives is highly probable. She would not have held her own property and would have been reliant on Besthlagai-ilth'ini Althts'-osigi's ability to house and protect her, which likely was an ongoing source of friction in her life. It is not known if she lived in Lukachukai, although that was Fred's birthplace. Lukachukai is situated well away from the hogans of Althts'osigi's other wives near Crystal, and Althts'osigi's business interests were also concentrated in the Crystal area. Medical help, if needed, would have been found closer to the Fort Defiance area. Was Fred's mother the result of community building between Taos and the Diné? Diné oral history reports that Manuelito's famous third wife Juanita was possibly of Zia Pueblo origin or had important ties there of matriarchal influences on community building. Was Fred's mother then part of this outreaching between Native tribes to consolidate themselves inside the changes being forced upon them? Hopefully, future discoveries of records will be found.

After their release from Bosque Redondo, the clan family of the Dibe'lizhiii Dinéé,' or the Black Sheep Clan, had returned to the regions of the Chuska Mountains where the clan retained its ancestral holdings. Besthlagai-ilth'ini Althts'osigi and his three Black Sheep Clan wives settled in the regions near Crystal, New Mexico, where each sister had her own hogan on her own portion of contiguous clan land. *Beshthlagai* or *Beshlah-k'ia* is the Navajo word that translates as "White Iron" in English. This word is an elaboration on the word "besh," which is Diné for 'dark metal,' referring specifically to iron. Other names for metals seen by the Diné were *beshleh chee* or red iron for copper, and *beshk' ha-geé* or thin iron for tin (Woodward 1938, 80).

Eastern Arizona with the Lukachukai Mountains on the horizon. 2012.

The oral histories recorded by Adair and Woodward state that Besthlagai-ilth'ini Althts'-osigi learned the art of silverwork from his "older brother" Atsidi Sani. It is likely, as in most culturally assimilated crafts, that there were several participants who were sharply interested in this new art form. There were new monetary incentives as well as status implications involved in the production and ownership of silver items. It is likely that there were many men interested in finding out if they could attain mastery over the *beshthlagai* but, as in any medium of artistic endeavor, some individuals naturally excelled over their colleagues.

There is scholarly disagreement about when the Diné production of silver actually began. For Besthlagai-ilth'ini Althts'osigi, it is reasonable to believe that he was influenced by the blacksmithing abilities of Atsidi Sani and that his advancement to silver production was tied to his early knowledge. There is no doubt, however, that Besthlagai-ilth'ini Althts'osigi excelled in the art of silver work and became regionally famous as a result. He would also come to be known internationally in the twentieth century, recognized as one of the best early Diné silversmith of his age. His Diné name, which translates into "Slender Maker of Silver," remains to this day synonymous with the best of early Diné silverwork. In his own time, his work was so much in demand that he set up a forge in the Crystal area that would eventually come to employ ten men. His skill was recognized so early in the history of Diné silver that the noted photographer Ben Wittick photographed him between 1883 and 85, barely fifteen years after his peoples' release from captivity and the end of the American Civil War. Wittick's photograph (see page 47) reveals the growth in sophistication and cultural interpretation in Diné silver by this date. It's easy to see why Slender Maker of Silver was so well known. Fred Peshlakai reported that he learned the art form from his father (John Bonner Strong, pers. comm; Adair 1944). This would indicate Slender Maker remained active until sometime around 1915.

In 1878, the white trader John [Don] Lorenzo Hubbell bought a trading post from another trader, William Leonard. The area where Hubbell operated would be named after a contemporary headman of Manuelito, Ganado Mucho, which translated to Much Livestock. Hubbell, as well as the area of Ganado, would be instrumental in the proliferation of Diné silver art.

Hubbell was well liked among the Diné, and he supplied them with the Anglo staples that the Diné had become accustomed to while in captivity. In exchange, Hubbell traded with them items of Diné manufacture that he then marketed to eastern, Anglo consumers. Silver was among the items he supplied to the Diné and he was instrumental in the acquisition of turquoise, which the Diné appreciated and had valued for centuries. Although there are no surviving records of transactions between Hubbell and Slender Maker of Silver, their relative close proximity makes some association likely. Such outlets for items made by Slender Maker of Silver give some explanation for the size of the Besthlagai-ilth'ini Althts'osigi workshop in Crystal during that era. The burgeoning relationships between local traders and the artisan is further demonstrated in that Slender Maker of Silver traveled to the Chicago World's Fair in 1893 to demonstrate Navajo silver art to the enthusiastic audiences in attendance.

Hubbell Trading post continued to be run by Hubbell family members until its sale to the National Park Service in 1967. John L. Hubbell is still well remembered by many people for his activism in the struggle for Diné rights as well as in their recognition by the world outside the reservation. The Parks Service still operates the site, making it the longest still-active trading post in the United States.

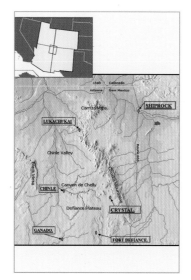
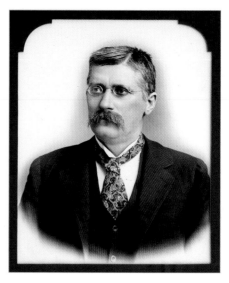

Left: Inset enlargement of The Four Corners area of the southwestern United States. The birthplace of Atsidi Sani was at To' Dzis'a or Many Ponds; Flowing Through Rock Crevice, (Navajo Nation Museum exhibit. 2012) which is northeast of Canyon de Chelly. The "Fluted Rock" area was his later home site. *Cartography courtesy of Jesse W. Byrd, Albuquerque, New Mexico.*

Right: J.L. Hubbell. Founder, Hubbell's Trading Post, ca. 1885. *Courtesy of Ed Chamberlain, Hubbell Curator, National Park Service.*

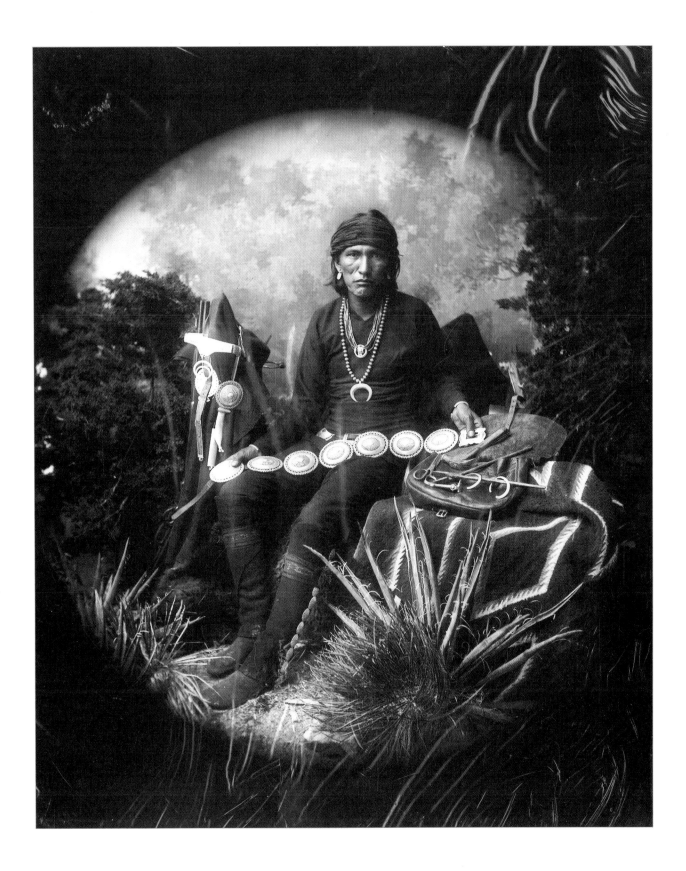

Slender Maker of Silver, ca. 1883-85. *Photo by Ben Wittick.*

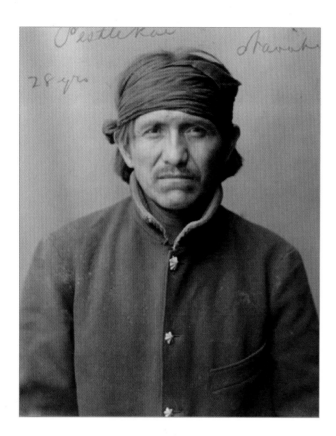

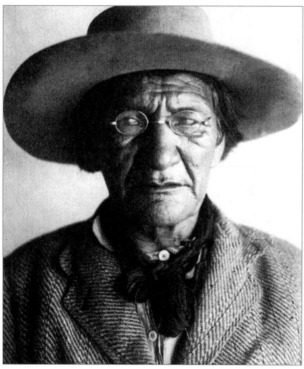

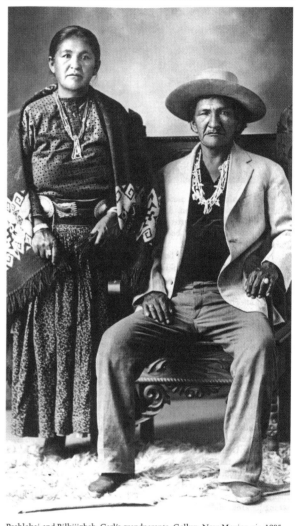

Peshlakai and Bilkijizbah, Carl's grandparents, Gallup, New Mexico, ca. 1905.

Top left: Slender Maker of Silver, ca. 1868. Conjecture remains concerning the true identity of this figure since the Smithsonian's archives lists this photo as possibly taken by Ben Wittick. However, since the gentleman is wearing a Civil War jacket and does not bear any resemblance to Peshlakai Etsidi, who is the only other candidate for attribution, it is likely this is indeed an early image of Slender Maker of Silver. *Courtesy of The National Museum of the American Indian, Smithsonian Institution.*

Top right: The parents of Alice Peshlakai Gorman: Slender Maker of Silver and Bilkijizbah, ca. 1905. *Courtesy of Clear Light Publishers, Santa Fe, New Mexico.*

Bottom left: Slender Maker of Silver, ca. 1914. *Courtesy of Clear Light Publishers, Santa Fe, New Mexico.*

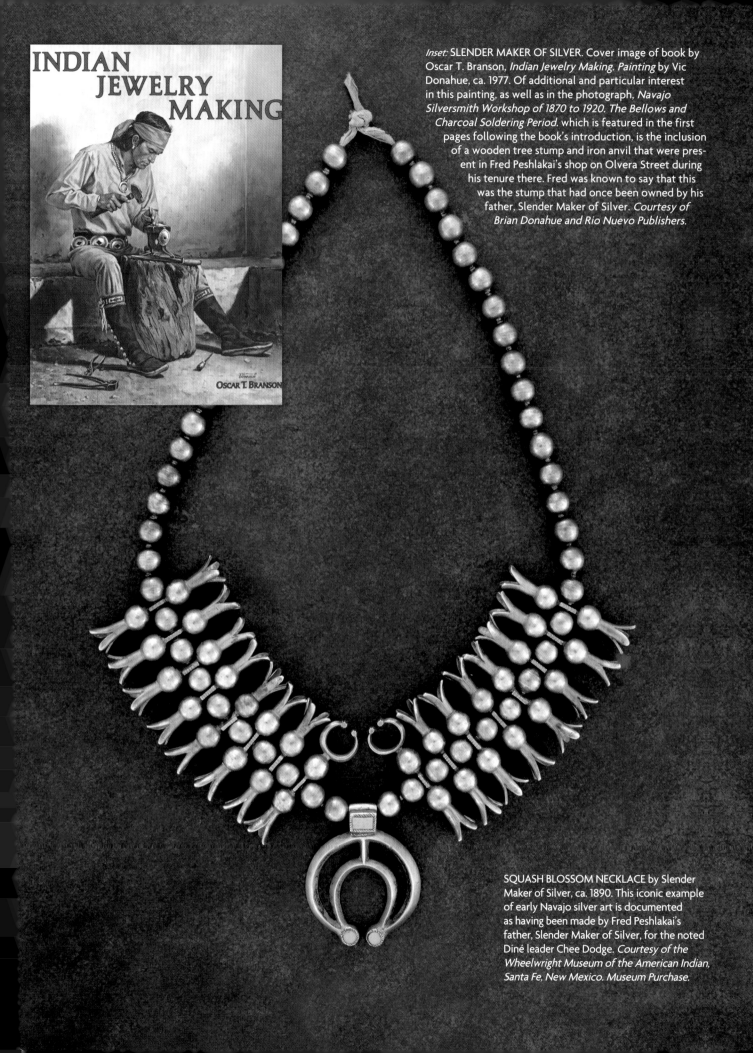

INDIAN JEWELRY MAKING

OSCAR T. BRANSON

Inset: SLENDER MAKER OF SILVER. Cover image of book by Oscar T. Branson, *Indian Jewelry Making. Painting* by Vic Donahue, ca. 1977. Of additional and particular interest in this painting, as well as in the photograph, *Navajo Silversmith Workshop of 1870 to 1920. The Bellows and Charcoal Soldering Period.* which is featured in the first pages following the book's introduction, is the inclusion of a wooden tree stump and iron anvil that were present in Fred Peshlakai's shop on Olvera Street during his tenure there. Fred was known to say that this was the stump that had once been owned by his father, Slender Maker of Silver. *Courtesy of Brian Donahue and Rio Nuevo Publishers.*

SQUASH BLOSSOM NECKLACE by Slender Maker of Silver, ca. 1890. This iconic example of early Navajo silver art is documented as having been made by Fred Peshlakai's father, Slender Maker of Silver, for the noted Diné leader Chee Dodge. *Courtesy of the Wheelwright Museum of the American Indian, Santa Fe, New Mexico. Museum Purchase.*

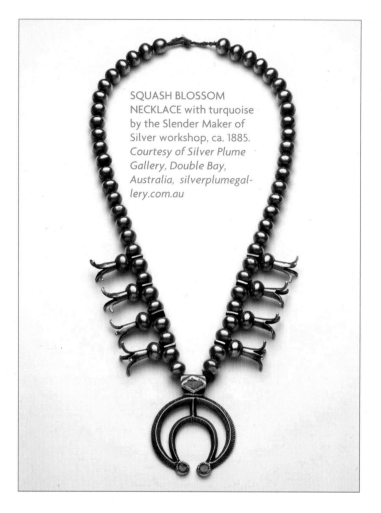

SQUASH BLOSSOM NECKLACE with turquoise by the Slender Maker of Silver workshop, ca. 1885. *Courtesy of Silver Plume Gallery, Double Bay, Australia, silverplumegallery.com.au*

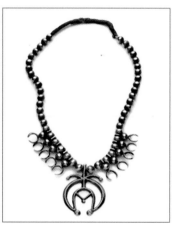

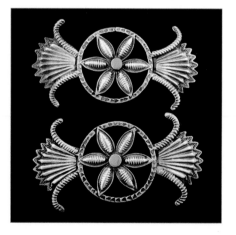

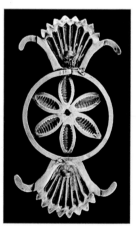

SQUASH BLOSSOM NECKLACE by the Slender Maker of Silver workshop with attached najaje elements in lieu of petals on the upper blossoms, ca. 1885. *Courtesy of Silver Plume Gallery, Double Bay, Australia, silverplumegallery.com.au.*

RARE PAIR OF ATTRIBUTED BUTTONS. Turquoise and coin silver. Maximum width: 4" x 2", ca. 1900. These rare, sew-on buttons are from the Williams Family Collection, which was noted for the fastidious record keeping of their extensive "Old Masters" collection. Slender Maker of Silver is listed in the family records as the maker. *Courtesy of Browns Trading Company, Safford, Arizona.*

Slender Maker of Silver and his shop did not ever hallmark their work. Attributions are based on documented pieces like the examples Slender Maker of Silver gifted to Chee Dodge, which are now in the Wheelwright Museum in Santa Fe, New Mexico.

SLENDER MAKER OF SILVER is credited with being a great innovator of form.

Early unique examples of inventiveness applied to relatively standardized design elements are associated with him and his production.

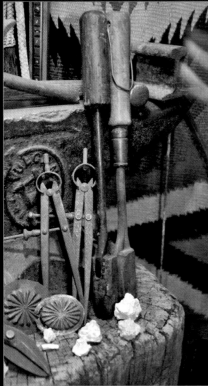

Examples of the Peshlakai family's silversmith tools on exhibit, with additional collection items, at the Fire Rock Casino in McKinley County, New Mexico. These early tools were purchased directly from the Peshlakai family descendants in the Crystal region of New Mexico. *Courtesy of Steve Coleman, The Nugget Gallery.*

(Continued on following page)

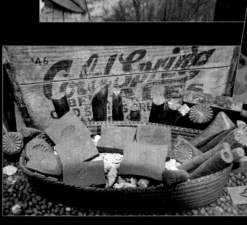

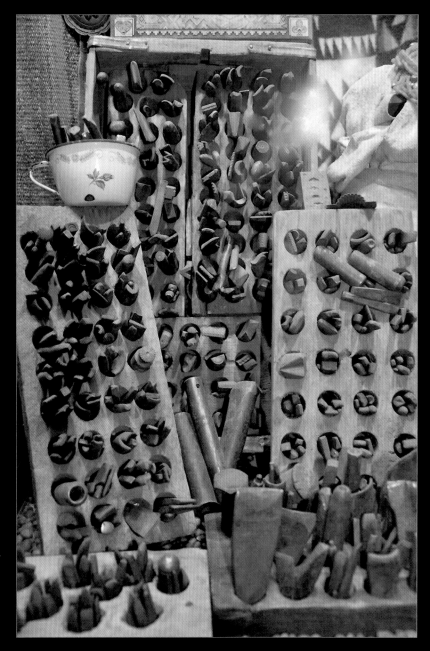
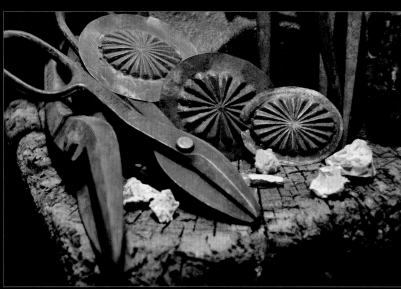

Slender Maker of Silver was changed by his experience at the Chicago World's Fair in 1893. Accompanying him there was Chee Dodge, who would become the first elected representative from the Navajo Nation. Both men realized, upon seeing the technical advancements of the city first-hand, that the Diné people would have to progress along with the rapid changes that were occurring in the world outside the Diné homeland. Education was paramount in both men's minds. They readily adopted the eventually famous words of their great compatriot Manuelito, who said:

My grandchild. The whites have many things that we Navajo need, but we cannot get to them. It is as though the whites were in a grassy canyon and there they have wagons, plows and plenty of food. We Navajo are up on the dry mesa. We can hear them talking but we cannot get to them. My grandchild, education is the ladder. Tell our people to take it. (Diné Education Web)

Slender Maker of Silver vowed to educate his children and was one of the first Diné to approach the newly introduced missionary groups who were coming to the Dinétah. The Catholics had established a mission and school in the Window Rock area in 1898 called Saint Michaels. The Presbyterian Mission in Ganado was established in 1901. Further advents included government schools for Native Americans in Colorado and elsewhere, although the United States government's interest in educating the Native populations was to assimilate them into Anglo society rather than to help the Natives prosper within their own community. The Christian mission's intentions were theoretically different. They were dedicated to bettering the lives

of the indigenous people rather than destroying their cultures. However, then as now, religions have differing tenets, and the Diné were quick in deciding which they personally preferred for themselves and their families.

Slender Maker and his wife Bil-ki jizbah's daughter Alice was born in 1885. Her father first sent Alice to the government school at Fort Defiance for schooling but became dissatisfied with the situation there and sent her instead to the Carlisle Indian School, which had been established by the government's Office of Indian Affairs in Colorado in 1887. She met her husband, Nelson Gorman, in 1903, and they married. Together they would become strong representations of Diné acceptance and integration into the modern world that the Diné people were encountering. They began their life together in the Fort Defiance area and eventually moved to Chinle in 1910 to open their own trading post. Alice stepped in to assume the care of and responsibility for the four young children of Slender Maker of Silver's fourth wife. Foremost in her duties to them was their education. It is unclear exactly where Fred and his siblings began formal schooling, but it was undoubtedly at one of the early Mission schools near Fort Defiance since these were the most readily available. It is recorded that Alice "had contacts with the Presbyterians having sent her brothers, Fred and Paul, to the early Presbyterian mission school at Leupp" (Greenberg 1996, 18).

The early mission schools would have a profound effect on Fred. Here he would find acceptance and encouragement. He personally included the tenets of one of these groups—the Presbyterians—for much of his life. Fred Peshlakai also forever remained fiercely proud of his Native American heritage. He always considered himself, above all, a Diné man and remained connected to his people and their struggles during the twentieth century. His life and art would always reflect his Diné lineage. Although he expressed himself outside stereotypical images of a Diné person for his time, the flavors of his life would remain deeply imbedded in his

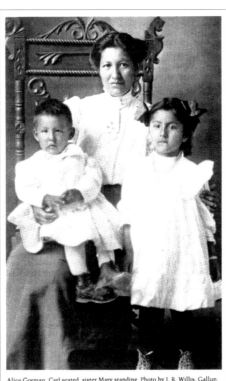

Alice Gorman, Carl seated, sister Mary standing. Photo by J. R. Willis, Gallup, New Mexico. 1909.

Alice Peshlakai Gorman with her sister Mary (standing) and her son, Carl Gorman, ca. 1909. Carl Gorman would become a noted Navajo Code Talker during WWII. Carl Gorman was also the father of the artist R.C. Gorman. *Courtesy of Clear Light Publishing, Santa Fe, New Mexico.*

achievements and would intrinsically be dedicated to the ancestral traditions of his ancestors.

Fred's summers were spent between the Gorman's home in Chinle, Arizona, and his father's workshop near Crystal, New Mexico. Fred gravitated naturally to the energy and progressive atmosphere of his father's silver shop, assisting the workmen at their forges and spending long hours watching his father work the beshthlagai into the shapes and forms that would become his life's work.

A necklace in the collection of the Museum of Indian Arts and Culture in Santa Fe was published in 1960, and the images were subsequently shown to Fred Peshlakai in 1964. Fred commented that it was a necklace he had personally watched his father make. (Stong, pers. comm.) (Note: The necklace was not attributed in 1960 by the Museum to Slender Maker of Silver and in 2010 is still on desplay there and was pointed out to the author by John Strong. Hopefully, this piece will come out of obscurity

and be assigned its proper place in history. For now, it remains a beautiful example of early Diné silver, and can be seen in Harry P. Mera's *Indian Silverwork of the Southwest*, D.S. King, 1959 on page 69 (Plate 10) and page 101 (Plate 5, third example from top of plate).)

In the early twentieth century, Fred was enmeshed in Anglo schools. It is likely that the transition from the traditional sheep-camp lifestyle of the Diné families of the period was an easy one for Fred. He was born outside that community, and his mother was herself an outsider to the Diné traditions. Living in Lukachukai or the surrounding area and being raised by a Pueblo mother likely decreased the culture shock that many other Diné children would have experienced moving from the desert plateaus to the boarding schools. The progressive nature of his sister Alice's household and her subsequent handling of Fred and his siblings would only have further encouraged Fred's attachment to the mission schools he attended and goes far in explaining his eventual affinities to their broader tenets.

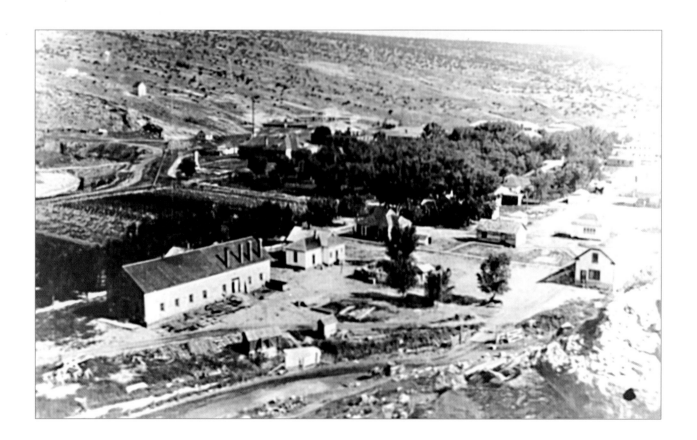

Ganado, Arizona, ca. 1910 with the school in the foreground, at left. Fred Peshlakai likely attended school here from 1904 to 1910. *Vol. 21, p. 25, Ganado Mission Photographic Essay and Oral History Project.*

Part I: A Place in History

A PRESBYTERIAN LIFE

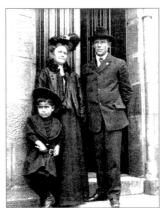

FRED'S EDUCATION THROUGH PRESBYTERIAN schools had a dramatic and lasting impact on his life. Presbyterian missionaries moved onto the homelands of the Dinétah in the late 1800s. History relates that the theological conversions accomplished by these Anglo teachers were relatively few, but still they remained in a sincere effort to help the Navajo people. They accomplished a great service to the Diné by providing them with medical treatments and education that they hoped could serve them and help them to understand the new world in which they found themselves.

Native populations had been decimated profoundly for decades by disease and violent conflict. Invading governments forced many into abject poverty. These Native Americans were left with no available recourse for themselves except to somehow try to endure.

It was into this arena of grief, poverty, and extreme environments that a small group of Anglo Presbyterians came to minister to the Diné of the Dinétah. The first of these was James M. Roberts, who was

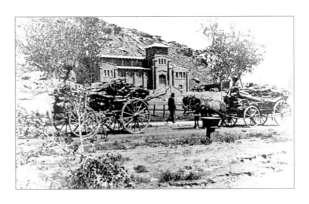

assigned to the Diné in 1868 by the Presbyterian Board of Foreign Missions. Mr. Roberts was unable to maintain his position and returned to the east after just two years. Then, in 1891, the Methodist Women's Home Mission Society opened a facility in Jewett, which was in northwest New Mexico. After a severe drought in 1894 and weak attendance by the seasonally migratory Diné, they opened a boarding school there in 1899. The Presbyterian Board of Home Missions, with a gift from the Indian Industries League, purchased the Jewett facility in 1903.

In Ganado, in, 1901 Presbyterian missionaries Charles Bierkemper and his wife began ministering to the Diné. Lorenzo Hubble is said to have given them a team of mules and later horses to help them in their endeavors there. Fred Peshlakai was six years old when the school opened in 1902.

In 1899, an early Presbyterian missionary named William Johnston left his wife and children in Kansas to secure a location for Presbyterian mission work in the heart of the Dinétah. In February 1900, he obtained permission from the government for a one-

Top left: **Ganado Presbyterian Mission, ca. 1901.** *Vol. 2; p. 63, Ganado Mission Photographic Essay and Oral History Project.*

Top right: **Mr. and Mrs. Charles Bierkemper with Charles Gray a.k.a. "Buck Chambers" at five years of age. 1906. Ganado Presbyterian Mission.** *Vol. 2; p. 63, Ganado Mission Photographic Essay and Oral History Project.*

Bottom: **Presbyterian Church, Ganado Arizona, ca. 1914.** *Vol. 1, p. 57, Ganado Mission Photographic Essay and Oral History Project.*

quarter section piece of land near the Little Colorado River, which was to be the headquarters for the missionary outreach he proposed to accomplish inside Navajo reservation territory. With help from the Diné, a site was selected some three miles upstream from the Wolf Trading Post, which was in the center of the Dinétah. In the same year, he summoned his family to join him and they began a life which was steeped in hardship and challenges.

In the beginning they set up tents, braving the same elements as the Diné themselves. Also, since they had come without soldiers or firearms the Diné where likely impressed by these exhibitions of sincerity and were immediately friendly to them helping them as they could to prepare a place to live. This place was called Tolchaco and was situated by the Little Colorado River about 52 miles northeast of present day Flagstaff, Arizona. The Johnstons would stay at Tolchaco until 1912 when they moved to another Mission location at Indian Wells, Arizona.

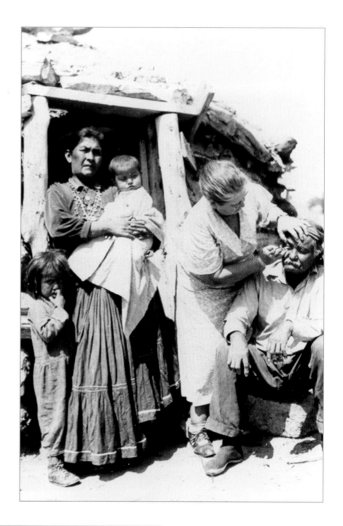

Above: Maggie Johnston treating a Diné man for trachoma. 1898. *Vol. 1, Pg. 14, Ganado Mission Photographic Essay and Oral History Project.*

Left: William and Maggie Johnston, ca. 1904. *Vol. 1, p. 12, Ganado Mission Photographic Essay and Oral History Project.*

The original old Johnston home, Tolchaco, Arizona. 1903. *Vol. 1, p. 16, Ganado Mission Photographic Essay and Oral History Project.*

The government school in Leupp, Arizona, was originally founded by the Presbyterians as a satellite to the main mission at Tolchaco. The abandoned remains (shown here, ca. 1965) were subsequently used as a Japanese internment site during World War II.

Fred Peshlakai knew the Johnstons when he was a young man. Historical records report that the government boarding school opened in Leupp, Arizona, in 1912 when Fred was sixteen years old. However, the missionaries at Tolchaco had opened an outpost in Leupp previously, and there is evidence that some regular school attendance was occurring there. The Tolchaco mission school records indicate that in 1912 they had 30 children enrolled. The original house built in 1902 served as "dormitories, classroom and dining hall" prior to that date. Scholars state that Tolchaco was primarily a bible school, and clearly older Diné students attended there in that capacity, but there are photographs showing small children in attendance at both locations prior to the opening of the government school. It appears that there was some effort to supply accommodations to their student body prior to the government school, and this seems reasonable since it would have been necessary for young children to travel large distances in order to attend. Also, the missionaries were interested in providing general education in addition to their religious tenets.

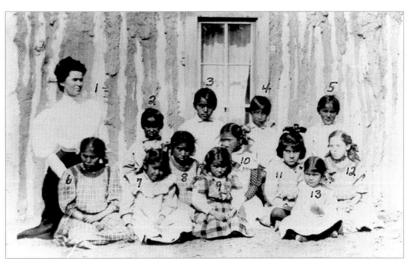

School children at Tolchaco, Arizona, with teacher Constantine Field, ca. 1908. *Vol. 1, p. 21, Ganado Mission Photographic Essay and Oral History Project.*

It is clear that, after the departure of his mother, Fred Peshlakai became dedicated to his education. After completing these early schools, Fred devoted himself to the Presbyterian efforts in the Dinétah and spent the years from 1914 to 1918 studying at the Bible School at Tolchaco, learning evangelical outreach skills when the school was in session. He was considered by all to be a brilliant student.

Left: Mr. Baldwin with three boys at Tolchaco, 1908. *Vol. 1, p. 21, Ganado Mission Photographic Essay and Oral History Project.*

Right: Fred Peshlakai with Rose Peshlakai (center) and Alice Peshlakai Gorman holding her son Stephen Gorman. Photo is on the doorstep of the Gorman Trading Post and home, ca. 1915; Chinle, Arizona. *Courtesy of Clear Light Publishing, Santa Fe, New Mexico.*

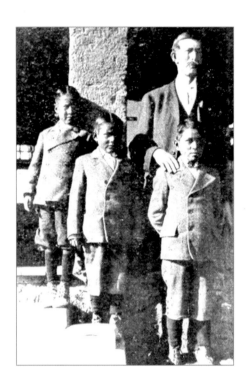

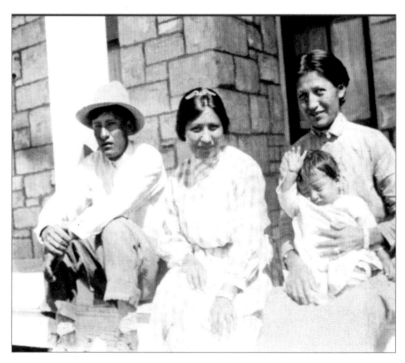

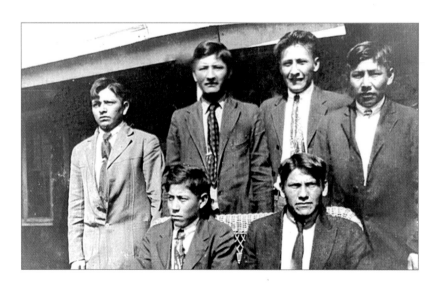

Fred Peshlakai, back row, second from right. 1908. *Vol. 1, p. 51. Ganado Mission Photographic Essay and Oral History Project.*

Part I: A Place in History

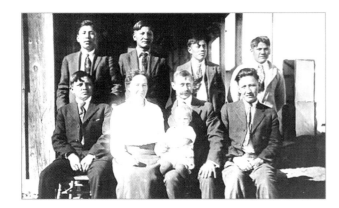

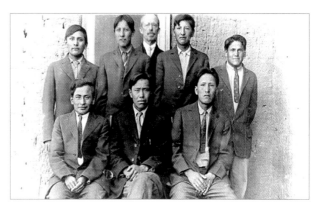

Fred's activities were not exclusive to the evangelical work that he was involved with at this time in his life. These efforts were seasonal, as it were, to his other obligations and interests for himself and his extended family. In the time period of 1914 through about 1928, while still active in evangelical outreach, he also was involved in unrelated activities necessary to making a living and being part of his family's rhythms of normal day-to-day life. During this time period he was a rancher for his family and helped tend the extensive

herds of his Black Sheep Clan relatives. Also, Fred spent a great deal of his time between 1908 and 1916 at his father's silversmith foundry in Crystal. From his father, Slender Maker of Silver, he learned everything form the basics of handling the metal to the nuances involved in creating his own designs. The artistic abilities of innovation pioneered by Slender Maker flowed naturally in the veins of his inquisitive son and would remain indelibly stamped upon his character and artistic voice.

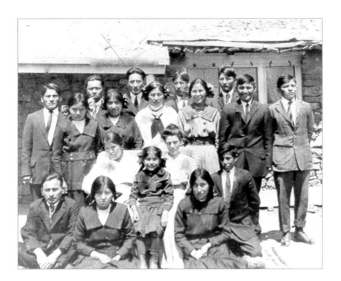

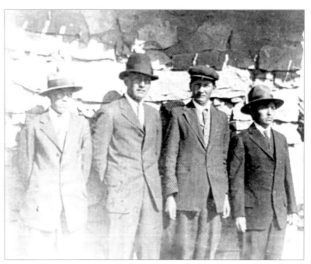

Top left: **Fred Peshlakai** (front row, far right). Sitting next to Fred is Mr. Baldwin, Fred's advisor. 1909. *Vol. 1, p. 51, Ganado Mission Photographic Essay and Oral History Project.*

Bottom left: **Fred Peshlakai** (back row, third from left) and his brother Paul (back row, fifth from left). Tolchaco, 1917. *Vol. 1, p. 55, Ganado Mission Photographic Essay and Oral History Project.*

Top right: *Fred Peshlakai (front row, far right). Their pastor, Fred Mitchell, is at back row center. 1915. Vol. 1; p. 49, Ganado Mission Photographic Essay and Oral History Project.*

Bottom right: **Fred Peshlakai** with his brother Paul; center left and right. Tolchaco, Arizona, ca. 1917. *Courtesy: Vol. 1; Pg. 55. Ganado Mission Photographic Essay and Oral History Project.*

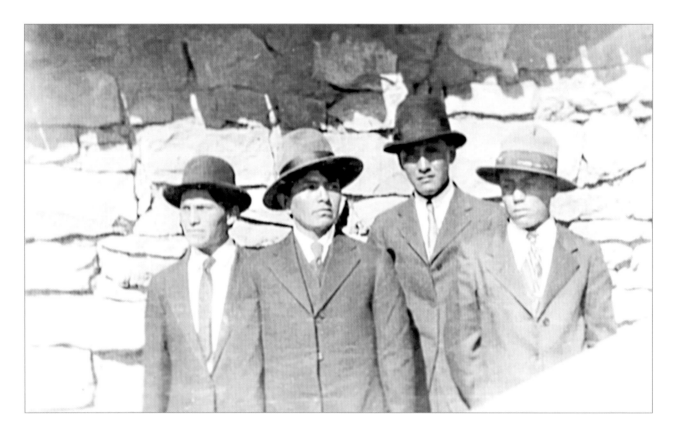

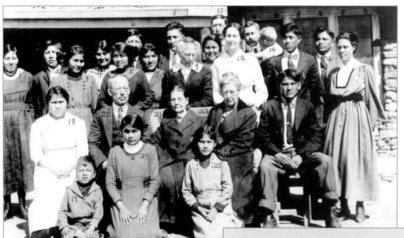

Above: Fred Peshlakai (third from left). Tolchaco, Arizona, ca. 1917. *Vol. 1, p. 55, Ganado Mission Photographic Essay and Oral History Project.*

Left: Fred Peshlakai (back row, fifth from left). Tolchaco students and staff. 1917. *Vol. 1, p. 55, Ganado Mission Photographic Essay and Oral History Project.*

Fred Peshlakai (back row center wearing the tall hat). The boys are on a hilltop overlooking the Tolchaco school. 1918. *Vol. 1, p. 47, Ganado Mission Photographic Essay and Oral History Project.*

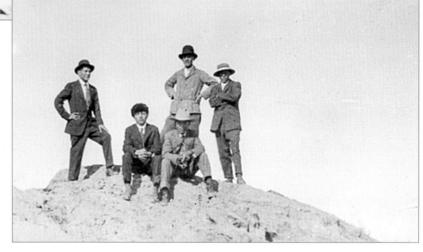

Part I: A Place in History

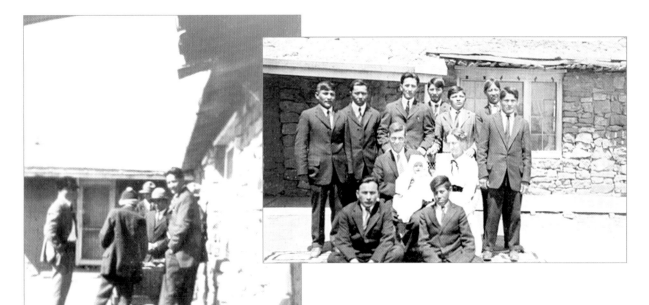

Above: Fred Peshlakai (back row, third from left with his brother Paul at Fred's left shoulder). Tolchaco, Arizona. 1918. *Vol. 1, p. 55, Ganado Mission Photographic Essay and Oral History Project.*

Below: Fred Peshlakai (far left). "Tolchaco Boys." Ganado, Arizona. 1921. *Vol. 1, p. 45. Ganado Mission Photographic Essay and Oral History Project.*

Fred Peshlakai (in foreground at right, looking at the photographer). Tolchaco, 1918. *Vol. 1, p. 55, Ganado Mission Photographic Essay and Oral History Project.*

Fred Peshlakai (back row at right). Tolchaco. 1918. *Vol.1, p. 55, Ganado Mission Photographic Essay and Oral History Project.*

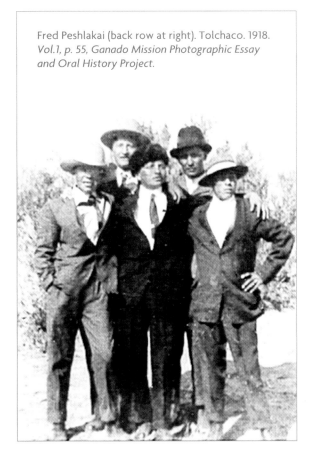

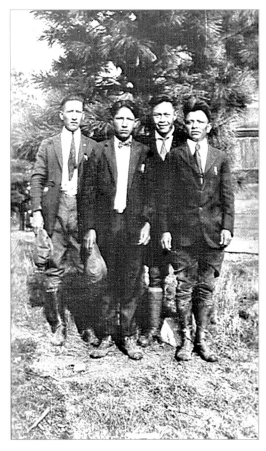

Fred had an intuitive sense regarding the beshthlagai, and Fred's approach to his art is one reason why, as later observers, we have such a magnetic appreciation for his art. His adherence to the basic traditional methodologies of the art-form speaks volumes to what Fred learned from his father when he was a young man. He would continue to embrace these for the rest of his life.

After the Johnston family relocated in 1912 to Indian Wells, Arizona, a teacher at Tolchaco, Fred Mitchell, was named pastor there in 1915. Mitchell was Fred's mentor during his

evangelical training as well as his evangelical outreach work to his people across the Dinétah. The school in Tolchaco burned down in 1918, and in 1921 Fred Mitchell abandoned the site and relocated to the Ganado Mission. Fred Peshlakai would remain involved in evangelical outreach until sometime around 1929, when his evangelical work ceased. After this, he devoted himself exclusively to his art.

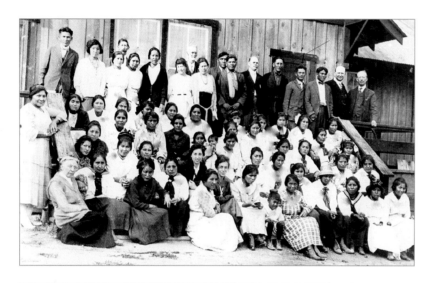

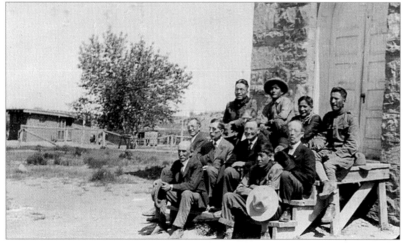

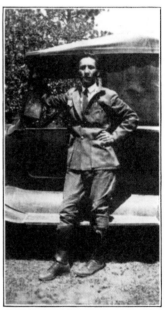

Fred K. Peshlakai, native evangelist. Ganado holds the key to the evangelization of this great tribe in that it is training a native force for the task.

A number of young people have finished training and are located at out-stations telling the Good News to those who have never heard. Work is being carried on at six centers covering an area of 360 square miles.

Fred Peshlakai (back row, fifth from right). At the Mt. Eden Presbyterian Mission Conference. 1925. *Vol.1, p. 30. Ganado Mission Photographic Essay and Oral History Project.*

Fred Peshlakai (far right) with his mission evangelical outreach advisors. Ganado, Arizona, ca. 1924. *Vol.1, p. 154, Ganado Mission Photographic Essay and Oral History Project.*

Fred Peshlakai, ca. 1924. This image is from the interior of a pamphlet produced by the Board of National Missions of the Presbyterian Church in the USA, New York, New York. *Courtesy of The Wheelwright Museum of the American Indian, Santa Fe, New Mexico.*

Not surprisingly, Fred also remained deeply linked to ancestral Diné heritage. Subsequently, Fred Peshlakai's art would always reflect—sometimes subtly, sometimes obviously and profoundly— his Diné heritage, yet would also encompass innovations influenced by the wider world. Today, he is recognized internationally as a great master of twentieth-century Diné silver art. All who knew him remarked on his genius and his kindness that came straight from the heart.

Fred Peshlakai (back row, forth from left). Ganado, Arizona, ca. 1920. *Vol. 3, p. 153, Ganado Mission Photographic Essay and Oral History Project.*

Indians for Leadership

TRAINING CLASS FOR EVANGELISTIC WORKERS AMONG NAVAJOS AT GANADO

NEW BEGINNINGS

MUCH OCCURRED IN THE EARLY DECADES OF THE twentieth century, both within its lands and outside, that affected the Dinétah. Oklahoma gained statehood in 1908 when Fred was eleven years old and in school in Ganado. The following year, the Model T automobile was marketed by the Ford Motor Company. The industrial age was about to break upon the twentieth century, and the Arts and Crafts artistic design sensibility was in full swing, back East and inside the exploding Anglo settlements of California. The media became more accessible, and information was abundant to influence a young student. The outbreak of World War I in 1917 had little effect within the Dinétah, except to further reduce supplies and staples. Fred was twenty-two years old when the old bible school in Tolchaco burned down in 1918.

Still, changes were slow to affect some traditional folk, like Fred Peshlakai's father, Slender Maker of Silver, who was 69 years old in 1900. He was forced to close his silversmith's shop in Crystal, New Mexico, in 1916, due to his failing health, when Fred was twenty years old. Fred also remarked that around 1910, Slender Maker of Silver, despite his comparative wealth, was still a blacksmith and that while shoeing a horse, the animal had kicked him in the face and knocked out his upper and lower front teeth. Instead of doing without,

Slender Maker of Silver made himself a set of dentures out of solid silver. He wore these dentures constantly during the last years of his life and his clan relatives referred to him as "Silver-Mouth" (John Bonner Strong, pers. comm.). Fred Peshlakai smiled broadly whenever he mentioned this to friends, finding it an endearing memory about his father and a testament to his father's skill as a silversmith. Slender Maker of Silver passed away in 1918 but would always be proudly remembered by his equally legendary son.

The word Peshlakai is only one of the Anglo variants for the spelling for the Diné word for silver. Early government and school authorities heard this name and wrote it phonetically, and it is fairly close to the audible phonetic in the Diné language. Fred would carry the name of his father as homage to this highly influential man.

The name Fred, which is derived from the German name Frederick, means "Peaceful Ruler" in that language. It is doubtful that the Anglo school authorities who gave Fred his Anglo name were considering his artistic future when they gave it to him, but the chosen name proved to be fortuitous. As a young child, they pinned a nametag to his shirt that read: "Fred Peshlakai," which would transcend in its interpretation to "Peaceful Ruler of White Iron." Apparently

there are no mistakes after all and, despite Fred's loss of his Diné name to history, some intentions of the spirit world seem inescapable.

Fred Peshlakai earned a salary of about $20 a month for his evangelical efforts from the Presbyterian authorities. During World War I, this sum was worthy for its time but still needed to be supplemented in order to keep up with the dreams and inclinations of a young modern man in his early twenties. Fred did what he could to earn extra money and learned some machinist abilities working around the mission and in the town of Ganado. He humorously recalled to John Strong that the reason he first left the reservation in 1926 was because he thought that a woman named Annie Dodge Wauneka had set her cap on landing him as a husband. Annie Dodge Wauneka was the daughter of the well-known Chee Dodge and would later become the second woman ever elected to the Navajo Tribal Council in 1951. She also would receive numerous accolades and honors from both her own people and President Lyndon B. Johnson for her work to improve health care and education for her people. Fred remembered her as an exceptionally determined woman, even at the age of sixteen, and felt that running was his only option.

Fred did run, all the way to Albuquerque where he had his first off-reservation job at an Indian silver jewelry production shop known as Maisel's on Main Street (John Bonner Strong, pers. comm.). This act laid the foundation for a pattern of work habit that Fred seems to have continued for much of his life. Although he would remain established in a certain locale, he would often travel and sometimes set up shop briefly in other places from which he would create his works of art.

Although in his later years he could be found working from early in the morning until quite late at night at his shop, earlier on Fred would occasionally take

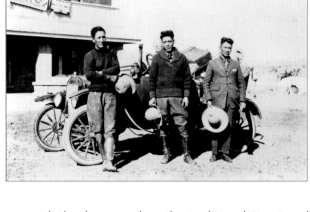

extended leaves from his home and explore other adventures with friends, family, and sometimes just to work, however briefly, in another location. However, in the late 1920s Fred didn't stay away long from Ganado, Arizona, due to several other interests he was pursuing. While participating in the Yei'bi'chei ceremonies of the traditional Navajo religion, Fred experienced new and "profound" spiritual experiences that reshaped his perspectives and subsequently enhanced his sensibilities for the traditional Diné iconography that appeared in his art. He smilingly related that, during this time, he took the Presbyterian mission vehicle as transportation to and from these events. (Strong, pers. comm.) These layered experiences certainly broadened Fred's world view.

Another primary interest of Fred's was a beautiful young girl named June Hubbard. He had known June for several years through the Presbyterian boarding school. After the death of his brother Paul, in 1926, Fred returned to Ganado to pursue his interest in Miss Hubbard, and on June, 3, 1927, the couple married in Ganado. June was born in 1909 in Fluted Rock, Arizona, and was seventeen years old when she married the thirty-year-old Fred Peshlakai. Fred found in her not just an evangelical partner but also a woman regionally known for her exceptional beauty. They took their evangelical work to Allentown, Arizona, to start their lives together. Here, they both served as missionaries, and Fred also had a small silversmith workshop inside their small railroad-stop home. Allentown still exists today just across the New Mexico/Arizona border on Highway 40. It was an early by-station for the railroad on its way to Flagstaff, Arizona.

Fred Peshlakai (left). Ganado, Arizona. 1924. *Vol. 3, p. 153, Ganado Mission Photographic Essay and Oral History Project.*

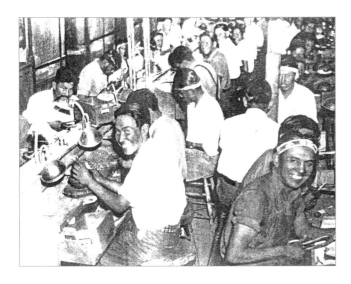

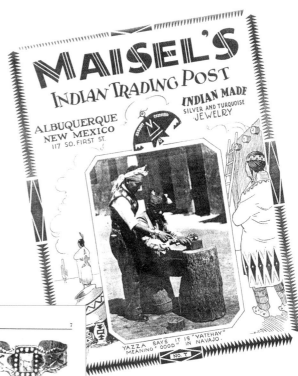

MAISEL'S INDIAN TRADING POST

INDIAN MADE SILVER AND TURQUOISE JEWELRY

ALBUQUERQUE NEW MEXICO
117 SO. FIRST ST.

YAZZA SAYS IT IS "YATEHAY" MEANING "GOOD" IN NAVAJO.

MAISEL'S INDIAN TRADING POST, INC., ALBUQUERQUE, N. M. 7

Indian-Made Bracelets

 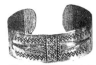 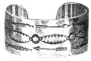 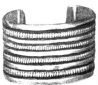 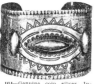 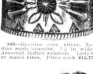 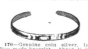 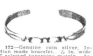 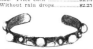 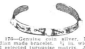 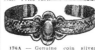 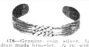 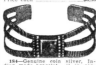 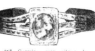 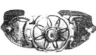 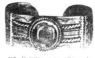 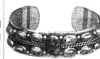

All Sets in Our Indian Made Jewelry Are Genuine Turquoise, Either Clear or Matrix Stones

These four images are from the memorabilia file at Maisel's trading post in Albuquerque, New Mexico, 2012. Included are two pages from an early catalog they released and images of the storefront, ca. 1940, and the in-house workshop, ca. 1930s. *Courtesy Skip Maisel.*

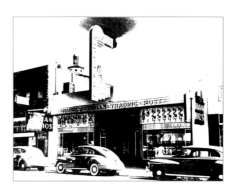

Fred and June's home and efforts at Allentown only lasted until 1929 when the great stock market crash in November profoundly affected their ability to make a living inside the remote railway station. They moved to Gallup, New Mexico, where Fred opened his own silversmith's/curio shop amidst Gallup's larger population. Somehow, they managed to get by selling various items to tourists. On January 5, 1931, June gave birth to their first child. Freda June Peshlakai lived less than one month and died on February 1 from dysentery at Sage Memorial Hospital in Ganado, where she had been born.

There exists some confusion in the official records for this period in the lives of Fred and June Peshlakai. Freda's birth and death were officially recorded at Sage Memorial Hospital, which was managed by the Presbyterian Mission until 1974. It makes sense that the young parents would travel 54 miles from Gallup (several hours journey at the time) to be with their spiritual caregivers. However there appears in the 1933 Indian Census, taken in April of that year, a listing for an Ireda Peshlakai, age 2, as a daughter to Fred and June. Sage Memorial does not show a birth record for Ireda, yet it appears the young parents had delivered twin daughters, one of which lived only briefly. Ireda's name appears again in the 1937 Indian Census at the age of six but is not listed in the federal census of 1940 among her mother's children. We are left to wonder at the official records for Fred and June's first-born daughters. This remains a mystery.

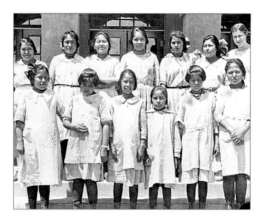

In October, 1931, Fred Peshlakai found new employment for which he would eventually be well remembered. He was hired as an instructor for silversmiths at the Charles H. Burk School at Fort Wingate, which had been founded by the Office of Indian Affairs in 1926.

Fort Wingate had several prior names. It was once called Fort Fauntleroy in 1860, then Fort Lyon when the original Fauntleroy character joined the Confederacy. It became Fort Wingate in 1868, taking its name from a U.S. lieutenant who was injured in 1862 at the Battle of Valverde. It still served as a United States post during World War I, and remained a military site until 1993. The government school, established in 1926, was officially given over to the Bureau of Indian Affairs in 1950.

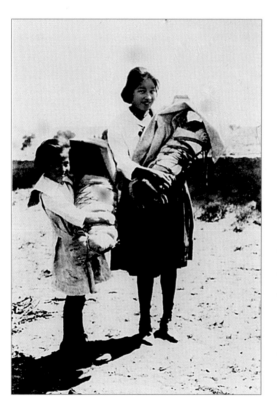

Fred Peshlakai taught there for three years as a government employee. However, in the fall of 1934, he took a leave of absence from the school, which lasted some six months.

Circumstances at the school were not without their share of politics, the affects of which show up clearly in Fred's "efficiency reports" from his superintendents. A memo from Michael Harrison, dated February 1934, criticized Fred Peshlakai's abilities as an instructor for young Diné silversmiths based on his use of "electric buffers, motor driven grind-stones for polishing turquoise, gasoline torches, ascetylene (sic) tanks, portable forges, French draw plates, (engraver's) blocks,

Above: June Hubbard (back row center), ca. 1924. *Courtesy: Vol. 3; Pg. 135. Ganado Mission Photographic Essay and Oral History Project.*

Below: June Hubbard with her sister, Alice Hubbard, and unknown babies, ca. 1925. Ganado Mission. *Vol. 3, p. 139, Ganado Mission Photographic Essay and Oral History Project.*

precision tools and so on," as this was "absolutely at variance with the order of the Secretary of the Interior" (Batkin 2008). Mr. Harrison, who at the time was with the Bureau of Indian Affairs, was against "hideous excuses for hand craftsmanship" that were being produced for the tourist trade during that period by those catering to the Anglo aesthetic and making inexpensive and overly stereotyped keepsakes available to the casual traveler. This was a complicated undertaking by Mr. Harrison because, on one hand, some of the marketing strategies for these tourist establishments called for romanticizing the Route 66 by producing items not necessarily in the fine art genre. These establishments also provided employment opportunities for Native workers during the Great Depression.

To add heft to Mr. Harrison's complaint, the Secretary of the Interior had recently ordered that "no jewelry (Indian) machine processed will be sold on any Government Reservation" (Batkin, 2008). It is easy to admire the intent of the Secretary of the Interior to preserve the integrity of this Native American art form and to help prevent Anglo-made pieces being sold as Indian-made. But it is also easy to understand Fred Peshlakai teaching the use of mechanized tools in his classroom. The manufacture of silver jewelry was a Navajo art-form only in about its seventy-fifth year and was still not firmly established

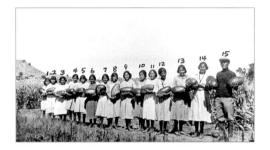

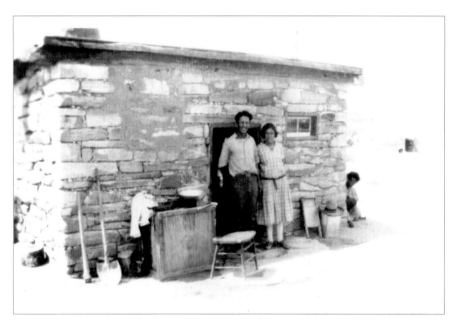

as a tradition. For example, its production was quite unlike the processes for making Pueblo pottery, which was rooted in that culture's rich and distant past.

Fred Peshlakai's viewpoint is clearly expressed in his subsequent, 1935 job application (shown in its entirety on pages 76 and 77) where Fred clearly states the essentials needed to develop a silversmithing business in the late 1930s. A contemporary analogy might be a school for Native American music students in the twenty-first century requiring the teaching of songs using only recordings on a Gramophone. Apparently, Mr. Harrison expected Fred to teach his twenty-four students in class to polish their

stones and silver with blow-sand and an old piece of leather, like the impoverished early Diné artists had to do.

Top: June Hubbard (far left), ca. 1925. Ganado Mission School. *Vol. 3, p. 135, Ganado Mission Photographic Essay and Oral History Project.*

Middle: June Hubbard, #13, with David Hubbard, #15, ca. 1924. Ganado Mission Cemetery. *Vol. 3, p. 142, Ganado Mission Photographic Essay and Oral History Project.*

Bottom: Fred Peshlakai and June Hubbard Peshlakai. Allentown, Arizona, ca. 1928. *Courtesy of Mr. Kenneth Douthitt.*

	ages of children in the family	number and kinds of subordinates you supervised. In reporting home management, describe your experience with children and your household duties	leaving
...t	A Instructor in Silversmithing	Present duties, to instruct boys of this government school, to learn how to undertake art in silversmithing (b) How to manage their own business as silversmith, and to be self-supporting.	$ 85.-- Per month $

Regardless of Mr. Harrison's broader intentions, this would not prepare young silversmiths to become self-sufficient in their practices or be able to be artistically competitive.

Fred Peshlakai left the Charles Burke School over a salary reduction (Batkin 2008). This reduction in pay, as well as BIA restrictions, had dampened Fred's enthusiasm to teach

Above and on the following pages: Efficiency reports for the years: 1931–32, 1932–33 & 1934–35. *Courtesy of The National Archives.*

COMMENT

The above personal and professional rating made by Walter C. Barton, I.S.S.J.H.
Head of Department.

Mr. Peshlakai has shown almost no interest in his work this year and has accomplished very little.

Leroy F. Jackson, Superintendent.

at a government school. This is clearly demonstrated in the superintendents' efficiency report on Fred for the year ending in 1935. His true reasons for leaving the Burke School were no doubt complicated.

Still, Fred Peshlakai's instructions would have a strong impact on many of his students. Some of them would remain silversmiths for the rest of their lives.

One of his students obtained stratospheric recognition and become known popularly as "The Father of Modern Navajo Silver." This man was Kenneth Begay, who became known internationally for his unparalleled interpretations of modernism in its applications to Diné silver art. Early pieces by Kenneth Begay showed

markedly the influence of his instructor on his more traditional output, and the skills Begay learned from Fred regarding the metallurgic handling of silver clearly impacted the student's career. This influence on Begay and others supports the idea that Fred Peshlakai was one of the most influential Diné silver artist of the twentieth century.

Left: Bracelet by Kenneth Begay. Sterling, ca. 1955. Maximum face height: 2.5". Hallmarked KB with a pictographic hogan. This spectacular example epitomizes the type of silver design for which Begay is so well appreciated. Rooted in the design era known as midcentury modern, Begay's handling of the medium transcended the period and resulted in his timeless creations of art. *Courtesy of Silver Plume Gallery, Double Bay, Australia, silverplumegallery.com.au.*

5-400-K
(February, 1931)

DEPARTMENT OF THE INTERIOR

OFFICE OF INDIAN AFFAIRS

EFFICIENCY REPORT—INDIAN SERVICE

Name of employee _____ Fred Peshlakai _____ Race __Indian__ Sex __M__

Name of unit _____ Charles H. Burke School _____ Date __April 1, 1932.__

Position _____ No. 26 Laborer _____ Age __33__ Married or single __M__

Salary _____ $1200 Years in service __1st__ Health _____ Good

Dependents: Adults—number _____ 1 Children—give ages _____

Highest Academic Training	Grades	High School	College	Degrees
	1 2 3 4 5 6 7 8	1 (2) 3 4	1 2 3 4	

Summer school _____

Extension courses _____

Professional training _____

SPECIALTIES: Music, vocal-instrumental; home economics; nursing; physical education; stenography; typewriting; agriculture; trades; dramatics; academic subjects. (Check subjects for which best qualified)

I. PERSONAL. (To be filled out for all employees.)

	P	F	M	G	E		P	F	M	G	E
Ability to execute				X		Initiative				X	
Adaptability				X		Originality		X			
Consideration for others				X		Personal appearance				X	
Cooperation				X		Refinement in taste				X	
Courtesy, manners, conduct				X		Tact			X		
Dependability			X			Use of English				X	
Industry			X								

GENERAL EFFICIENCY _____ Good.

II. PROFESSIONAL. (To be filled out for teachers and advisers only.)

	P	F	M	G	E
Cultural background (with particular reference to intimate and sympathetic understanding of lives of Indian children)					
Respect for personality of children					
Responsibility for social growth of children					
Resourcefulness as a teacher					
Skill in directing children's activities					
Skill in directing children's initiative					
Number of pupils in grade _____ GENERAL EFFICIENCY _____					

COMMENT

This man is a Navajo silversmith and is an exceptional workman and teacher. He should be given a position as silversmith instructor for this next year.

E. B. Dale _____ Supt & S.D.A.
(Signature and title)

(If necessary, use other side for further comments)

6—8098

5-400-k
(January, 1932)

DEPARTMENT OF THE INTERIOR
OFFICE OF INDIAN AFFAIRS

EFFICIENCY REPORT—INDIAN SERVICE

Name of employee ___**Fred Peshlakai**___ Race ___**Indian**___ Sex ___**M**___

Name of unit ___**Charles H. Burke School**___ Date ___**April 1, 1933.**___

Position ___**Laborer**___ No. ___**26**___ Grade ___**4**___ Age ___**34**___ Married or single ___**M**___

Gross salary ___**$1200**___ Years in service ___**2nd**___ Health ___**Good**___

Dependents: Adults—number ___**1**___ Children—give ages and sex ___**- -**___

Highest Academic Training	Grades	High School	College	Degrees
	1 2 3 4 5 6 7 (8)	1 (2) 3 4	1 2 3 4	

Summer school_____

Extension courses_____

Professional training_____

SPECIALTIES: Music, vocal-instrumental; home economics; nursing; physical education; stenography; typewriting; agriculture; trades; dramatics; academic subjects.

(Check subjects for which best qualified)

I. PERSONAL. (To be filled out for all employees.)

	P	F	M	G	E		P	F	M	G	E
Ability to execute			X			Initiative		X			
Adaptability			X			Originality		X			
Consideration for others		X				Personal appearance				X	
Cooperation		X				Refinement in taste				X	
Courtesy, manners, conduct			X			Tact		X			
Dependability			X			Use of English				X	
Industry			X								

GENERAL EFFICIENCY ___**Medium**___

II. PROFESSIONAL. (To be filled out for teachers and advisers only.)

	P	F	M	G	E
Cultural background (with particular reference to intimate and sympathetic understanding of lives of Indian children)				X	
Respect for personality of children				X	
Responsibility for social growth of children				X	
Resourcefulness as a teacher			X		
Skill in directing children's activities			X		
Skill in directing children's initiative			X		

Subject or grade taught ___*Silversmithing*___

Number of pupils in grade ___*24*___ General efficiency ___**Medium**___

COMMENT

Services satisfactory.

___**E. B. Dale, Superintendent & S.D.A.**___
(Signature and title)

6—8210

(If necessary, use other side for further comments)

5-400-k
(January, 1932)

DEPARTMENT OF THE INTERIOR
OFFICE OF INDIAN AFFAIRS

EFFICIENCY REPORT—INDIAN SERVICE

Name of employee __Fred Peshlakai__ Race __Indian__ Sex __M__

Name of unit __Charles H. Burke School__ Date __April 1, 1935.__

Position __Laborer__ No. __26__ Grade __4__ Age __36__ Married or single __M__

Gross salary __$1200__ Years in service __4th__ Health __Good__

Dependents: Adults—number __1__ Children—give ages and sex __One girl 17 mo.__

Highest Academic Training	Grades	High School	College	Degrees
	1 2 3 4 5 6 7 (8)	(1) 2 3 4	1 2 3 4	

Summer school

Extension courses

Professional training

SPECIALTIES: Music, vocal-instrumental; home economics; nursing; physical education; stenography; typewriting; agriculture; trades; dramatics; academic subjects.
(Check subjects for which best qualified)

I. PERSONAL. (To be filled out for all employees.)

	P	F	M	G	E		P	F	M	G	E
Ability to execute				X		Initiative			X		
Adaptability			X			Originality			X		
Consideration for others				X		Personal appearance					X
Cooperation			X			Refinement in taste					X
Courtesy, manners, conduct					X	Tact			X		
Dependability				X		Use of English			X		
Industry			X			Punctuality			X		

GENERAL EFFICIENCY __Medium__

II. PROFESSIONAL. (To be filled out for teachers and advisers only.)

	P	F	M	G	E
Cultural background (with particular reference to intimate and sympathetic understanding of lives of Indian children)			X		
Respect for personality of children			X		
Responsibility for social growth of children			X		
Resourcefulness as a teacher			X		
Skill in directing children's activities			X		
Skill in directing children's initiative			X		

Subject or grade taught __Jr. & Sr. High__

Number of pupils in grade _____ General efficiency __Medium.__

COMMENT

The above personal and professional rating made by Walter C. Barton, I.S.S.J.H.
Head of Department.

Mr. Peshlakai has shown almost no interest in his work this year and has accomplished very little.

Leroy F. Jackson, Superintendent.
(Signature and title)

6—8210

(If necessary, use other side for further comments)

In filling out the blanks the following standards should guide:

E means EXCELLENT
G means GOOD
M means AVERAGE
F means FAIR
P means POOR

DEPARTMENT OF THE INTERIOR
OFFICE OF INDIAN AFFAIRS

Fred Peshlakai,
Gen. Delivery,
Gallup, N.M.

5—294

TRANSMITTING CHECK 6/16/33

Accompanying check is tendered in payment of voucher dated ___6/15/33___ , 19 , for

$37.50 Salary for first half June 1933.
(Kind of supplies or service)

CHAS. H. BURKE SCHOOL

furnished for **FORT WINGATE N. MEX**
(Agency, school, or project) 6—6197

Claimant's identification No. _____

STANDARD FORM No. 7
(Approved by the President March 28, 1924)

SERVICE RECORD CARD

NAME (Surname first):

Peshlakai, Fred

(Place of birth.) 5/28/1888 (Date of birth.)

LEGAL (VOTING) RESIDENCE			
State and Cong. District:	County:		City or town:

Retirement age 62 65 70 | M. | F. | Mar. | Sin. | Wid. | Div. | Wh. | C. | Other race: **INDIAN** | Previous Government service
(Indicate by check.)

SERVICE RECORD

DATE OF ACTION	DATE E.O.D.	NATURE OF ACTION	POSITION	SALARY	BUREAU, DIVISION, OR OFFICE	OFFICIAL STATION	APPROPRIATION	CIVIL SERVICE Status	Authority
#26	10/1/31	A.Uncl.	Laborer	$1200		Chas.H.Burke	No ded.	Gr.4	
	5/31/32	Furloughed.							
26	8/1/32	A. Uncl.	Laborer	$1200		Chas.H.Burke	No ded.	Gr.4	
	6/26/33	Res.							
26	9/11/33	A. Uncl.	Laborer	$1200		Chas.H.Burke	No ded.	Gr.4	
	5/31/34	Res.							
26	10/15/34	A. Uncl.	Laborer	$1200		Chas.H.Burke	No ded.	Gr.4	
	6/30/35	Res.							

10—1658 GOVERNMENT PRINTING OFFICE

Top: Efficiency reports legend.

Middle: Paycheck copy. June 1933. Half month's pay is $37.50. *Courtesy of The National Archives.*

Bottom: Fred Peshlakai's Charles F. Burke School service record. 1931–35. Fort Wingate, New Mexico. *Courtesy of The National Archives.*

Two life-changing experiences happened before Fred left the school's employment. On June 23, 1933, Fred's wife delivered their next child. Dorothy Rose Peshlakai was a robust and healthy child. The government records do not indicate if the housing at Fort Wingate included his wife and daughter, and an authorization for change in residence from "Unit 26 to Unit 25" mentions only Fred's name for November of that year. But Dorothy's birth certificate does list the address for June Hubbard and Fred as Fort Wingate, New Mexico, even though Dorothy was born at Sage Memorial Hospital in Ganado, Arizona. It appears that the government housing included Fred's family, a living situation that would change out of necessity as the Great Depression wore on.

Also in 1933, President Roosevelt issued his New Deal in response to the economic collapse that was occurring at that early time period of the Great Depression. Unemployment in 1933 had risen to 25 percent with nearly one-fifth of all nonfarm mortgages foreclosed. However, that didn't deter the city of Chicago from celebrating its centennial and hosting a World's Fair, all in one grand outpouring of innovation and prosperity. The fair, also known as the Century of Progress, would last from May 27, 1933 to December 31, 1934, with an apparent hiatus in the deep of winter to revamp and refine the exhibits.

In 1934, demonstrations at the World's Fair were performed by American Indians in the States Building, after the scrapping of the Indian Village at the other end of the park. Maria and Julian Martinez demonstrated pottery and Hastiin Klah showed Diné sand-painting-inspired weaving techniques. Fred Peshlakai joined these "New Mexico Tribal Members," demonstrating as an "Indian Silversmith." He may have been chosen because he had worked as a government teacher. However, Hastiin Klah, who attended the Chicago Fair in 1893 with Fred's father, was undoubtedly very familiar with Slender Maker's talented son. Hastiin Klah's good friend and collaborator, Mary Cabot Wheelwright, likely wielded considerable influence with the chairman for the New Mexico Commission of The Century of Progress. At the end of the 1934 school year, Arthur Prager, fair chairman, requested Fred's superintendant to allow him to demonstrate at the fair, even though Fred was reserved as a federal employee. Fred's permission letter

was finalized in June 1934, allowing the Commission to arrange Fred's transport and salary of "$50.00 per month and all expenses." The management in Chicago liked Fred so well they requested and were granted an extension of Fred's leave until the Fair ended on December 31, 1934.

Fred returned to the Charles Burke School in January 1935 in a different frame of mind than when he had left. As a progressive and integrated person and having been encouraged and treated as a peer by the Presbyterians, it was an odd experience for Fred to perform as an old-style silversmith, as he had done during the Chicago fair. The image of him sitting on the ground in a staged setting did not reflect how Fred created his silver pieces. The BIA had removed Fred's mechanized implements from his classroom at Wingate. This, combined with his experiences seeing the modern advancements of Anglo society in Chicago, must have made him feel thoroughly put upon by the expectations of the BIA for his classroom. His efficiency report for April of 1935 noted that he showed "no interest in his work" (National Archives, National Archives Personnel Records).

Permission letter written to the New Mexico Commission of The Century of Progress International Exposition dated June 16, 1934 from the Charles Burke School Superintendant. *Courtesy of The National Archives.*

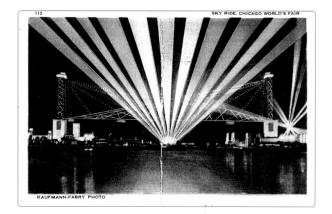

Top left: Face of postcard show-
ing the 'Sky Ride' at the Chicago
World's Fair sent by Fred Peshlakai
to the C.H. Burke Superintendant
requesting to extend his leave of
absence. August 24, 1934. *Courtesy
of The National Archives.*

Top right: Post card's message side
that details Fred Peshlakai's writ-
ten request, including his signature.
Courtesy of The National Archives.

Right: Fred Peshlakai (right) and
Hastiin Klah at the Century of
Progress Exposition, Chicago. 1934.
Photographer unknown. *Courtesy
of The Wheelwright Museum of
the American Indian, Santa Fe,
New Mexico.*

Below: Elongated "Penny Token"
from the Century of Progress. 1933.
Author's collection.

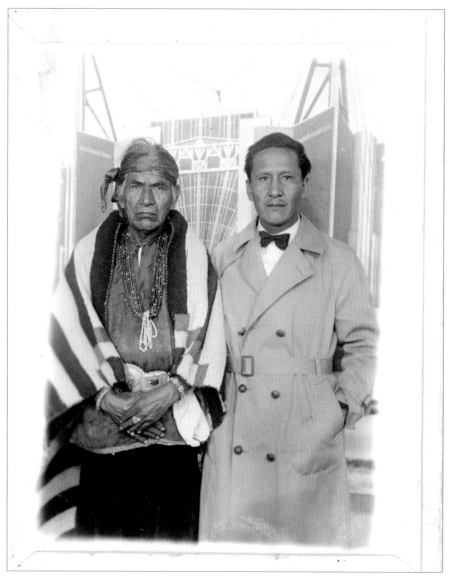

Part I: A Place in History

Fred Peshlakai demonstrating traditional Diné silversmith's techniques, ca August, 1934. Chicago Century of Progress and World's Fair. Despite the initially unfamiliar countenance of the figure when compared to the Wheelwright image, the Chicago History Museum adamantly verifies this figure as Fred Peshlakai, stating he was the only Navajo silversmith present at the Exposition that year. Comparative face recognition techniques, using various facial enlargements, verify the probability of the supposition despite the geographic anomalies in the background. This image was also found elsewhere as having been used by the Santa Fe Railroad as part of their marketing archives, leaving posterity to conclude that Fred possibly supplied the images to the Century of Progress for their own marketing purposes. *Courtesy of The Chicago History Museum.*

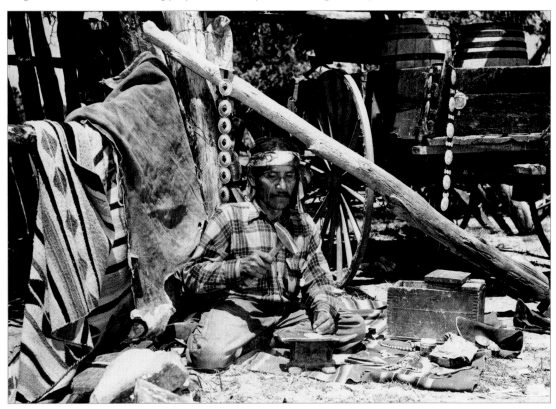

Site map for the Chicago World's Fair, 1934 session. The location of the States Building where Fred demonstrated is indicated in red. *Author's collection.*

He was probably not alone in this perspective. The derogatory opinions toward Native American populations across the United States were still widely prevalent among the Anglo people with whom Fred interacted. As an example, there is an image from the 1934 World's Fair of Maria Martinez receiving a "Council Fire Medal" for "Outstanding Achievement by an Indian" at the fair. In this image, she and her husband Julian are being handed a prize from a man in full stereotypical Hollywood regalia that included a full feather headdress. Obviously, it was still a time prior to white America realizing that these artisans were world-class artists and not just novelties. If Fred Peshlakai were teaching silver art today, it is unlikely he would have been treated so despairingly and become so subsequently discouraged that he would have received the critique he did from Mr. Jackson in 1935.

There is an interesting set of documents in the government record for Fred Peshlakai for 1935 and 1936. In the file is a job application dated April 1935 (based on the length of residency on the application) and there is no mention of what job Fred was applying for with the Department of the Interior. He would not have needed to reapply for the position he already held, so we are left to wonder at what he was about. There is fascinating information written there in Fred's own hand regarding his life at the age of 39.

On this application, Fred describes his father as having been a "silversmith and stockman" and his mother as a "weaver." His work that he did between the ages of 12 and 21 included: "Farming, herding and rounding up cattle, house chores." Birth: "Nov. 27th 1999." He says he is "5' 11, 165 lbs." (These documents reveal a man of humble nature attempting to interface honestly with the BIA management of the time.)

While Fred did not return to the Charles Burke School in the fall of 1935, people who knew Fred always remembered him as a very kind person. Fred's comment to John Adair regarding his leaving the school over his salary is a good example of Fred being kind. Fred was already a brilliant craftsman and simply took his skills out into the market where it was easy for him to find employment, even during the Depression—although he had to travel to find it.

Above & Following page: Four page application for employment written in Fred Peshlakai's hand to the Department of the Interior; Office of Indian Affairs. April 10, 1935. *Courtesy of The National Archives.*

Part I: A Place in History

3

31. What language did you learn to speak as a child? *Native language* 32. What languages, including Indian tribal languages, can you (a) understand? *English*

(b) Speak? *yes* (c) Read? *yes* (d) Write? *yes*

33. Where did you live when between 12 and 21 years of age? (Give name of States, counties, cities, towns, reservations, institutions, etc.) *Crystal, N. Mex.*

34. What were the occupations of your parents during that period? (a) Father *Silversmith, Stockmen,* (b) Mother *Weaver*

35. Describe the kinds of work you did, whether with or without pay, between 12 and 21 years of age, including work done around home, such as farm chores, housework, care of children, temporary employment during vacations, etc. *Farming, Herding, and rounding up Cattles, horse, Sheeps.*

36. What U. S. Civil Service examinations have you taken? (Give places, dates, and state whether you passed) *no*

37. What State or local examinations have you taken? (Give places, dates, and state whether you passed) ✗

38. If you have ever received any local, State, or Federal permit, license, registration card, certificate, or other authorization to practice some particular trade, or profession, give its title, place, and date of issue and state when it will, or did expire. If you are a member of the bar, state when and where you were admitted.

39. For what kind of work do you think you are best fitted?
40. For what kind of work would you like, if possible, to prepare yourself?

41. Give below the information required concerning your occupational experience, following directions under each heading:

Places and dates of employment	Employer and location	Kind of business	Description of your duties	Rate of pay
City *Ft Wingate* State *N. Mex.* From *Oct 3rd 1931* To *April 10 1935*	Government *at Wingate, N. Mex.*	(a) Instructor in Silversmithing	Present duties, to instruct boys of the government school to learn how to undertake art in silversmith. (b) How to manage their own business as silversmith, and to be self-supporting.	$ 85.00 Per month
City *Gallup* State *N. Mex.* From *May 10 1928* To *Oct 2 1931*	Self	Had a shop of my own	Did business for myself as silversmith, managed and operated my own shop	$100.00 Per month
City *Ganado* State *Ariza* From *June 1924* To *May 1 1928*	Missions	As Field worker	Deal with the educated and uneducated Indians, served them the right ways of living. Helped with their living conditions in their homes.	$75.00 Per month
City State From 19 To 19				$ Per

* Mention specifically, giving dates, and places, experience of the following sorts: Anesthetizing, operating room, laboratory and X-ray, contagious diseases, psychiatry, obstetrics, tuberculosis, pediatrics, dietetics.

If more space is required, paste a sheet of paper on this margin, extend column lines, and continue your entries. 6—6571

4

42. If you have any musical ability, state whether vocal or instrumental and name instruments you play

43. How and to what extent has your musical ability been cultivated?

44. What are your favorite recreations or hobbies? *Bas Ball.*

45. Mention any books you have read during the past six months and any magazines or periodicals which you frequently read *Physical Culture books & magazines. Literary Digest.*

46. Check (✓) any of the following in which you have participated or been actively interested, and give particulars, as to when and where, on the second line below this list:

✓Athletics	Civic Organizations	Fraternal Orders	Inter-tribal Organizations	Oratorical or Debating Contests	School Publications
Bands or Orchestras	Community	Glee Clubs	Labor Organizations	Outdoor Clubs	School Societies
Boys' or Girls' Camps	Organizations	Grain Clubs	Livestock	Pageants	Scouting
Business Clubs	Dramatics	Grain Judging		Playground Activities	Student Councils
Ceremonials	Farm Chapters	Home Economics	Associations	School Offices	Study Groups
✓Church Societies	4-H Clubs	Clubs	Livestock Judging		✓Sunday School

✓Tribal Council
Veterans' Organizations
Welfare Organizations
Women's Clubs
Y.M.C.A. or Y.W.C.A.

Others:

1, 2, 3, and 4, while a student at Ganado, Ariz.

47. If you have any military or naval record, show by ☒ your branch and other information and give dates of enlistment and discharge:

☐ Army. ☐ Navy. ☐ Marine Corps. ☐ Coast Guard. ☐ War veteran. ☐ Pensioner. ☐ Veterans' Bureau beneficiary.

Date enlisted Date discharged Date enlisted Date discharged

Rank Rank Rank Rank

Organization Organization Organization Organization

48. If retired, state reason for retirement and amount of retirement pay per month

49. Are you the wife of a disabled veteran? 50. Are you the widow of a man who was in the U. S. Military or Naval service? 51. Are you an orphan of a person who was in the U. S. Military or Naval service?

52. If you answered "Yes" to question 49, 50, or 51, give name, organization, and last year of service of the veteran or deceased

53. What military training have you had other than in the U. S. Military or Naval service? When and where?

54. Have you ever been arrested, or otherwise charged with a crime or misdemeanor? If so, give date, place, charge, and disposition of each instance. (Attach separate sheet, if necessary)

55. Have your fingerprints ever been taken? If so, state when and where and in what connection?

56. Describe any chronic disease, defect of speech, sight, hearing, hand, foot, or limb which you have.

57. Have you been sick within the past two years? If so, give brief statement of diagnosis and state what is the present condition of your health

58. Do you now hold any State, county, or municipal office? If so, give title, location, and date appointment expires

59. Would you accept a position in Washington, D. C.? 60. Would you accept a position anywhere else in the United States? If not, indicate where you would be willing to work

61. When could you report for duty, if appointed? 62. If appointed to a field position, for how many persons would living quarters be needed? Adults? Children (give ages)?

63. Would you accept temporary employment for six months? For three months? For one month?

64. Give names, occupations, and addresses of two persons (neither relatives nor persons who have employed you) to whom we may write regarding your qualifications:

Name Occupation

Full address

Name Occupation

Full address

65. Give any further information about yourself which you think significant, such as special knowledge or experience which would be of value to the Indian Service

(Continue on an attached sheet if you desire)

Date Signature of applicant

U. S. GOVERNMENT PRINTING OFFICE: 1935 6—6571 DO NOT WRITE BELOW THIS LINE

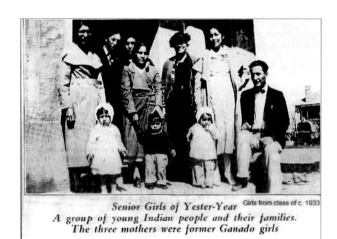

Senior Girls of Yester-Year Girls from class of c. 1933
*A group of young Indian people and their families.
The three mothers were former Ganado girls*

Ganado News Bulletin June 1935, p. 2

According to the 1936 census, Fred's wife gave birth to a son, "Wilbur Peshlakai," on March 11, 1936. Unfortunately, the work that Fred could find was not in the Ganado area, and he had to leave June, Dorothy, and little Wilbur in Ganado and travel to where the production shops for Indian jewelry existed.

Sometime between 1935 and 1937, Fred Peshlakai worked for Vaughn's Indian Store in Phoenix, Arizona. Sam Vaughn, the son of the original owner of Vaughn's Indian Store stated that "wealthy Easterners were interested in buying authentic Indian arts and crafts, and they wanted items they could not obtain in the East". Sam Vaughn stated, "Every piece (of Peshlakai's) was a masterpiece... (His work) was so perfect. There was nothing you could find wrong with it." Although esteemed Hopi silversmith Morris Robinson also worked at Vaughn's at the same time, Sam Vaughn credits Fred Peshlakai as being the most talented silversmith his father employed (Pardue 2005).

Records show Fred still married in January 1937, in Apache County, Arizona, with his family. (Indian Census Records 1936-1940). Interestingly, subsequent documentation states that Fred Peshlakai was also working in Los Angeles, California, in 1937 (Woodward 1938, 56). Fred Peshlakai indicated that his first job in Los Angeles was "in the window" at Vaughn's on Hollywood Boulevard and that he had enjoyed working

there (John Bonner Strong, pers. comm.). The Vaughn family sold their store in Phoenix in 1936, so it could safely be concluded that Fred relocated to the Vaughn's location in Los Angeles immediately thereafter. Further reports indicate that the Vaughn family's Los Angeles store's location was across the street from Grauman's Chinese Theatre during their years of tenancy there (Art Tafoya, pers. comm.).

The Federal Census of 1940 documents Dorothy Rose Peshlakai, age 6, as the "stepdaughter" to Benny Tilden, age 25, husband to June Tilden, age 30, with son Wilfred Tilden, age 4, and daughter Florence Tilden, age 1. This document infers there was dissolution of Fred's family sometime between 1937 and 1939. Florence was one year old in 1940 with Benny Tilden listed as her father. Also, since the 1937 Indian census states Wilbur Peshlakai was born to Fred and June Peshlakai, the baby then appears to have been adopted by Benny Tilden, as the name "Wilfred Tilden" appears in the 1940 census at the age of 4. Dorothy Rose Peshlakai, however, retained her last name.

Nothing is known about the dissolution of Fred's marriage. June probably needed someone who was at home more often. Dorothy Rose would keep in contact with her father for the rest of his life. Many times, he would travel to Arizona to see her. They would go to the Grand Canyon and visit with Dorothy's family. It was also Dorothy who would care for Fred in the last year of his life.

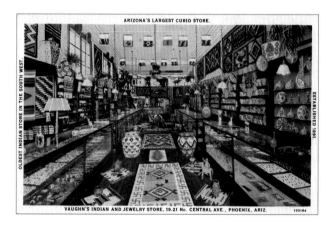

Above: Fred and June Peshlakai with daughter, Dorothy Peshlakai, at right, in 1935. *Courtesy of Mr. Kenneth Douthitt.*

Bottom right: Postcard. ca.1940. Vaughn's Indian Store. Phoenix, Arizona. *Courtesy of Lake County, Illinois Discovery Museum. Curt and Teich Postcard Archives.*

OLVERA STREET

FRED PESHLAKAI RELOCATED PERMANENTLY TO LOS Angeles, California, sometime around 1937. It is estimated that around 1940 to 1941, Fred moved on from working at Vaughn's Indian Store as well.

The advent of World War II in 1939 likely influenced Fred's decisions. Pearl Harbor was attacked by the Japanese on December 7, 1941, and on February 25, 1942, "The Battle of Los Angeles" occurred where the United States shot a barrage of anti-aircraft artillery (to the tune of 1,400 shells) at an "invading aircraft" seen over Los Angeles that night. Several people were even killed by falling shrapnel from the attack. This aircraft has never been positively identified by any authority and was not removed from the airspace by the Army's efforts during the "blackout" of that dramatic evening, but, rather, it apparently departed under its own volition. Its unexplained presence remains, to this day, listed as a possible UFO encounter with extraterrestrials by many enthusiasts.

There was a sudden increase in available work for the war effort, and Fred's family recalls that Fred participated in that type of work (*Navajo Times*, January 1975). These events also prompted Fred to register for the draft in Los Angeles in 1942 at the age of 46 or 47. Fred's registration card places him in California in 1942, and it documents the location of his silversmith shop at #27 Olvera Street ("Alvera", sic) at that time. His personal residence is shown as 1425 Pleasant Avenue, which was about 10 blocks from his shop. The card is a rare documented example of Fred's relationship with Doc Wilson, the gentleman from whom Fred obtained most of the famous stones he used in his work (John Bonner Strong, pers. comm.).

There is a beautiful bracelet (see page 111) that demonstrates Fred's uncommon multiplicity in his endeavors during this time in his life. This early, if not the earliest known, dated example from Fred's tenure on Olvera Street in Los Angeles, clearly shows an evolved artisan with an established address on Olvera Street.

Fred actively worked with the war effort until the war ended in 1945. His family recalls that in the 1940s he was also doing "wax works" in California, as well as dabbling in movie acting in the "Wild West" films that were fashionable at the time (*Navajo Times*, 1975). Olvera Street in the 1940s was a sensible place for Fred to set up his silversmith shop. It was decidedly ethnic, and Fred's appearance would have blended in very acceptably in an otherwise still prejudiced Anglo city that appreciated ethnicity only as a novelty at best.

Draft registration card for Fred Peshlakai, 1942. Los Angeles, California. *Courtesy of The National Archives.*

Olvera Street, which contains the oldest remaining architecture in Los Angeles, was once the town center for Spanish Colonial California. Established in September 1781 as the "El Pueblo de la Riena de Los Angeles" it was originally inhabited by 44 settlers coming from northwestern Mexico. The settlement was arranged traditionally around a plaza in front of a Catholic Church. The street at the north end ran north to south and was called Wine or "Vine" Street. The church's front door was actually the town center mark for the town's first official survey conducted in 1849. The original Mexican rancheros lost their rights and properties to the Americans in the 1860s during the political upheaval of the American Civil War. This had been complicated by the influx of Americans during the California Gold Rush during the 1840s and 1850s. Additionally the American population increased due to the completion of the railroad to Los Angeles from San Francisco by the Southern Pacific Transportation Corporation, whose first train arrived in 1876. Wine Street had its name changed to Olvera Street in 1872, and the change was ratified officially in 1877. The street was named after Mr. Agustin Olvera in honor of his services as the first Superior Court Judge in Los Angeles County.

The city of Los Angeles continued to grow steadily in an outward sprawl from this old city center. The fashionable district moved away from the old district and the Pueblo area declined into vagrancy. The original Chinatown in Los Angeles sprung up on the east side of the old plaza, and in 1900 had 3,000 Chinese residents. This often prompted city leaders to lay the blame for anything disreputable that occurred in the city on the area's inhabitants. The plaza became known as a meeting place for undesirables and questionable political activities. Respectable people of the time stayed far away from this place of steady decline.

Into this arena appeared an interesting and eventually beloved woman named Christine Sterling who, in the 1920s, began a one-woman effort to restore and revitalize the "forsaken and forgotten" historic remnants of the original Pueblo area of Los Angeles. Fueled by an enthusiasm to preserve the history of Los Angeles and a vision to create a "Mexican Marketplace" as part of the noble lineage for Los Angeles proper, she succeeded in converting and restoring this historic district into the vital point

of interest that it is to this day. The streets within the district were officially closed to vehicular traffic in 1929, and in 1953 the area became a California State Historic Park. The transition was gradual, but the area eventually gained in popularity and was even visited in 1939 by Eleanor Roosevelt. In the 1940s, when Fred Peshlakai set up shop there, it was well-known as a destination for tourists and the well heeled. The area's air of festival was, and is, a popular draw where a "Little Bit of Mexico" could be found.

This was a perfect environs for Fred to sell his art. The exact building for #27 Olvera Street shown on Fred's draft card is not known. What is known is that his permanent location solidified into what is now part of Building #23, known as the Jones Building that was built in the late 1880s. The shop location is shown on the Olvera Street El Pueblo Historical Monument site map and merchant directory as location number W-08.

Fred Peshlakai sublet the space on Olvera Street from Hugh Henderson, who owned the store spaces from 1940 to 1988. During Fred's tenancy, the shop space he occupied was a working silversmith's shop complete with all of the equipment needed for Fred's artist endeavors.

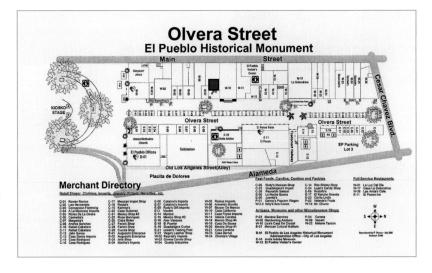

In the 1960s there was a chain across the main entry door to Fred's shop that was generally in place, barring the entrance. Fred's glass case was rarely occupied with pieces available to the public. Since Fred was so consumed with the production of custom orders, there was little available inventory for the casual passers-by (Strong, 2012, CD no. 3). There's a humorous account of Fred having a sign that he

Top left: Merchant directory for Olvera Street, Los Angeles, California. 2012. Fred Peshlakai's shop location from 1941 to 1972 is highlighted in red. *Courtesy of El Pueblo de Los Angeles Historical Monument.*

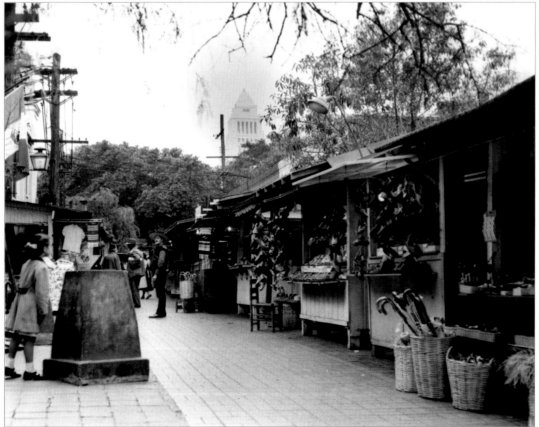

Olvera Street, ca. 1948. These images portray the market festival environment of the "Little Bit of Mexico" envisioned by its original revitalization advocate, Christine Sterling. Olvera Street became a California State Historic Park in 1953 and is now referred to as El Pueblo de Los Angeles Historical Monument. *Courtesy of El Pueblo de Los Angeles Historical Monument archives.*

had picked up on one of his travels abroad that read "Indian Jewelry Made While You Wait" that he propped up on the windowsill to indicate that he was in the shop.

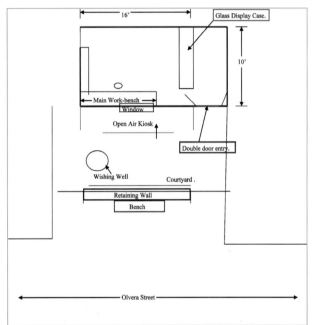

Fred Peshlakai maintained his shop on Olvera Street for the remainder of his life. However, he would not always be there during his 30-year tenancy. After the end of World War II, while the American economy began to recover, he often took his equipment and reputation on the road and set up at various locations inside some burgeoning tourist attractions. A couple of these

Top: Fred Peshlakai's shop location on Olvera Street, 2012. The entrance was located inside the right alcove. *Photo by Jay Rozenzweig.*

Bottom: Drawing of the interior of Fred's workshop on Olvera Street, ca. 1960, as described by John Bonner Strong.

locations were Babbitt Brother's Trading Post in Flagstaff, Arizona (Art Tafoya, pers. comm.), as well as the Hotel El Escalante in Cedar City, Utah (Independent 1975). Touted by the Parks Service as a way-station for the North Rim of the Grand Canyon, the Hotel El Escalante was run by the Utah Parks Company between the North Rim of the Grand Canyon and Zion National Park and Cedar Breaks National Monument byway.

On Sunday, August 27, 1950, the Salt Lake City newspaper *Deseret News* published an article that was featured in the newspaper's subsection called *Deseret News Magazine* on Fred Peshlakai and his attraction at the Hotel Escalante during the summer months. Written by Jeanne Bethers, this rare, if not unique, example of a published interview with Fred was titled "Peshlakai. Master Silversmith" and offers some exceptional insights into Fred's personality and artistic temperament. In the article, Bethers writes:

> *In the summer 'Fred' as he is affectionately called by his intimate friends and 'Peshlakai' by those who know his work, plies his trade at Grand Canyon. At the north rim of the Grand Canyon many people order special work so that they can watch Fred as he takes crude bars of silver and bits of turquoise and makes articles from necklaces to heavy salad sets. He polishes each piece to a shiny finish and uses as much care and skill in one article as he does another.*
>
> *Peshlakai has a background of silverwork. He remembers his father who was the original Peshlakai as he sat among heaps of silver making all kinds of art objects. His father never left the reservation to make the silver objects but his work did. Fred has met people who treasure work done by his father. Although the owners of the work had not been on the reservation they had bought it because of its beauty and learned that is was made by Peshlakai.*

Because his father did not sign his work so that it could always be distinguished from the work of his apprentices Fred has all his articles stamped with the capital letters "FP" with an arrow running through the initials from the P through the F.

Peshlakai senior died when Fred was quite young. He had learned the rudiments of hammering objects and could do some crude objects at that time. He did however learn many of the white man's ways from Peshlakai senior. Fred says, 'My father was not only in the midst of so much silver which made him the great silver worker but he was also a strong leader among the Navahoes (sic) and the white people. He was an influential person. Someday I would like to go to Washington D.C. and see the records of assistance that my father gave in working out peaceable settlements.'

When one studies Fred Peshlakai's work one notices it is apparently perfect. It looks as if it were made by machines. When asked about it Fred only smiles, showing his remarkable even pearly white teeth, saying, 'It is easy when one knows how.' The rejoinder is usually, 'But how did you learn to do it so perfectly? (He responds): 'It is inside of me, it is a talent and I just know how it is to be done.' Although his work is done free hand one is amazed at the geometric perfection he achieves. Designs do not vary the amount that could be measured by the eye. Their perfection looks as though he uses precision instruments but he doesn't. His tools consist of hammers, a torch, emery cloth, some dies (which he made himself), pliers, vices and a device used by jewelers, ring size circles.

If one visits Peshlakai in his shop, which is at the Hotel El Escalante in Cedar City, no matter where one puts a hand a mark is left in the fine dust which covers everything. When asked about it Fred will say, 'Yes, it is ruining my health but I like it.'

One has a feeling that if Fred were to go back, he like his father, would be 'a strong leader among the Navahoes' (sic), but unless he continued with his silversmith work the southwest would lose one of its great artisans." (Bethers, 1950)

The quoted segments from this article detail clearly the prevailing opinion people of many walks of life had in 1950 for the artistry of Fred Peshlakai.

Fred purveyed an air of grace and peace, but received little media attention, unlike future celebrity artists. Fred would never attend large parties in his honor or ride in limousines or travel to Paris for an exhibition. Abundant funding would never come his way, which would have allowed him to frequently work more precious metals. He would never be found among the trendy jet-setters who found it fashionable to embrace and uplift Native artists. Although he was quite personable, as well as being extremely proud and dedicated to his art, Fred would never engage in seeking the limelight. Fred was popular, yes, but he was never wealthy like some other Native artists. Money that Fred received during his lifetime was redirected into his art and used to for pay the ever-present bills that accompany everyday life.

By the mid 1950s, Fred Peshlakai no longer took his mobile silversmith's shop abroad and was back in Los Angeles to stay. Although Fred had entered and won many Native arts and crafts shows over the course of his career, his winning of the Indian Arts and Crafts show in Los Angeles in 1954 appears to be one of his last entries into these types of venues (Art Tafoya, pers. comm.). Fred was fifty-nine years old in 1954, and interviews with John Strong indicate an increasingly sedentary Fred. When Strong first met Fred in 1960, Fred was so entrenched on Olvera Street that Strong had trouble imagining that Fred had not been exclusively habituated to his shop location for "many years." Also, the Diné community in Los Angeles had increased substantially in the 1950s, and Fred was active in various efforts of the growing community.

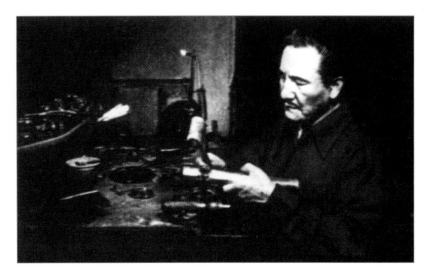

best to alleviate some of the hardship that the newcomers experienced. The Navajo Club was also interested in preserving the Diné culture and, once the white community in Los Angeles noticed the efforts of the Club to uplift their people in residence there, churches and other philanthropic groups began to invite members of the Diné to put on dances and exhibits that would show a "truer picture of the Indian of today, in contrast to the stereotyped Hollywood version" (Greenberg 1996). This started a true community experience for the Diné and other Native people living in Los Angeles at the time. These events would blossom into powwows and other tribal-oriented celebrations, which were repeated for several decades, gradually creating the stronger sense of cultural self that can be found more readily there today.

In 1948, Fred's nephew Carl Gorman and a group of Diné men and women living in Los Angeles formed what was to be known as The Navajo Club. This organization was formed in response to the government's plan for the rehabilitation of the Navajos who were starving on their reservation from an acute drought that had lasted from 1947 to 1949. Generally referred to as a "termination" program designed by the government to end Native life on their reservations, the Bureau of Indian Affairs began a relocation program in 1952 to implement this program of assimilation of the Native Peoples into Anglo society.

From the onset, this government program had disastrous results. The Navajo people were offered grand promises of assistance in finding work and housing, even to the extent of recruiters being sent to the reservations with fine words and images of "new housing, of beautiful automobiles and bright appliances" (Greenberg 1996, 90). As usual, none of these promises were kept once the people relocated and many found themselves destitute and living in slums with no recourse for employment or training opportunities inside the dizzyingly foreign environments in which they found themselves.

Some 6,000 Diné persons, some as complete families, were relocated into the Los Angeles area. Although the Navajo Club could not even begin to help all of these new tribal members adjust to conditions in Los Angeles, they did their

Fred's brother Frank Peshlakai, who was about the same age as Carl Gorman, was also involved in this movement. Fred also became involved, doing what he could to encourage the Navajo artisans who had relocated to Los Angeles to pursue their crafts. Although Fred was, and had always been, deeply concerned for the plight of his people, he was also constantly in demand for his silver-work. However, he did what he could, when he could, to help the Diné populations in L.A. better themselves.

Frank was an accomplished silversmith as well. Frank Peshlakai was born in 1903, and, although Slender Maker of Silver had other wives, Fred and Frank had the same mother. Although Frank would not dedicate himself to the silversmith's art full time, he had not escaped the influence of the art form in his genetics. There is an article on Frank Peshlakai in the June 1932 edition of *The Union Pacific Magazine* that reveals Frank working as a silversmith for the Utah Parks Company that year. The article states, "After graduating high school, Frank lived for some time with one of his brothers, who taught him the silversmith's trade." The article goes on to describe him as a "high class craftsman, and guests of the Grand Canyon Lodge enjoy watching him work, and keep him busy making rings,

Fred Peshlakai at work in his shop on Olvera Street. Los Angeles, California, ca. 1949. *Author's collection.*

bracelets, necklaces, wrist watch bands, earrings, cuff links, etc., to their order." It also says that he "makes the dies used in stamping the various hieroglyphics or characters appearing on articles manufactured."

Later in life, Frank was also known as a truck driver, Navajo rug marketer, rancher, and soldier. He visited Fred often on Olvera Street and Fred even sold pieces of silver jewelry Frank had made through his shop (Strong, 2012, CD No. 3). Social Security records show Frank Peshlakai passed away in 1965.

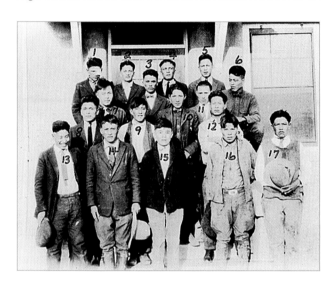

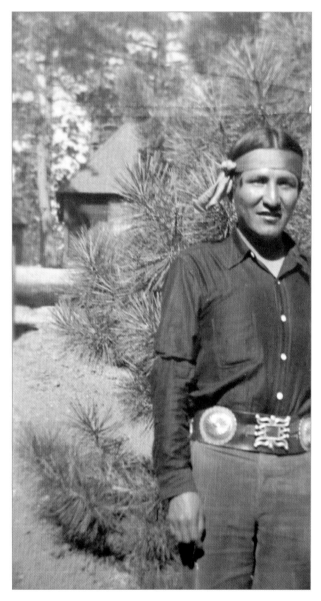

Above: Frank Peshlakai (center; #10), ca. 1918. Ganado Mission School. anado, Arizona. *Vol. 3, p. 154, Ganado Mission Photographic Essay and Oral History Project.*

Frank Peshlakai wearing a concha belt of his own manufacture, ca. 1936. Cope Family Ranch, Bryce Canyon, Utah. *Courtesy of The Dr. Marjorie Chan collection.*

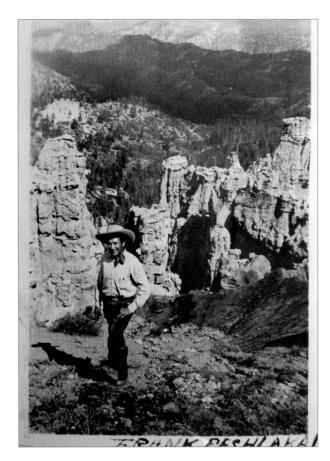
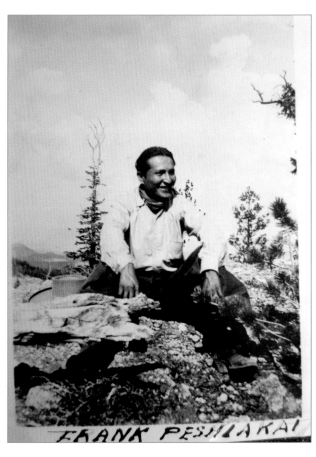
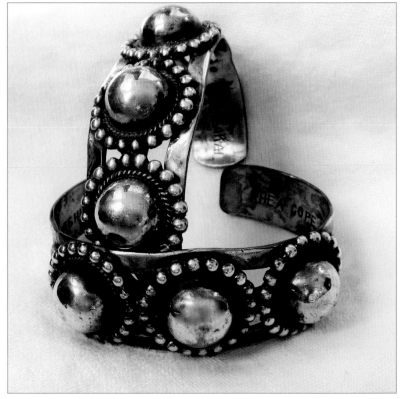

Top, both images: **Frank Peshlakai.** ca. 1936. Cope
Family Ranch; Bryce Canyon, Utah. *Courtesy
of The Dr. Marjorie Chan collection.*

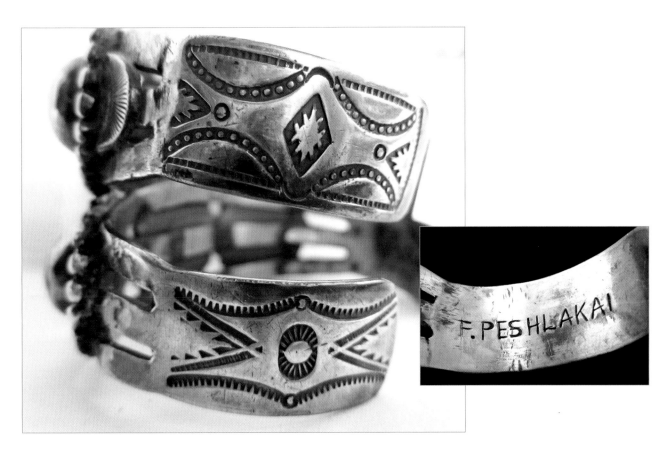

Top left and right, and previous page bottom: Possibly the only existing, perfectly documented examples of the early silver pieces by Frank Peshlakai that have clear provenance, ca. 1936. These bracelets were custom-ordered for Gwen and Rhea Cope, the daughters of Maurice Cope, while Frank was a ranch hand for the Cope family during that period. Clearly inscribed with the name of each daughter as a dedication, these pieces were also signed with Frank's signature as "F. Peshlakai" rendered in a rounded-letter version. (Note the double strike "C" in order to create the letter "S.") Observation concludes that pieces of Frank's work appear somewhat simpler in design when they are examined in bulk and compared to Fred's overall inventory. Fred was, however, fiercely proud of his younger brother. Irrefutable examples of Frank's work are exceedingly rare and John Strong, who knew Fred, feels Fred would have laughed at the conundrum among scholars concerning which of the two brothers actually was the producing artist on certain pieces. *Courtesy of The Dr. Marjorie Chan collection.*

This page bottom: FRANK PESHLAKAI BRACELET, ca. 1942–1954. Frank appears to have also used a full version of his signature, possibly in order to differentiate his work from Fred's. *Courtesy of Brown's Trading Company.*

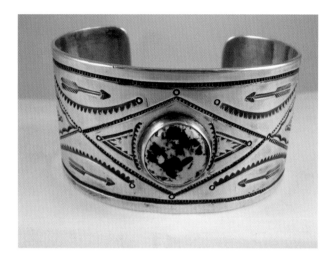
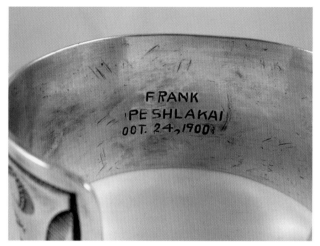

The later years of the 1960s, the elderly Fred Peshlaki became steeped in his habits. Fred turned 70 in 1966 and was exhibiting enough of a personal routine for his friends to know exactly where to find him at any given time. He was almost always to be found at his shop on Olvera Street from seven in the morning until sometime around nine at night Sometimes he took several hours off in the early afternoon for a leisurely lunch and a walk. He would take the Paloma bus and visit the Heights, lost in his thoughts and memories. He gathered shells on the beaches and used clam shells to hold the flux for his solder (Strong, 2012, CD No. 3).

Fred lived on Pleasant Street for many years, in an apartment portion of the house. Later, as his health began to decline, he moved to a small hotel that rented single rooms by the month near Olvera Street. By all reports he was happy, always smiling and listening to European polka on his little radio, which sat on his workbench in his shop.

Customers came and went. He knew many, many people in the area but had very few friends with whom he socialized outside his shop. Occasionally he would meet these friends for lunch at places like Felipe's French Sandwich Shop, which he especially liked.

Fred never remarried or had other children while living in Los Angeles. A Los Angeles County search revealed no surviving official records for Fred Peshlakai in California. Inquiries at Olvera Street found that since so much time had passed, or perhaps because Fred was a quiet man, there are only a very few people remaining there who have a vague memory of him (Jay Rosenzweig, pers. comm.).

BRACELET. Carlin turquoise and sterling silver, ca. 1940. Size: 7. Maximum height: 1.75". Signed: Frank Peshlakai. This rare example bears Frank Peshlakai's full signature. The dedication appears to be in commemoration of some unexplained event since it is very clearly rendered and Frank was not born until 1903. *Courtesy of The Gloria Dollar Collection.*

In the early 1970s, Fred's health began to decline rapidly. He suffered from chronic tuberculosis, for which he was hospitalized several times at the Olive View Medical Center in Van Nuys, California. In 1972, Fred suffered a severe collapse of his respiratory system and was hospitalized again for several months. In January of 1973, an unknown healthcare worker at the Beverly Palms Hospital in Los Angeles wrote to the *Navajo Times Newspaper* in Window Rock, Arizona, and made the following request on Fred's behalf:

February 1, 1973.

Dir Sir: Will you please print this in the Times if possible to cheer up this lonely Navajo:

Fred Peshlakai, Navajo silversmith is in the hospital in Los Angeles. Like very much to hear from his relatives and friends.

Fred Peshlakai.

Fred never regained his health. Long years of breathing the silver dust produced during the process of creating his art had complicated his tuberculosis. Fred also suffered from diabetes, which resulted in the amputation of his right foot later that year. Some friends closed his shop for him, and he stayed with his friends Bob and Jean Babcock several times after his releases from the hospital to hospice. The Babcocks went to Fred's shop, at his request, to sell his equipment, reportedly to a Mr. Jones Benally (Strong, 2012, CD No. 2). Still, some unaccounted-for things remain a mystery. Fred's father's stump and anvil, which were in Fred's shop during his entire tenancy, remain missing. Although there was some initial confusion regarding the disposition of the shop, relatives in the Gorman family line inherited or were given things by Fred. Dee Morris received many of Fred's stamps, probably from his Gorman relatives. Those stamps are now in the Heard Museum in Phoenix, Arizona.

Postcard of Olvera Street. *Courtesy of Lake County, Illinois Discovery Museum. Curt and Teich Postcard Archives.*

Fred traveled briefly to his sister Rose Peshlakai Johnson's home in Sitka, Alaska, for care but was unable to bear the dampness and returned to stay with the Babcocks in Los Angeles. Leaving there, he moved in September 1973 to stay with his daughter, Dorothy Rose Peshlakai/Tso/Yazzie who lived in Many Farms, Arizona, just north of Chinle. She had worked for the Chinle School system for many years. It was Dorothy who cared for her father the last year of his life.

Fred Peshlakai passed away on Sunday, December 22, 1974, at the Gallup Indian Medical Center hospital where he had been since late November. He was laid to rest at the Old Chinle Cemetery on

December 26 after a 1:00 p.m. service held at the Chinle Presbyterian Church. His life had come full circle, ending near the old Gorman trading post site where he had spent his summers as a child—a childhood in which dreams of horses and the old ways were shoved relentlessly forward into a modern world. In that world, Fred had wandered, seeking a voice that would be remembered by his ancestral Hozho. His chanted song had been of "Silver" left for us to follow.

Fred Peshlakai, ca. 1969. Olvera Street. Los Angeles, California.
Author's Collection.

Epilogue

IN MAY 2012, JOHN STRONG AND I MADE A JOURNEY to Chinle, Arizona, in search of the final resting place of Fred Peshlakai. The Old Chinle Cemetery lies about a mile northwest (as the crow flies) of Basha's grocery store on Highway 191, which is just north of the Chinle town turnoff. The car trail wanders off in that general direction, but is best found by circling around to the back of the Chinle Comprehensive Healthcare Facility and then taking the only existing dirt track briefly north, and then east, to circle back down to the cemetery's location. We stopped and asked directions from a young Diné couple who were flirting furiously with each other out behind the hospital's main building. She pointed to our right over the barren hill, and he pointed to our left, which followed a meandering dirt trail. Not surprisingly, both of them turned out to be correct in their smiling and shy assistance.

The Old Cemetery is situated on a site perhaps 300 yards due east of the hospital and well away from any other landmark. Pulling off the hard-packed dirt approach, we parked outside the chain link fence encircling what appeared to be a 50 by 100 yard raised escarpment.

I was immediately struck by its solitude. The hills around Chinle have little vegetation and there was none here at all, the land swept as it was by the relentless Chuskas winds. The place felt abandoned to me, like some forgotten, lover's dream. Brightly colored remnants of artificial flowers were strewn all around and were blown in heaps against the bitter fence. The main walk from the gate was lined with the oldest resting sites but most had no stone markers of any kind. Crucifixes tilted, while broken vases spilled empty dust in a sad lament. A grieving touch seemed to move back and forth across the sand. As the ground rose and fell in sharp undulations of several feet, it created little barren valleys that hid and harbored countless broken, porcelain saints, some of which lay face down and seemed to speak aloud their long grief of endless days. Thin galvanized rods held aloft their thin and wildly tilted galvanized name plaques with plastic faces. Most of these faces were faded blank by the relentless sun and sprawled in disheveled harmony with all the other lost offerings. The sun burned brightly and beat down on our bent and searching heads. Undeterred, it warmed the indifferent earth, despite what had befallen the Dinétah. There was a sense that the sun would always burn there, and all of these other inhabitants would simply, and eventually, just blow away, leaving the sacred land like it was so long ago.

Well over two hours of searching left us unable to find Fred's final resting place. I wanted to find him and somehow honor him there, to offer words about his amazing life and the beauty he'd left behind for the world to emulate and for all humans to feel validated by as a species. But in that moment, I knew it was not meant to be.

I felt that Fred would have laughed at all this fuss. He would have simply turned away from all this attention like he always had. And wearing his habitually amused look, returned lovingly to the beshthlagai that called to him from his workbench.

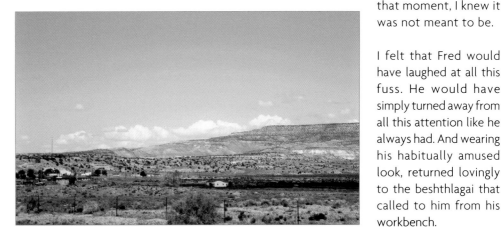

The mountains several miles west of Chinle, Arizona. May, 2012.
Photograph by the author.

A Legacy of Art

PART II

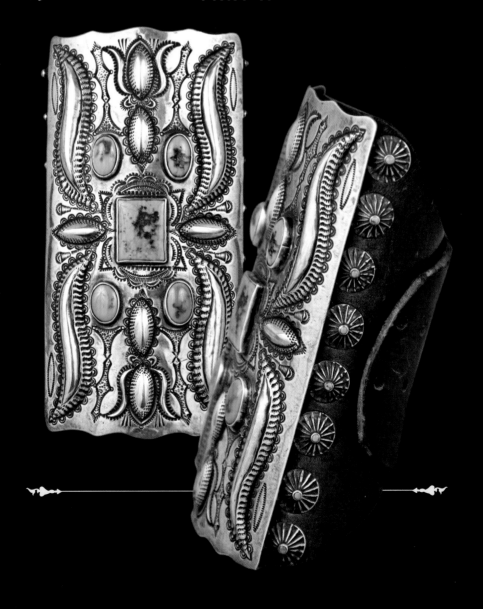

THE ART OF FRED PESHLAKAI

FRED PESHLAKAI WAS A TRUE ARTIST. DESCRIBED broadly within the human experience an artist is a "person who expresses themselves through a medium." Fred typified that appellation with a profound mastery that placed him among the upper echelon of his remarkable peerage.

People everywhere uplift and venerate the artists among us. And it is into this veneration that the silver artwork of Fred Peshlakai is placed by those familiar with his life's work. His creations typically exude something that transcends the tangible. There is a mystique of spirit that advocates of Fred's art appreciate. His art appears to leap out visually at the observer, especially if it is placed near other works, and we somehow seem to automatically and intuitively relate to Fred's artistic message. Through his life and art, we come into closer contact with that better part of ourselves and who we all are as human beings. Fred's artistic creations individually can stand alone. However, in order to fully appreciate why Fred Peshlakai's art has this capacity, it is helpful to first realize all the things that Fred's art is not, and in doing so, glimpse the indomitable character that dictated the life of this brilliant artist.

There was a machine age revolution occurring in modern cultures around the planet in the early twentieth century. Industrialization was burgeoning and intense attention was being showered on new possibilities for people and the ways a myriad of objects could be produced. The time-honored labors of handcrafted objects suffered a subsequent decline due to more price-driven options for things of modern manufacture.

The American Southwest was not immune to these changes. There were forces at play that were keenly interested in bringing that region of the United States to the attention of the rest of this world. Companies such as The Fred Harvey Company grew suddenly to meet the needs of passengers on the new railway systems that crisscrossed these hitherto remote regions. Part of their marketing strategy was to romanticize the potential excursions of east-coast clients by enticing them to the area as part of an exotic adventure quite outside the normal possibilities of the regular traveler. This new interest generated an additional demand for keepsakes and mementos for travelers to acquire in remembrance of these adventures.

Part of this demand was for silver jewelry made by the Navajo. A whole industry arose to supply the demand for these pieces, which needed to be cliché as well as inexpensive for many of these new consumers. This would come to be known as "The Fred Harvey Era" of the American Southwest by many categorizing the history of the region. Quite unfairly, many casual observers tend to lump much of the kitsch produced during this period under the name of Fred Harvey. Although the Fred Harvey Company did offer some of these things in their establishments, they were not the sole perpetrators for the production of these items. They also had a large and varied offering of very high-quality indigenous art in their venues and were instrumental in elevating Native American art and artisans to a realm of high appreciation. Their Museum Collection was donated to the Heard Museum in Phoenix, Arizona, and it is well worth the visit to this institution in order to fully appreciate the intentions of the Fred Harvey Company and its veneration of the American Southwest.

It is, however, important to acknowledge the impact of the endeavors of these companies on the mind of a craftsman like Fred Peshlakai. This impact was exacerbated by Fred's first off-reservation job, which was at Maisel's in Albuquerque, New Mexico, in the 1920s. This establishment boasted a mechanized production shop as well as an in-house handcrafted jewelry department. Maisel's shop owners were forced into great effort to differentiate between these two types of products and even went so far as to offer a standardized catalog of design offerings. Also Maisel's, unlike other shops that scandalized the authorities by hiring non-native workmen, did hire Diné craftsmen and did produce a higher than average offering. Still, it was into this standardization of the art form that Fred found himself confronted when he first renewed his artistic endeavors at the end of the 1920s.

Fred Peshlakai was acutely aware that less costly, machine-made jewelry was randomly being represented as authentic Navajo pieces by many businesses less

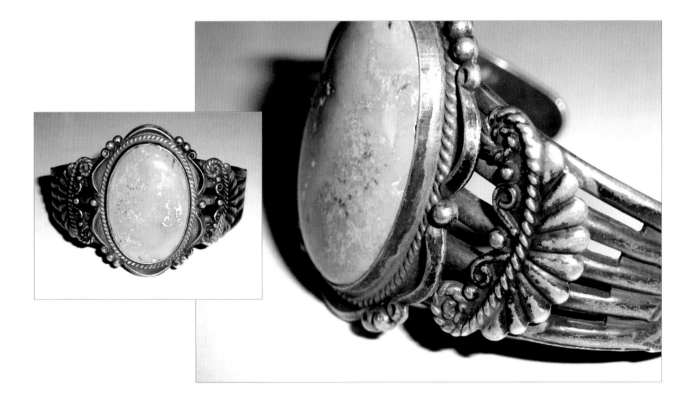

monitored than Maisel's. This hugely impacted the traditional artisans who were producing at the time. It was impossible for them to compete in the face of these abundantly available alternatives. Also, abject poverty prevailed across the Dinétah after World War I, and relatively few consumers were well off enough to solicit and support traditional crafts people.

The bracelet shown above clearly represents the machine-made jewelry that Fred Peshlakai's art was not. This piece, circa 1925, is attractive at first glance and has been laboriously pre-designed. However, upon very close examination, accompanied by a comparative study of handcrafted jewelry, it can be determined that it has been almost entirely machine-made. Although all of the bracelet's elements are designed to mimic a handcrafted bracelet, the curvilinear elements around the stone, the bracelet band, and the applied complicated single pieces at the bracelet's shoulder are all created hydraulically or in a mold and then assembled together with solder.

This degeneration of handcrafted artistry typifies the standards that Fred Peshlakai chose to be at odds with while striving to find his own way. In defiance of preconceived stereotypes, Fred Peshlakai maintained his cultural integrity

while breaking the bonds of conformity to produce what now is recognized as world-class art. The standards he developed for himself are emulated to this day.

Fred Peshlakai's work clearly communicates his intuitive sense for beautiful design combined with a profound mastery of the technical dexterities required to handle silver. In the late 1920s ,when Fred first began to produce his own art, he immediately observed strict fidelity to many of the older techniques and methods he had observed in his father's shop when he was young. The only real exceptions were the convenient addition of mechanized grinders and buffers and acetylene torches used for heating the silver and his solder work. All of Fred's design elements were hand-cut into the shapes and forms he desired using small jewelers saws and then grinding away the larger burs. The individual elements were then filed and buffed to the smoothness desired.

STERLING SILVER AND BLUE STONE BRACELET, ca. 1925. Although this type of jewelry mimics aspects of traditional Diné silver, examination of the product reveals it has machine-manufactured origins. Hydraulic presses and molds produced the individual elements for this piece, which were then assembled and soldered by hand. *Author's collection.*

In order to create relief designs on the face of the silver, Fred took annealed iron bars and iron rasps that were first ground into the overall shape desired. These were then embellished with small grooves, individually rendered using tiny jewelers files, onto the flat surface of the shaped bar-end. Often the diminutive detail, accomplished by Fred in the creation of his individual stamps, defies comprehension. Contemporary artists consulted for this study remain uncertain how Fred Peshlakai could have obtained such finely rendered stamps using the technology he had available during his lifetime. They note that fantastically tiny files or engravers must have been used to create these stamps, which possessed miniscule separations within the individual teeth of the iron die (Strong 2012, CD No. 2; Art Tafoya, pers. comm.). The tiny separations would also have rendered the stamps' ridges quite fragile against the strike force required to hand-impress them onto the face of the silver. They would have had to be constantly reproduced if Fred wanted to reuse them with any frequency. This necessity for constant production of individual dies accounts for the phenomenal variation in stamps used over the lifetime of Fred Peshlakai.

Repoussé is another technique for embellishing silver often associated with the work of Fred Peshlakai. This involves the use of a matched pair of male and female iron dies, wherein the silver being worked is placed between the two elements and domed out convexly to form various shapes. The many shapes produced include half spherical very small domes called 'raindrops' and elliptical lozenges of various shapes. Curvilinear or twisted wire elements were created by first hand-pulling the heated silver through a measured perforation in an iron or steel plate selected to produce varying thickness of wire. Carinated wire, or heavy wire with a triangular keel shape, was made by pounding the wire into a groove on his anvil. Elements applied secondarily to the surface of the main piece were hand-cut to shape, then repoussé-domed or stamped with a decoration before being individually layered onto the piece being created.

The technical prowess required to accomplish the complicated and beautiful designs of Fred Peshlakai illustrates why his exemplary abilities are so highly revered, both by the artisans still attempting to emulate his skill and the many, many admirers who treasure his contributions to the world of Navajo silver art.

Top: **Sixteen stamps created by Fred Peshlakai, ca. 1960. Iron bars, which were originally iron punches and rasp-file ends, were repurposed to create these stamp-work dies. Purchased by John Strong from Fred Peshlakai.** *Author's collection.*

Middle: **Iron dies made by Fred Peshlakai. Heard Museum Collection, Gift of Dee Morris, 4625-10.** *Courtesy: The Heard Museum. Photographs by Craig Smith.*

Bottom: **Detail from bell, page 137. Fred Peshlakai. The individual grooves cut into the die used to impress the rayed burst design at the apex of the triangular element are only 1/32nd of an inch apart.** *Courtesy the Gloria Dollar collection.*

Fred Peshlakai is also well known for the distinctive methods he used for signing his silver art. These signatures are referred to as a "hallmark," which describes the use of a descriptive mark, cipher, or set of ciphers impressed into metals in order to grant it a distinguishing characteristic. Hallmarks have been used on silver dating back to the fourth century AD by Byzantine authorities to help regulate purity and value standards for the metal. These ciphers eventually evolved to include source and craft guild information in Europe by the early Middle Ages.

In the late nineteenth and early twentieth centuries, Anglo traders moved into Navajo territory and became interested in promoting the indigenous art-forms and products they encountered there. As the early twentieth century progressed, these traders, and others who were becoming more familiar with these items, began to encourage artisans to take an interest in personally differentiating their individual creations. For Navajo silver art, versions of the Anglo hallmarking system would evolve into becoming the expected system for that differentiation.

It is believed that Fred Peshlakai was one of the first, if not the first, Navajo artist to hallmark his work. Certainly his early use of a hallmark places him at the forefront of this process among Native American silversmiths. Fred's first self-owned shop was in Gallup, New Mexico, around 1930 and, as an artist who was new to the market, he likely would have agreed with this interest in differentiating his work from the work of others. Fred's use of a hallmark in the 1930s was commented on by Sam Vaughn, of Vaughn's Indian Store in Phoenix: "I think it was his own idea. He was very proud of every item he ever made" (Pardue 2005). A reiteration of the 1950 Bethers article includes the remark that: "Because his father did not sign his work so that it could always be distinguished from the work of his apprentices Fred has all his articles stamped with the capital letters 'FP' with an arrow running through the initials from the P through the F" (Bethers 1950). Fred's early use of a hallmark is further documented in *Bulletin* #14 issued by the Museum of Northern Arizona in 1938. In this manuscript it states:

A modern Navajo who stamps his ware FP superimposed upon an arrow is Fred Peshlakai, who in February of 1937 was working in an Indian curio store in Hollywood Boulevard, Los Angeles. Peshlakai said he was the son of Ansosi

Peshlakai. Fred began stamping his wares thus about 1934 or 1935. He was vague as to the exact date he began. Prior to that time he stamped his wares with a small hogan as a trademark. (Woodward 1938, 56)

Fred Peshlakai's identifying hallmark did not remain static, and the different versions have been a topic of conversation for a very long time. Different versions of signatures used by an individual artist are not uncommon, and Fred was not an exception. The small "hogan" mark mentioned by Woodward as Fred's early hallmark was a pictographic symbol representing a traditional Navajo dwelling. This mark is mentioned again by Fred's descendants as: "His first trade mark was a hogan, later used by a former student of his at Fort Wingate BIA boarding school where he taught for a time (*Navaho Times*, 1975). The student was the now famed Kenneth Begay, who worked for the White Hogan in Scottsdale to whom Fred sold the hallmark." Additionally it is reported that: "Peshlakai's earliest hallmark was a stamped arrow. Later hallmarks used his initials, at times combined with an arrow, or his initial and his last name" (Pardue 2005).

These remarks exemplify the relative abundance of signatures Fred Peshlakai used on his silver art over the span of his 40-plus year career. Certain variants of these signatures, which were rendered with a stamp-work die, are distinctive. However, the signatures incorporating only Fred's initials or his first initial and last name became quite naturally slightly modified since they were rendered by hand using a single-stroke engraver, sometimes in combination with 'U'-shaped arcs. Different versions of different letters within the signature appear within his catalogue. Dated examples, accompanied by Fred's engraved signature, are also known to exist. However, since the pieces examined for this study did not have any accompanying provenance, it remains unclear if these dates represent their date of manufacture or were intended as dates commemorating some event in the lives of Fred's patrons. Interestingly, the few examples that include engraved dates also predominantly bear the longest version of Fred Peshlakai's signature. This may eventually be helpful, but at the moment no broad conclusion can be definitively made. These hand-engraved variations have prompted modern scholars to call for a certain amount of caution when it comes to vetting absolute authenticity on a piece of silver art bearing hand-engraved ciphers. Fortunately, Fred Peshlakai's dominant artistic style is very

distinctive and not easily reproduced. Additionally, his exceptional technical prowess further clarifies his work. As such it remains exceedingly difficult to fraudulently reproduce most of Fred's designs. Still, overly casual conclusions regarding the authenticity of a piece of Fred's artwork, based solely on an engraver-rendered signature without the accompaniment of stylistic and technical indicators, remain largely discouraged.

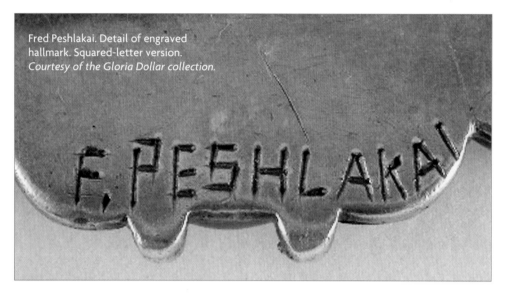

Fred Peshlakai. Detail of engraved hallmark. Squared-letter version. *Courtesy of the Gloria Dollar collection.*

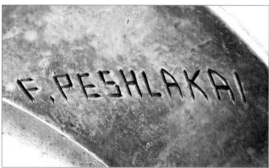

DETAIL OF ENGRAVED HALLMARK. Fred Peshlakai. Squared- letter version. *Courtesy of the Gloria Dollar collection.*

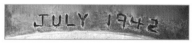

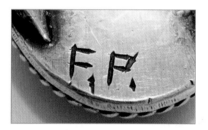

DETAIL OF ENGRAVED HALLMARK. Fred Peshlakai. Squared-letter version with accompanying date. *Courtesy of the Gloria Dollar collection.*

DETAIL OF ENGRAVED HALLMARK. Fred Peshlakai. Rounded-letter version. *Courtesy of the Karen Sires collection.*

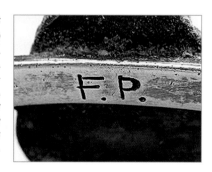

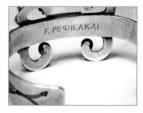

Fred or Frank Peshlakai. Detail of engraved hallmark. Rounded-letter version. *Courtesy of the Martin and Lisa Monti Collection.*

PESHLAKAIS' HAND-ENGRAVED HALLMARKS

The engraved signatures represented here reiterate the distinct variables present in the way the arcs in the some of the individual letters are rendered. Examples examined for this study, which are vetted as the work of Fred Peshlakai by the majority of scholars, predominantly all bear the "square letter" version of Fred's first initial and full last name signature variant. It is of further interest to note that the individual pieces that have also been cross-referenced to matching die-stamps on the silverwork of Frank Peshlakai, which also bear a similar signature, or retain provenance, all seem to exhibit the 'rounded" version of these arcs. However, some pieces that scholars feel may be the work of Frank Peshlakai bear a squared rendering of these same arcs. It is equally important to note that pieces that are irrefutably the work of Fred Peshlakai that bear the hallmark of "F.P." also exhibit both square and rounded arcs in the "P." within that version of Fred's hallmark. This dichotomy points to the possibility of "rounded" arcs in Fred's longer version signature as well, despite the fact that they are, based on the individual pieces examined for this study, apparently fewer in number. A fascinating example of this dichotomy, which has been largely agreed upon by scholars as being the work of Fred Peshlakai, is depicted on page 132. Since the entire catalogue of the silver art of Fred Peshlakai is only beginning to be assembled, further research is clearly needed in order to distinguish which brother was the artist on certain pieces. However, since direct provenance is predominantly lacking, it may not be possible to do so beyond the application of unique design and stylistic distinctions that will undoubtedly become increasingly clear as additional comparative analysis becomes more readily available.

As stated previously, Fred's younger brother, Frank, was also a talented silversmith. Frank, however, did not always make his living as a silversmith and, as such, Frank did not produce silver objects at anywhere near the overall volume of his brother Fred. Frank did produce many fine objects of Navajo silver during his lifetime but well-documented examples of Frank's work are exceedingly rare. Since the brothers shared the same first and last initials, some confusion exists on certain select pieces between the works of the two brothers. Frank Peshlakai also signed his work "F. Peshlakai" with a single stroke engraver, possibly accompanied by a 'U'-shaped die. Additional examples show Frank's signature as his entire name spelled out in block letters. It is also reported that there are examples of finger rings made by Frank that bear the makers mark of his initials only (Strong, pers. comm.). Based on the examples that have been currently examined, it appears that the individual stamps use by Frank Peshlakai on pieces of his silver jewelry tend toward those that were more simply manufactured and, as such, are more linear.

The 1932 article in the *Union Pacific Magazine* states that Frank learned silversmithing from "one of his brothers," which clearly points to Fred Peshlakai since no other direct siblings were know to be silversmiths. The implication is that there was the potential for cross-over in the types of stamps used by the brothers during this very early time period. The individual dies in question are not necessarily among the obviously unique types that would have resulted in any ethical ownership of their particular designs and, as such, the potential attribution becomes increasingly unclear. It has been well argued that Fred's intrinsic brilliance would have been clearly manifest at the onset of his career and been discernible in his individualized art

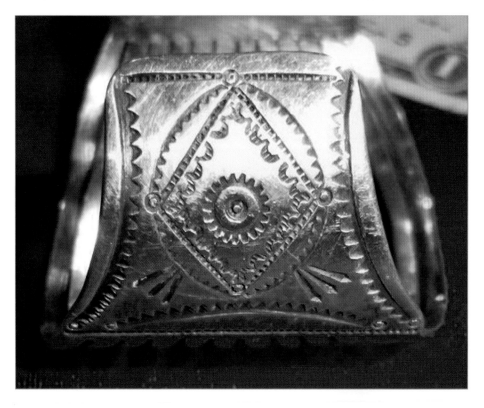

very early on (Strong, pers.comm.). Although this is very likely true, some of the examples of "F. Peshlakai" signed material remains potentially indistinguishable between the two brothers without the inclusion of the vastly superior design elements typically associated with Fred Peshlakai. It does appear that there are some basic differences between some of the individual artworks that bear the F. Peshlakai signature. However, it can also be well argued that Fred Peshlakai's art, produced during the very early years of his life, may not all exhibit the traits associated with what could be considered his mature artistic voice. It is a rarity that an artist immediately universally produces works in the masterpiece category. All artists typically exhibit a natural artistic evolution in their productive output. No documentation is currently known that comments on the stylistic archetypes for the earliest works of Fred Peshlakai, and it remains entirely possible that some similarities could exist in the type of dies used along with some similarities in the individual layout presentations of the two brothers on certain pieces.

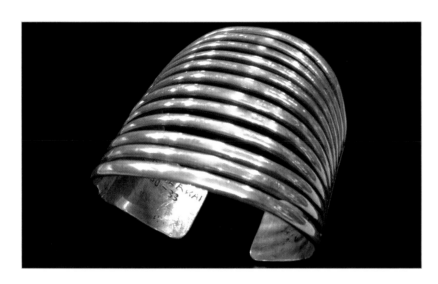

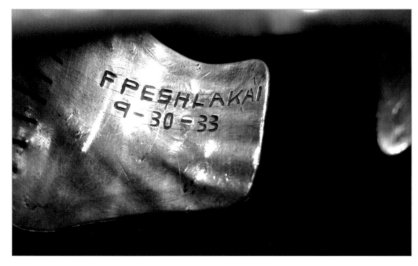

BRACELET. Sterling. Size 7. Maximum face height: 3". Signed: F. Peshlakai. Dated: September 30, 1933. Fred or Frank Peshlakai. The inscribed date places this fine example well ahead of the midcentury modern styles typically associated with this type of design. Also, the stamped designs on the bracelet's sides resemble an older type style of handmade silver dies used earlier in the twentieth century and argue for the inscribed date's accuracy. However it should be noted that the date may be misleading as it could represent a commemoration rather than its date of manufacture. The solid plate of silver was hand-split into twelve separate bands before each had its edges smoothed down. *Courtesy of a private collection.*

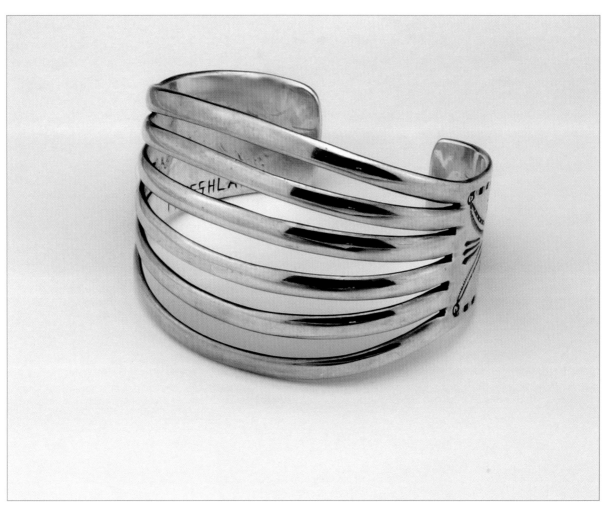

SPLIT BAND BRACELET. Sterling, ca.
1945. Signed: F. Peshlakai. Fred or
Frank Peshlakai. *Courtesy of the Gloria
Dollar collection.*

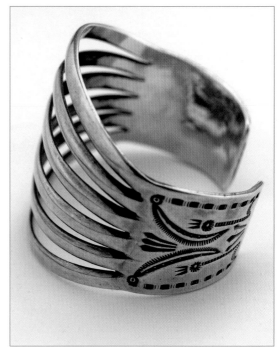

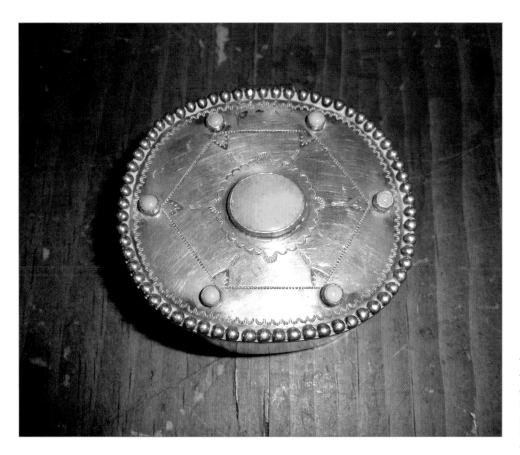

TRINKET BOX. Blue Gem turquoise and sterling, ca.1935. Maximum measurements: 2.5" x 1.75" x 1.25". Signed: F. Peshlakai. Fred or Frank Peshlakai. *Courtesy: Cowboys and Indians Antiques, Albuquerque, New Mexico.*

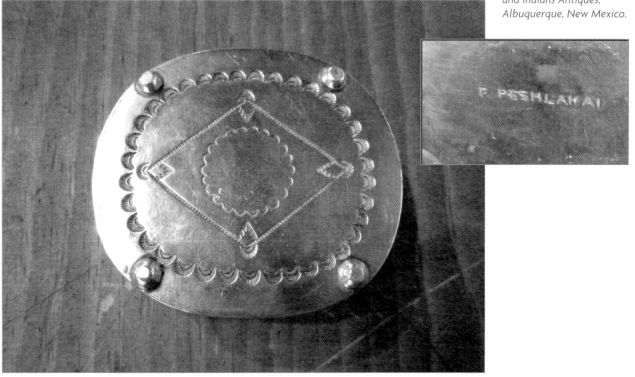

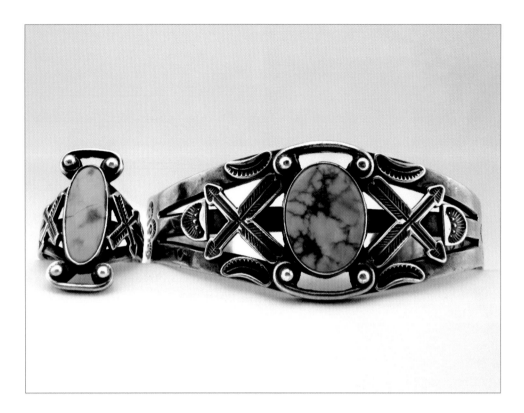

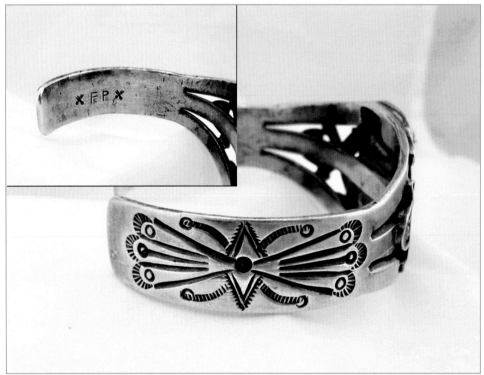

BRACELET AND RING SET. Blue Gem turquoise and coin silver, ca. 1935. Bracelet size: 6.5. Maximum height: 1.12". Ring size: 7. Maximum height: 1.12". Signed: F.P. with two sets of crossed arrows. Fred or Frank Peshlakai. This beautiful bracelet set exemplifies the greater need for further comparative analysis between the works of the two Peshlakai brothers in the quest to fully differentiate their artistic creations. Although the bracelet bears the initials-only signature that is more typically associated with Fred, the presence of the unique arrow stamp that flanks the signature is also present on the trinket box examined on the previous page. *Courtesy of the Gloria Dollar collection.*

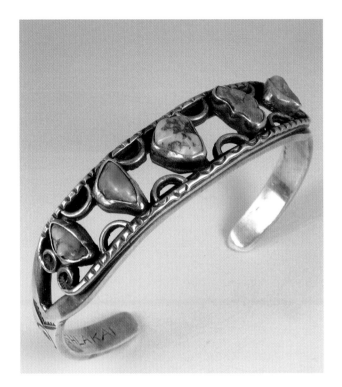

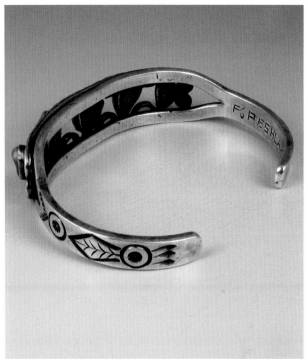

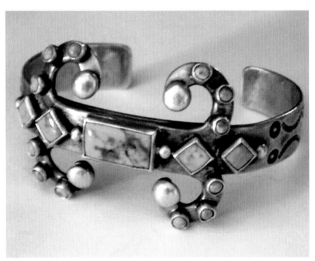

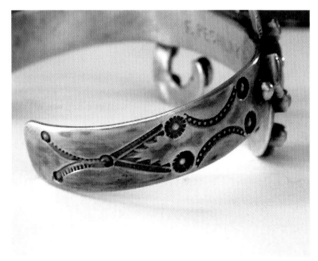

Top row: FREEFORM NUGGET BRACELET. Blue Gem turquoise and sterling. Size: 6.5. Maximum height: 3/4". Signed: F. Peshlakai. Fred or Frank Peshlakai. *Courtesy of the Laura Anderson collection.*

Bottom row: BRACELET. Blue Gem turquoise and sterling, ca.1940. Size:7. Maximum height: 2". Signed: F. Peshlakai. Fred or Frank Peshlakai. Some of the individual dies used on the side-bands of this striking example are also found on the documented examples made by Frank Peshlakai from the Cope collection. The highly unusual design of the bracelet's face speaks to ingenuities not yet typically associated with Frank Peshlakai but which he likely deserves. This particular piece exemplifies the need for further comparative study regarding the artworks of the two brothers signed as "F. Peshlakai." *Courtesy of the private collection of Martin and Lisa Monti.*

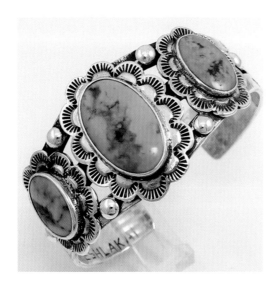

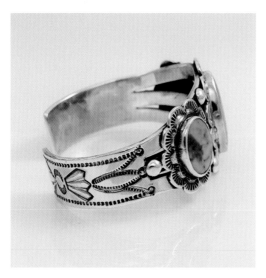

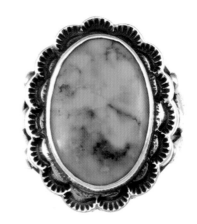

BRACELET AND RING SET. Blue Gem turquoise
and sterling, ca. 1938. Bracelet: size 6.25. Maximum
height: 1.4". Ring: size 4.5. Signed: F. Peshlakai
on the bracelet only. Frank or Fred Peshlakai.
Straightforward stamp work with large raindrops
enhances the lighthearted presentation of this fine
set. *Courtesy of Waddell Trading Company.*

Fred Peshlakai's stamped hallmarks that were rendered using a stamp-working die also exhibit a variety of renditions. Despite historical remarks stating that Fred used a single pictographic hogan and a single pictographic arrow as his earliest hallmarks, no examples definitively attributed to the hand of Fred Peshlakai were reliably found during this study. This does not mean that these works do not exist, but infers only that pieces that may bear those particular marks are either not distinguishable by any other definitive characteristics as being the art of Fred Peshlakai exclusively or could be considered scarce. The evolved form of the pictographic arrow superimposed with Fred's capitalized initials is, however, more readily associable, despite the fact that it was never completely standardized.

The most confusing variations within this later hallmark have revolved around which direction the head of the arrow pointed in its associated horizontal relationship with Fred's initials. Variations in the direction the head of the horizontal arrow points do exist. However, on the pieces examined for this study, the version with the FP superimposed over a left-facing arrow, i.e. with the arrow pointing from the P through the F, are overwhelmingly dominant. Hallmarked examples bearing a right-facing arrow are exceptionally rare, and only one such example has been found and included in this study. Other variations are relatively limited to changes

to the overall length of the arrow, many of which contain longer versions of the feather fletching. Some of these arrow variants appear to have a gap in their running length wherein the initials clearly float. Other examples show the arrow shaft running relatively uninterrupted through the initials. It can be hypothesized that the initials and the arrow were separately applied elements of the final cipher based on their variations, however that has not been fully substantiated. The only verified type is the hallmark used during the decade of the 1960s, which was rendered using a single amalgamated stamp (Strong, pers. comm.).

Research has found few chronological associations for the different hallmarks on pieces of Fred Peshlakai's silver art. Again, the only known exceptions are the forty pieces from Strong collection, which were purchased directly from Fred Peshlakai and were systematically assembled between 1960 and 1973. These examples have documented provenance combined with the exclusive use of a distinctive version of Fred's hallmark. This particular hallmark exhibits the shortest arrow length variant of any of the examples examined for this study and, therefore, it can safely be concluded that this particular hallmark was likely used on all signed pieces manufactured during this period. However, how long this particular cipher had been in use prior to 1960 has not been definitively substantiated.

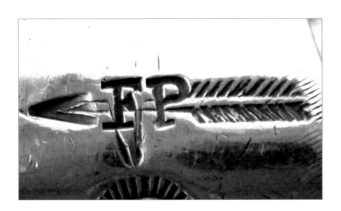
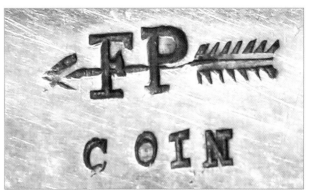

Left: Detail of die stamped FP superimposed over a long arrow. Fred Peshlakai. *Courtesy of the Karen Sires collection.*

Right: Detail of die stamped FP superimposed over a long arrow. Fred Peshlakai. *Author's collection.*

Stylistic changes in overall design may eventually prove some chronology to these hallmarks, but until the entire Peshlakai catalogue has been assembled, those associations are not yet possible. Further, Fred's personal inclinations for using the type of signature he used on his different creations was not clearly recorded during his lifetime. Bearing that in mind, any specific dates of manufacture that appear in the following chapters should be considered suggestive and only included as introductory, educated overtures toward any future chronological study regarding the use of Fred's particular hallmarking system.

It is known that Fred did not sign all of his pieces and is reported that "in his later years was known to sign only about twenty percent of his work" (Pardue 2005). Those who knew Fred have related that he was more interested in the creation of his art than in featuring his signature. They also remark that the low percentage of signed pieces was also likely prevalent well before the final decade of his life (Strong, pers. comm.). This inclination can be borne out by the fact that the inclusion of a die impressed hallmark had to be planned as an integral part of the finished artwork well in advance. It is very difficult to place a stamped hallmark on a completed interior surface and can even damage the finished face surface if rendered by a hammer strike after completion (Art Tafoya, pers. comm.). The presence of the single stroke engraver variants of Fred's signature were likely occasionally the solution to this situation since they are more easily rendered after the piece's completion.

It should be reiterated that all of the documented works by Fred Peshlakai's brother Frank Peshlakai are also engraved or stamped "F. Peshlakai" or "Frank Peshlakai." These signature marks are currently the only known verified versions of Frank's signature. There are currently no known documented examples made by Frank Peshlakai that bear any kind of die struck hallmark that includes a right- or left-facing arrow. All of the particular marks rendered as FP superimposed over an arrow, in all their documented variations, are all exclusively associated with the work of Fred Peshlakai.

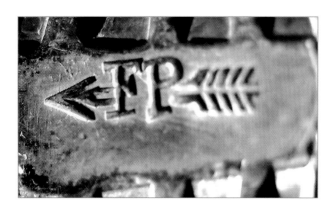

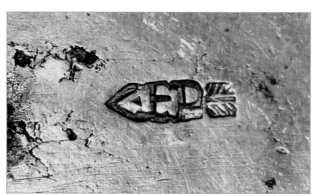

Left: Detail of die stamped FP superimposed over a long arrow. Fred Peshlakai. *Courtesy of a private collection.*

Right: Detail of die stamped FP superimposed over a short arrow. Fred Peshlakai.. John Strong custom order #19. *Courtesy of a private collection.*

Shines the light of invention,
Compelled to fill the empty dark.
And into the void comes
The mind of human brilliance
Where it finds its most sacred and
Beautiful voice.

— OLORIN ITHILIEN - 2009

WORKS OF ART SIGNED:
F. PESHLAKAI

THIS BRACELET, AT RIGHT, IS CURRENTLY THE ONLY KNOWN dated piece by Fred Peshlakai that can be associated with his earliest years on Olvera Street in Los Angeles, California. Some scholars have proposed that Fred Peshlakai's work became increasingly Mexicanized over the course of his long tenancy at Olvera Street, and this beautiful early example demonstrates why some may have supported that belief. However, when the larger body of Peshlakai's art is examined, it is revealed that Fred's art was never dominated by Mexican design influences. The front view of this particular piece does, indeed, suggest something Moorish in its lineage. Also, Diné silver stamps did find much of their origins in Spanish leather-work, and that design influence can occasionally be discerned. However, the designs on the bracelet's sides harken back to Eastern and Plains Native American motifs, and the applied stamped and repoussé butterfly elements on the upper shoulder of the piece remain intrinsically Diné. Despite the stereotypical associations of curvilinear elements with Baroque and other European design standards, their presence within the pallete of Fred Peshlakai should only be considered integral to the overall visual movement or particular statement that Fred wished to express with any particular piece. Any

interpretations that conclude standardization within Fred's creativity will ultimately be at odds with the sizable expanse of his artistic expression.

On this piece, all the design elements lead the eye upward to the spectacular stone that is framed by deeply stamped concave crescents and small stars. The repoussé raindrops flanking these stars and crescents join the butterflies and create an overall continuity of unbridled exuberance. This piece, which appears to have been made at the onset of World War II, remains forever dedicated to "Helen Hansen." Was it a parting remembrance from a soldier about to leave on his tour of duty? Currently the real story behind the piece remains unknown, but the dedication still evokes something eternally heartfelt and romantic.

Of further interest on this particular example are the downward facing flaming triangles below the butterflies and the stamped leaf pattern on the bracelet's sides. These motifs appear to soon be abandoned by the artist since they do not appear on any of the artwork that is associated with his later style of more complex stamp-work.

BRACELET WITH BUTTERFLIES. Nevada turquoise and sterling. 1942. Size: 7. Maximum height: 2.25". Signed: F. Peshlakai. Dated: 1942 and dedicated to Helen Hansen. *Courtesy of the Gloria Dollar collection.*

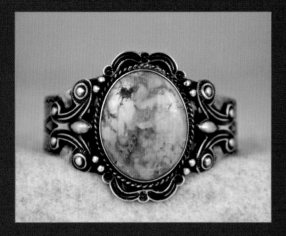
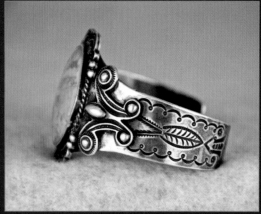
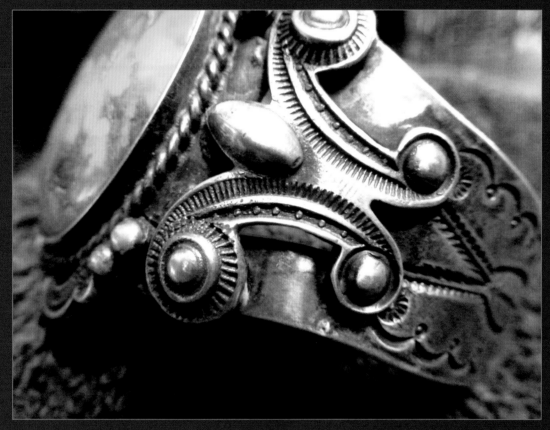
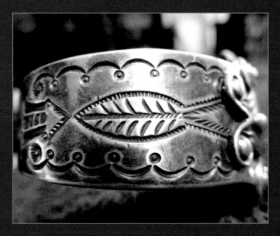
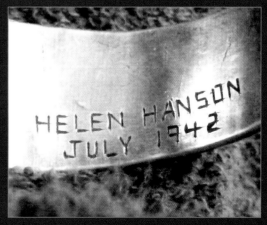

WORKS OF ART SIGNED:
F. PESHLAKAI

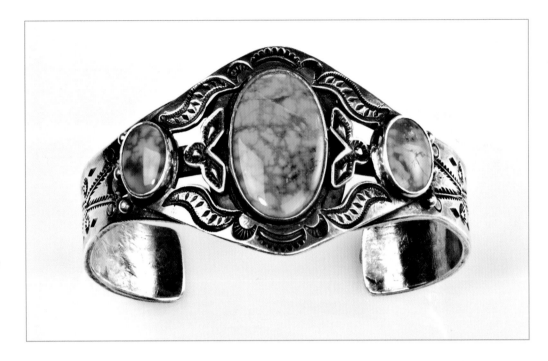

BRACELET. Blue Gem turquoise and sterling, ca. 1941. Size: 7. Maximum height: 2". Signed: F. Peshlakai. Applied elements flank the oval central stone that has been mounted on a pierced and shaped back plate stamped with arcs and Four Winds elliptical designs. *Courtesy of the Jeff and Carol Katz collection.*

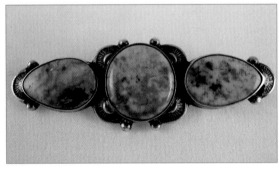

THREE-STONE PIN. Blue Gem turquoise and sterling, ca. 1938. Maximum measurements: 2.5" x .75". Signed: F. Peshlakai. *Courtesy of the Gloria Dollar collection.*

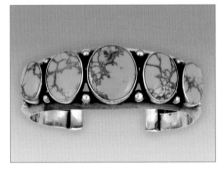

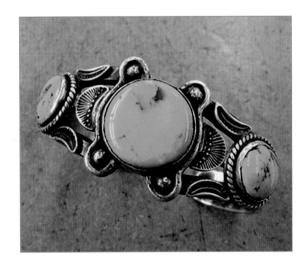

BRACELET WITH THREE ROUND STONES. Nevada turquoise and sterling, ca. 1940. Size: 7. Maximum height: 1.175". Worn signature: " *** KAI ." Fred appears to have increased his use of secondarily added silver elements during this period, as is clearly demonstrated in this fine example. *Courtesy of Perry Null.*

FIVE-STONE ROW BRACELET. Blue Gem turquoise and sterling, ca. 1941. Size: 6.5. Maximum height: 1.2". Signed: F. Peshlakai. This simple design, which Fred used many times during his career, enables an uncluttered appreciation for the beauty of the stones. Sometimes this type of bracelet was rendered with as many as nine stones, not always graduated in size, and was usually adorned with simple Raindrops. This type of bracelet is iconic within Fred's repertoire. On this example, Fred rotated the positioning of the otherwise matched stones to attain visual balance and keep the eyes focused on these amazing specimens of intensely blue American turquoise. *Courtesy of Waddell Trading. Scottsdale, Arizona.*

Fred rarely used serrated bezels to support the individual stones in his work unless he felt they would add an important element to the overall design. That added element is clearly demonstrated on these two fine examples.

The bezel's serrations, which were unnecessary for securing the stones, were hand-cut with a checkering file and draw immediate attention to the shape of the individual stones. The placement of irregular-shaped stones that still achieve perfect visual balance is an accomplishment readily associated with Fred Peshlakai's work.

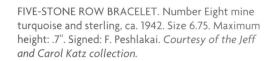

FIVE-STONE ROW BRACELET. Number Eight mine turquoise and sterling, ca. 1942. Size 6.75. Maximum height: .7". Signed: F. Peshlakai. *Courtesy of the Jeff and Carol Katz collection.*

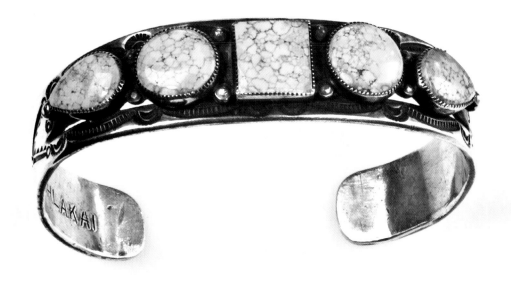

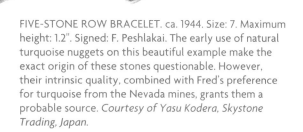

FIVE-STONE ROW BRACELET. ca. 1944. Size: 7. Maximum height: 1.2". Signed: F. Peshlakai. The early use of natural turquoise nuggets on this beautiful example make the exact origin of these stones questionable. However, their intrinsic quality, combined with Fred's preference for turquoise from the Nevada mines, grants them a probable source. *Courtesy of Yasu Kodera, Skystone Trading, Japan.*

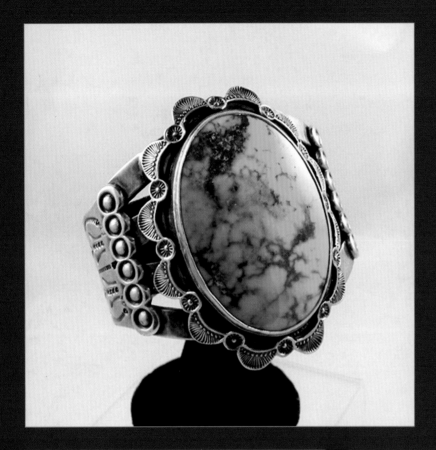

BRACELET AND RING MATCHED SET.
Blue Gem turquoise and sterling, ca.1945.
Bracelet: Size 7. Maximum height: 2.25".
Ring: Size 9. Signed: F. Peshlakai. This rare
and beautiful matched set shows the skill
Fred Peshlakai exhibited during his career
as a full-time silversmith. Individually
executed appliquéd elements surmount the
beautiful turquoise stones. The six simple,
round, indented and conjoined elements on
the bracelet's shoulder anchor and relieve
the iconography on the wristband. Twelve
rayed crescents, separated by 1/8-inch stars
surround the main stone. This embossed
collar, on both the ring and bracelet, tilt at
45 degrees from the flat plane of the main
stone's bezel plates and cantilevers off the
edges of these pieces appearing to push the
stones forward as if caught in motion. This
effect softens the design and adds elegance
while retaining a powerful presentation
and clearly demonstrating Fred Peshlakai's
consummate skill. *Courtesy of Turkey
Mountain Traders, Scottsdale, Arizona.*

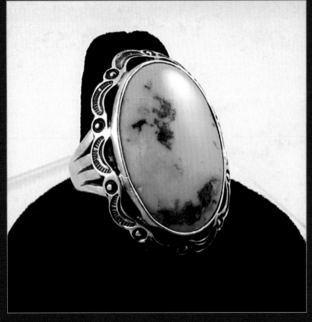

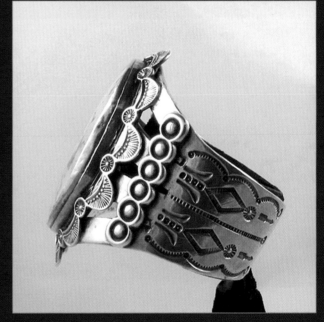

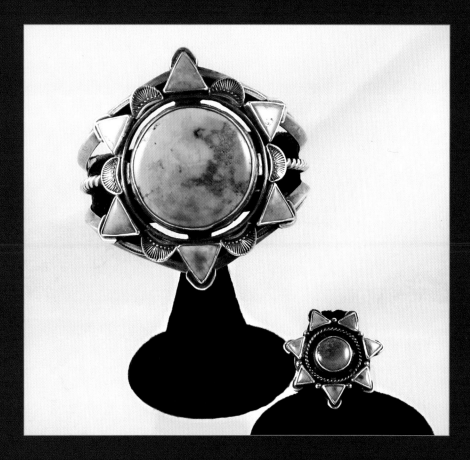

STAR BRACELET AND RING SET. Blue Gem turquoise and sterling, ca. 1948. Bracelet size: 7. Maximum height: 2.5". Signed: F. Peshlakai. The scope of Fred Peshlakai's fascinating design capabilities is clearly demonstrating in these stunningly unique examples. The open space surrounding the bracelet's center stone amplifies its size and echoes the bracelet's open band-work with its sparse and carefully placed stamp work. Every single element in the suite is sharply pertinent, yet serves to merge all of their differences into a cohesive single statement. *Courtesy of the collection of Quinn and Judith Holloman.*

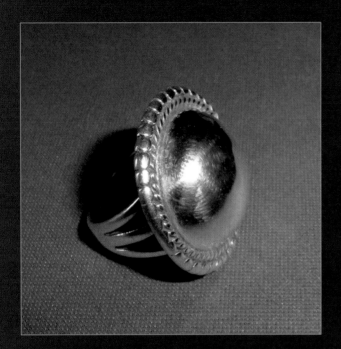
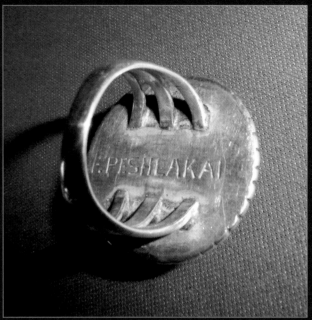

DOMED REPOUSSÉ RING. Sterling. Size: 6.5. Maximum height: 1". Signed: F. Peshlakai. Even the most standard of traditional Diné jewelry designs took on new dimensions under Peshlakai's hand. *Courtesy of the Gloria Dollar collection.*

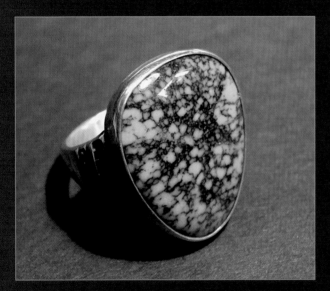
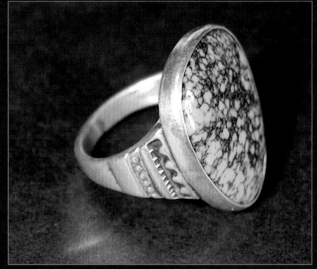

TEARDROP CABOCHON RING. Lone Mountain turquoise and sterling, ca. 1945. Size: 7.5. Maximum height: 1". Signed: F. Peshlakai. Fred Peshlakai let the beauty of this evocative stone speak for itself yet the quality of the silver work still serves to amplify this exceptional example. *Courtesy of Bob Brucia's Nevada Gem Collection.*

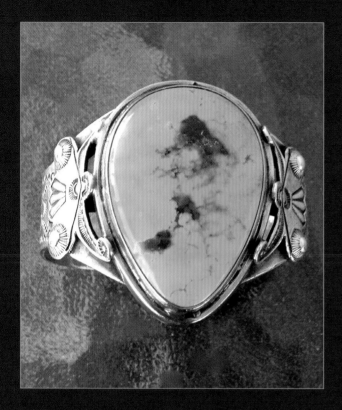
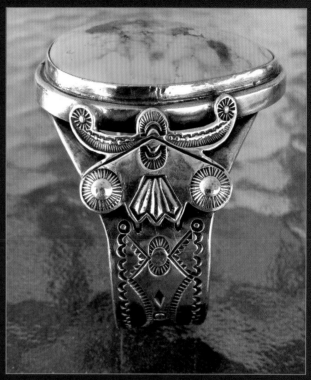

BRACELET WITH LARGE TEARDROP STONE. Gem chrysocolla and sterling, ca. 1942. Size 7. Maximum height: 2.25". Signed: F. Peshlakai. It is suggested that during World War II all Navajo artisans used alternative stones rather than turquoise due to the dearth of turquoise production during this time. The beauty of this stone, as well as Fred's inclusion of alternative stones in his art over the entire course of his career, implies their possible implicit selection rather than a forced necessity. The upward momentum of the lower applied plates on the shoulder of the bracelet join the stamped winged figures above. The large false bezel plate, which is stepped down from the tall bezel surrounding the central stone, dramatizes the stone's shape. Repoussé eagle tail designs and buttons on the bracelet's shoulder add carefully placed three dimensional aspects to the composition. *Courtesy of William and Therese Seydel.*

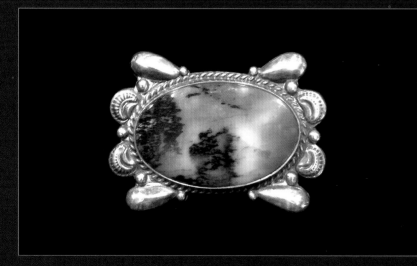

PIN WITH REPOUSSÉ. Petrified wood and sterling, ca. 1942. Maximum width: 2". Signed: F. Peshlakai. *Courtesy of a private collection.*

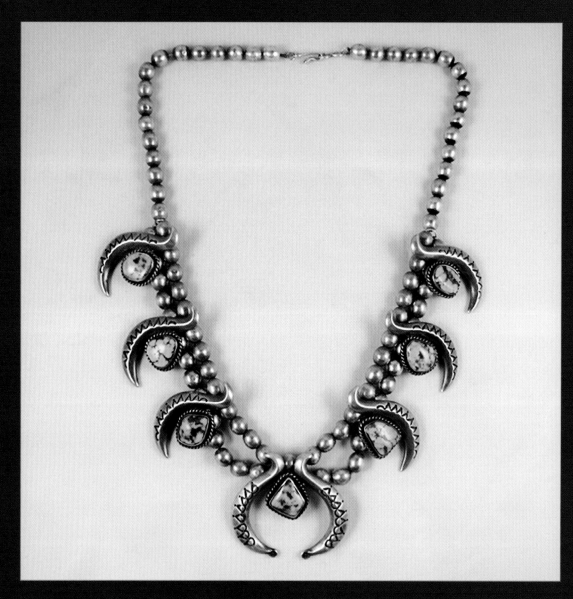

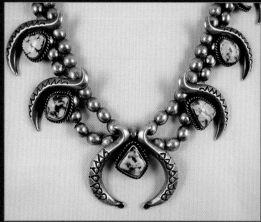

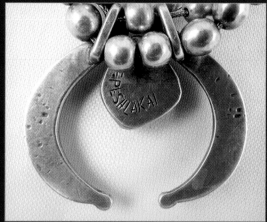

"FOUR WAYS" SQUASH BLOSSOM NECKLACE. Freeform turquoise and sterling, ca. 1947. Central element maximum width: 2". Signed: F. Peshlakai. The curved silver Tufa cast elliptical lozenges are Diné representations of the "Four Ways" or "Four Winds" that originate within Diné cosmology and were originally depicted on their ancient sand-paintings. Here, stamped zigzags on the upper elements, then turn to raindrops on the najahe and speak to water and the abundance of the natural world. *Courtesy the R.F. Koda collection.*

WORKS OF ART SIGNED: F.P.

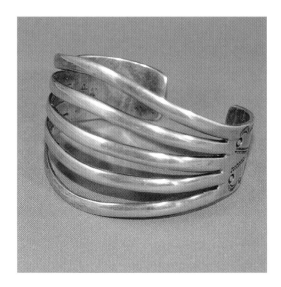 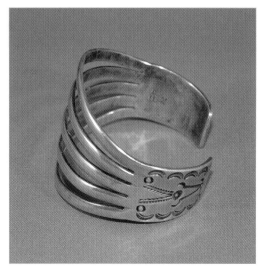

BRACELET. Sterling, ca. 1944. Size: 7. Maximum height: 2.75". Signed: F.P. and a sub-hallmark of two crossed arrows. The unusual presence of the sub-hallmark on this piece demonstrates an example of Fred's Peshlakai's occasional further modifications to his signature. *Courtesy of the Beverly Twitchell collection.*

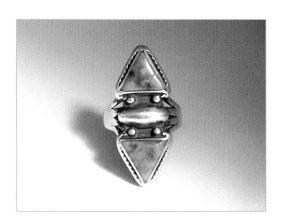

DOUBLE TRIANGLE RING. Blue Gem turquoise and sterling. ca. 1944. Size: 7. Signed: F.P. *Courtesy of the Martin and Lisa Monti collection.*

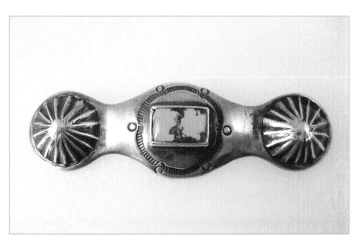

BAR PIN WITH REPOUSSÉ. Turquoise and sterling, ca. 1945. Maximum width: 2.5". Signed: F.P. Repoussé buttons flank an unusually cut rectangular stone. The circular stamp work combines to form a graceful arch that offsets the shape of the stone. Small circular arch separators lie outside the circle, creating further dimension. *Courtesy of the Gloria Dollar collection.*

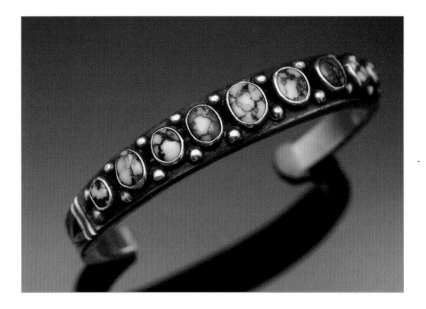

Referred to by many as "Row" bracelets, due to their side-by-side alignment of stones on a relatively narrow band, this is a category of cuff design that remained popular with Fred throughout his career. Meant to be worn singly or in multiples, the emphasis was always geared toward the presentation of the beautiful stones. The use of such high-grade turquoise stones, combined with meticulous silver-work, separates Fred Peshlakai's work from all other artists of the period.

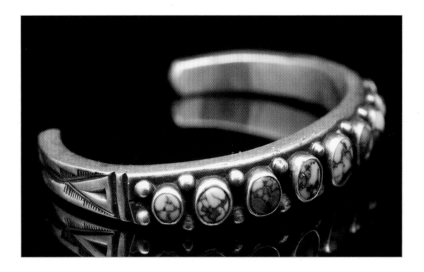

NINE STONE ROW BRACELET. Lone Mountain turquoise and sterling, ca. 1945. Size: 6.5. Maximum height: .5". Signed: F.P. *Courtesy of Jodi and Don Dionne.*

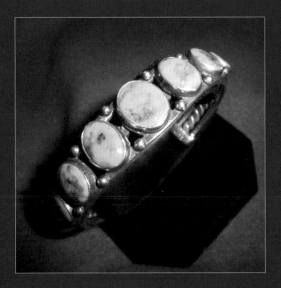

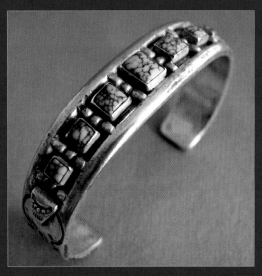

FIVE STONE ROW BRACELET. Blue Gem turquoise and sterling, ca. 1945.Size: 6.5. Maximum height: .65". Signed: F.P. *Courtesy of Linda Kennedy Baden.*

SEVEN STONE ROW BRACELET. Lone Mountain turquoise and sterling, ca. 1945. Size: 7. Maximum height: .65". Signed: F.P. *Courtesy of the Karen Sires collection.*

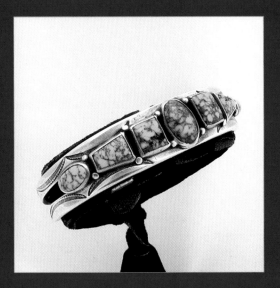

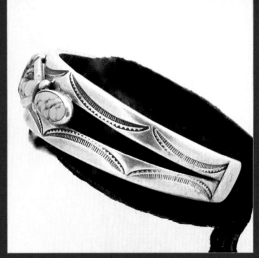

SEVEN STONE ROW BRACELET. Lone Mountain turquoise and sterling, ca. 1955. Size: 6.75. Maximum height: .75". Signed: F.P. *Courtesy of Turkey Mountain Traders.*

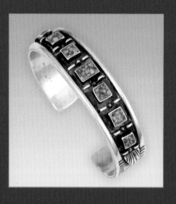

SEVEN STONE ROW BRACELET. Lone Mountain turquoise and sterling. ca. 1956. Size: 6.75. Maximum height: .65". Signed: F.P. *Courtesy of a private collection.*

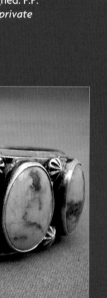

Above: SEVEN STONE ROW BRACELET. Lone Mountain turquoise and sterling, ca. 1956. Size: 6.75. Maximum height: .5". Signed: F.P. *Courtesy of a private collection.*

FIVE STONE ROW BRACELET. Blue Gem turquoise and sterling, ca. 1956. Maximum height: .75". Signed: F.P. *Courtesy of the Karen Sires collection.*

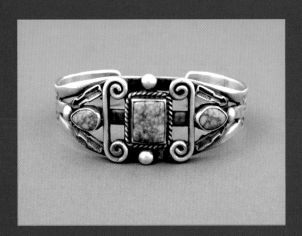

BRACELET. Lone Mountain turquoise and sterling, ca. 1949. Size: 6.75. Maximum height: 1.65". Signed: F.P. inside a horizontal cartouche. The appliquéd arrow figures were die stamped and then shaped prior to their application. The wires that flank the center stone are also of an unusual gauge, further demonstrating Fred Peshlakai's avoidance of repetition in almost all aspects of his art. *Courtesy of Martha Struever.*

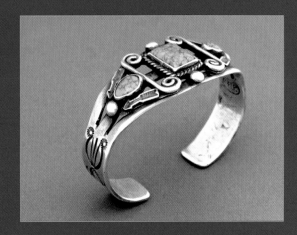

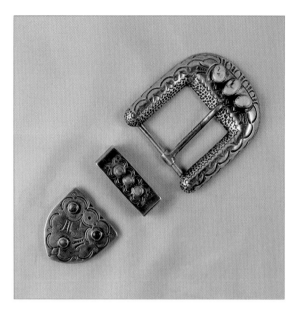
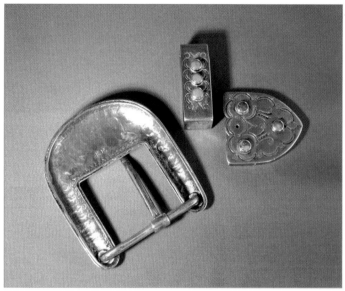

RANGER SET BELT BUCKLE. Nevada turquoise and sterling, ca. 1945. Maximum width of buckle: 2". Signed: F.P. *Courtesy of the Lisa Lehman collection.*

Based on the works catalogued for this study and their tentative dates, it appears that Fred Peshlakai's design style continued to grow even more distinctive during the decade of the 1940s. His ability to create complex combinations of many elements marks a possible decrease in the more linear stamp work that could separate his earlier work. However, Fred's humorously approached penchant for dichotomy of any stylistic chronological archetype within his art makes overly generalized conclusions problematic. It may take many years and a full overview of his catalogue before any such conclusions could possibly be substantiated. In the interim, enjoying his art within groups bearing similar hallmarks is an intriguing way to appreciate his artistic messages.

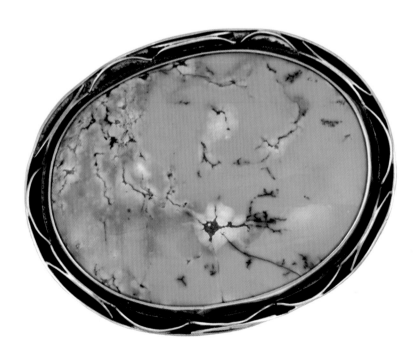

BROOCH WITH OVAL STONE. Dendrite turquoise and sterling, ca. 1948. Maximum width: 2". Signed: F.P. *Courtesy of Yasu Kodera, Skystone Trading, Japan.*

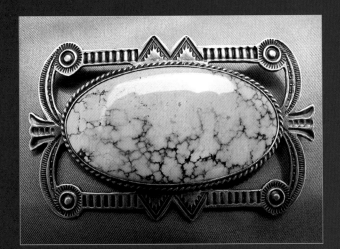

LARGE OPENWORK PIN. Nevada turquoise and sterling, ca. 1944. Maximum width: 3". Signed F.P. *Courtesy of the Karen Sires collection.*

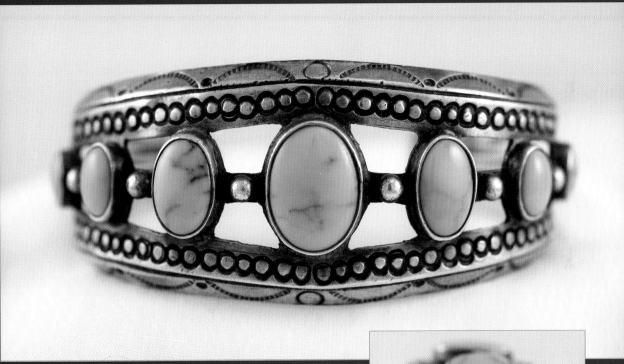

SEVEN-STONE BRACELET WITH INSET PLATE. Burnham turquoise and sterling, ca. 1945. Size: 7. Maximum height: 1.5". Signed: F.P. A high degree of skill was required to pierce and shape the back-plate that provides support for the stones while giving the overall design its open-work effect. The assemblage is then perched perfectly on the carinated ridge of the band wires with a perfectly tight seam. The stamped circle motifs were likely rendered with a dapping cutter. The overstrike, at #5 top left of center, is repeated at #5 right below. *Courtesy of the Gloria Dollar collection.*

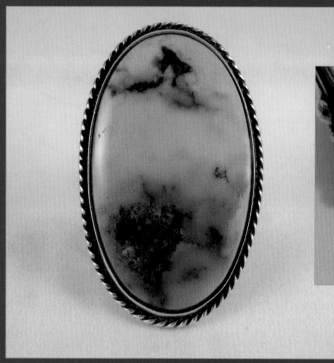

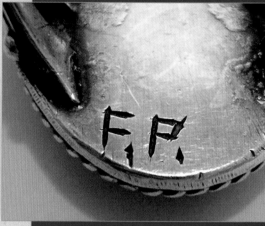

RING. Blue Gem turquoise and sterling, ca. 1948. Size 7. Maximum height: 1.2". Signed: F.P. This beautiful stone, cut to balance its beautiful matrix, combines with its silver mount to show the heavier organic quality of much of Fred Peshlakai's artwork. The pair or raindrops perched under the bezel plate finish the appliquéd arch with a subtle touch. *Courtesy of the Gloria Dollar collection.*

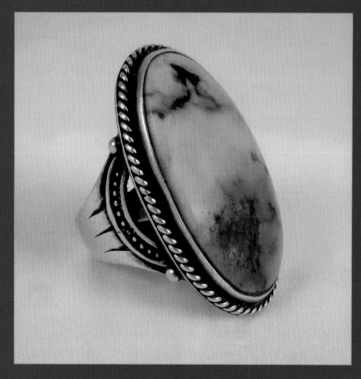

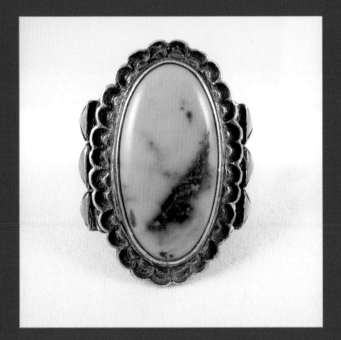
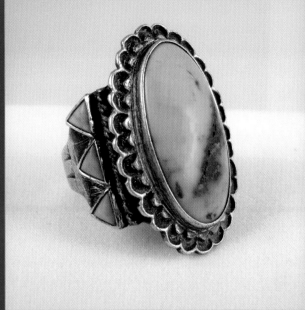

RING WITH SIX SIDE-STONES. Blue Gem turquoise and sterling, ca. 1954. Size: 7. Maximum height: 1.12". Signed: F.P. The atypical combination of designs incorporated on this ring could only be successfully accomplished by the mind of Fred Peshlakai. *Courtesy of the Gloria Dollar collection.*

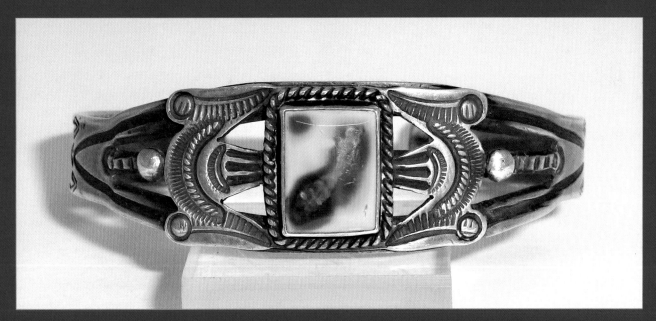

BRACELET WITH RECTANGULAR STONE. Blue Gem turquoise and sterling, ca. 1956. Size 6.25. Maximum height: .8". Signed: F.P. The multiplicity of differently shaped lines and negative space created by overall form, raindrops, stamp-work, piercings and stone combine in a cohesion that demonstrates Fred Peshlakai's intuitive grasp of perfect balance. *Courtesy of the Art Tafoya collection.*

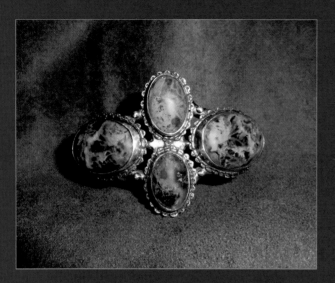

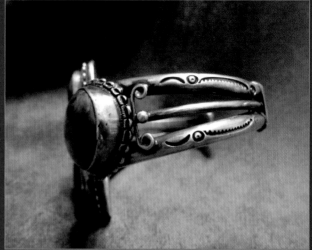

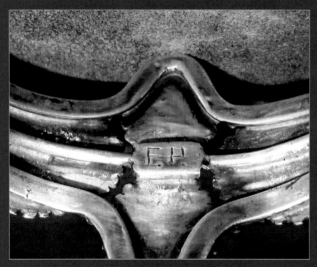

FOUR-STONE BRACELET. Chrysocolla blended malachite and sterling. ca. 1952. Size: 7. Maximum height: 2". Signed: F.P. The atypical set of the cabochons typifies many of Fred Peshlakai's designs. Surrounding each stone is a 1/16-inch raindrop that was individually applied to the narrow shelf of the bezel plate and then crushed. Each was further enhanced with a tiny indentation. On the verso is a rectangular block designed as a support for the center stones. The bracelet's outside bands are dramatically pulled to an extreme angle in order to create the atypical exterior supports for the center stones. *Courtesy of the Gloria Dollar collection; from Joe Tuzzolino.*

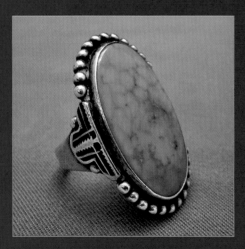

RING. Nevada turquoise and sterling. ca. 1955. Size: 7.5. Maximum height: 1.25". The bezel plate was filed away to highlight each of the individually applied exterior raindrops. Their typical cyclical continuity has been broken by applied side elements that amplify the juxtaposition of the bands attachments. *Courtesy of the Karen Sires collection.*

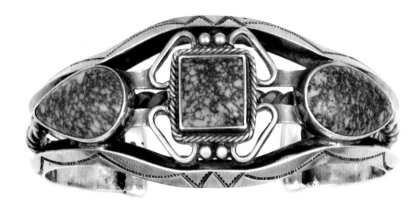

OPENWORK BRACELET. Lone Mountain turquoise and sterling, ca. 1955. Size: 7. Maximum height: 1.6". Signed: F.P. *Courtesy of the Hiroyuki Narita collection.*

The openwork presentation of this rare, three-piece demi-parure demonstrates Fred's ability to create the illusion that the individual elements are suspended without any support other than meticulously placed solder points. Close examination reveals the meticulously rendered pierced back-plate that has been sculpted to follow the lines of the individual surface elements. Graceful curvature in the stamp work amplifies the overall design, shape yet brings the eye back to the dramatic quad of plain wires. These smooth wires are attached underneath the twisted wires framing the center stones and lift the focal point forward.

OPENWORK PIN. Lone Mountain turquoise and sterling. ca. 1955. Maximum width: 2.5". Signed: F.P. *Courtesy of Yasu Kodera, Skystone Trading, Japan.*

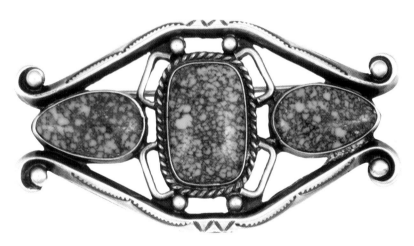

OPENWORK RING. Lone Mountain turquoise and sterling, ca. 1955.Maximum height: 1". Unsigned. *Courtesy of the Hiroyuki Narita collection.*

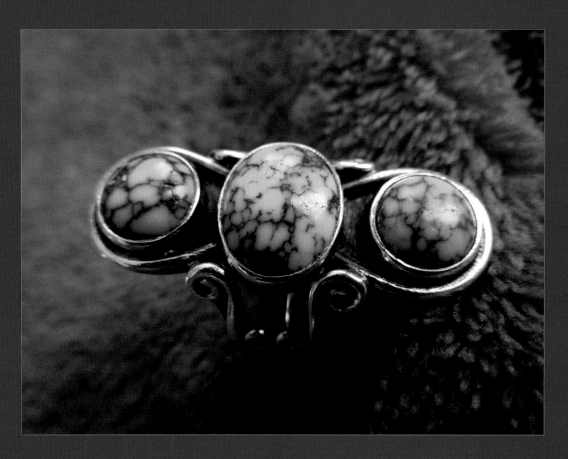

THREE-STONE RING. Lone Mountain turquoise and sterling, ca. 1955. Size: 6. Maximum height: 1.25". Signed: F.P. Fred Peshlakai often used unembellished hand pulled wire in order to offset and soften the often complicated matrix in the stones he used in his art. By incorporating the altered play of light from the differently handled wire forms it shows their placement was never simply random. On this ring, a shadow-box was created by placing a smooth round wire as an elliptical element around the smaller spherically domed side-stones. This negative space, as well as the curvatures of the Four Ways wires on the band, creates a graceful yet powerful focal point out of the center stone. *Courtesy of the Nona Northrup and Kelly Murphy collections.*

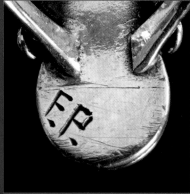

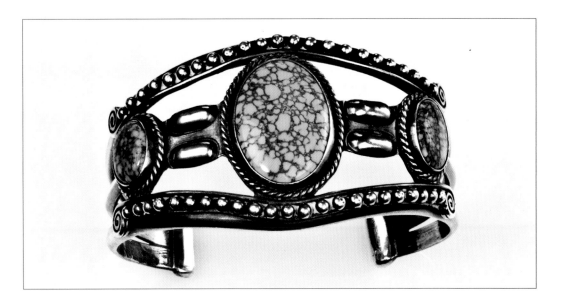

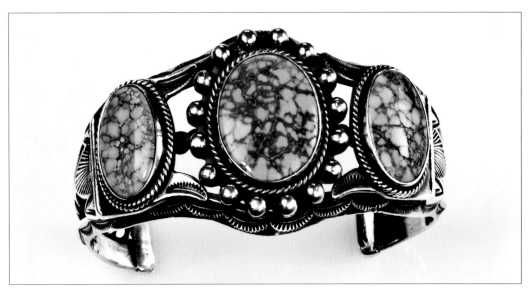

OPENWORK BRACELETS. Lone Mountain turquoise and sterling, ca. 1955. Sizes: 7. Maximum heights: 1.75". Both signed: F.P. Fred Peshlakai rarely allowed any of the back plates on which the stones were mounted to show through to the artworks presentation surface unless they were an integral part of the overall design. This painstaking process allowed the unique shapes of the individual elements to retain their clarity of purpose. Using either a cut-away technique for a longer plate, or a multiple of singly fashioned plate supports, Fred's openwork designs resulted in a visual diaphaneity that belied their extremely complicated execution. Each element was individually created and often layered to complete a three-dimensional design. Every element was painstakingly planned in advance, often created specifically for the individual work of art. *Both courtesy of the Jeff and Carole Katz collection.*

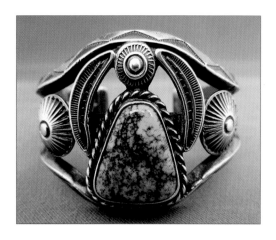 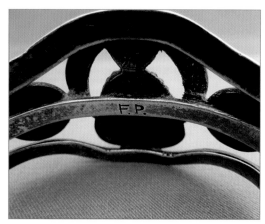

Research indicates that the decade of the 1950s includes some of Fred Peshlakai's most unique overtly designed creations. The two pieces shown here typify the mature artistic voice of Fred Peshlakai which was unparalleled during his lifetime. Incorporating avant-garde arrangements of thoroughly traditional Diné symbols, Fred broke away from everything else being created in his genre. It is clear why he is considered one of the most, if not the most, influential Diné artist to impact the art form of the twentieth century.

Doc Wilson was Fred's main source for the stones he used during his thirty-two years on Olvera Street in Los Angeles. Their sophisticated collaboration resulted in the spectacular stones now fundamentally associated with the art of Fred Peshlakai. Some of the best examples of these stones appear during the 1950s period.

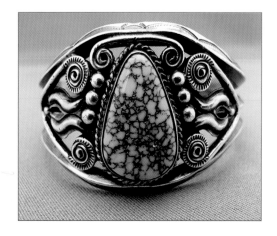 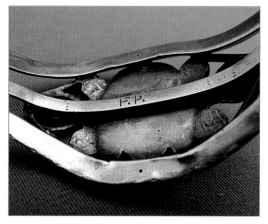

TWO MASTERWORK BRACELETS BY FRED PESHLAKAI. Nevada turquoise and sterling, ca. 1955. Bracelet with three repoussé buttons: Size 6.5. Maximum height: 2". Bracelet with spider-web stone: Size 7. Maximum height: 2". Both signed: F.P. *Both courtesy of the Karen Sires collection.*

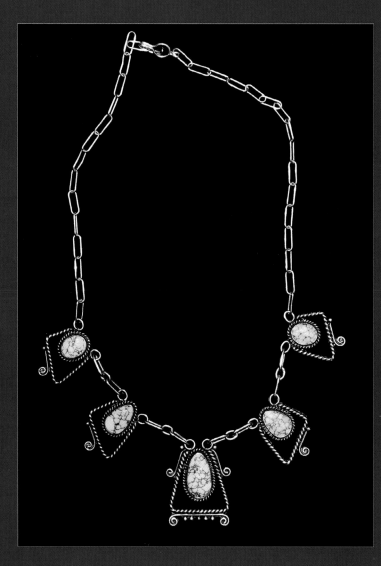

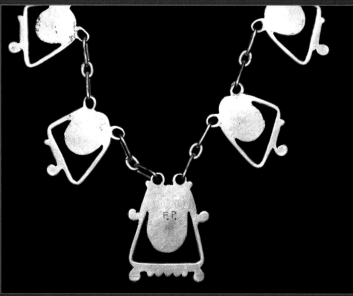

OPENWORK NECKLACE. Lone Mountain turquoise and sterling, ca. 1955. Maximum height of central pendant: 1.35". Signed: F.P. This wonderful necklace appears at first glance to only incorporate simply bent twisted wires in order to create the dramatically shaped openwork frames that underscore the stones. It isn't until the verso of each pendant is examined that the full genius of Fred Peshlakai is revealed. Peshlakai hand-cut each of the pendant's back plates in order to permanently reinforce each of element's particular shape. Virtually undetectable from the front, these plates retain the visual fragility of the design while also speaking to the underlying technical quality inherent in all of Peshlakai's art. *Courtesy of The Victoria Herrick collection.*

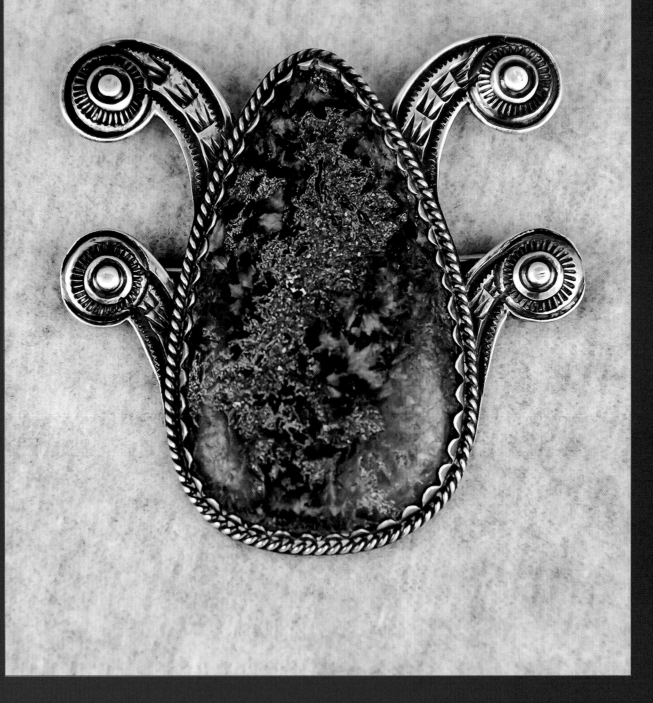

THE DOUBLE FLEUR DE LIS PIN. Dendrite azurite blended with leather malachite and sterling, ca. 1955. Maximum height: 2.16". Signed: F.P. The rare use of a scalloped bezel on this piece exemplifies Fred's restricted use of such a feature to only when he intended it as part of the overall design. *Author's collection.*

WORKS OF ART SIGNED:
FP OVER A LONG ARROW

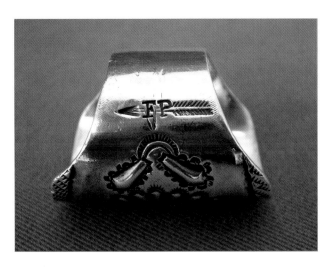

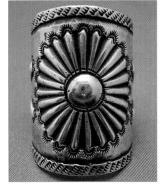

ACCORDING TO the article published in December 1950 by Jeanne Bethers, Fred Peshlakai was signing all his work using his iconic hallmark of an FP superimposed over a left-facing arrow at that time. Woodward also commented on the use of this particular hallmark as early as 1937. The presence of the shortest arrow-size versions of this particular cipher on all the pieces within the Strong collection implies that Fred's hallmarked examples that have a longer arrow version belong to earlier periods. However, the hundreds of pieces currently evaluated for this study reveal that this longer version of Fred's hallmark are fewer in number, suggesting either a shorter time frame of use or a smaller survival rate. Although the images in this book are presented in groups that each bear similar hallmarks, it should be reiterated that little specific chronological associations for the use of these individual types of hallmarks is concluded and should remain inconclusive pending a complete study of the entire catalogue of the known works of Fred Peshlakai. Currently, some stylistic chronological associations do appear, but they remain tentative.

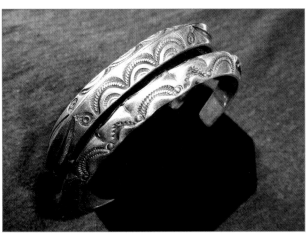

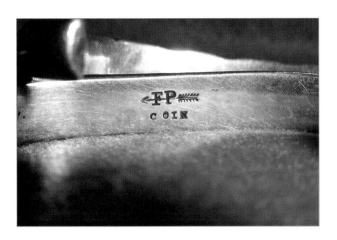

Top left & right: REPOUSSÉ RING. Sterling, ca. 1950. Size 8. Maximum height: 1". Signed: FP over a long arrow. This stamped and repoussé ring incorporates a wide multiplicity of techniques inside a very small area. Approximately 125 individual hammer strikes, using many different dies, were used on this single ring. *Courtesy of the Karen Sires collection.*

Left middle & bottom: CARINATED BRACELET PAIR. Sterling, ca. 1952. Sizes: 6.75 and 7. Maximum height: .4". Signed: FP over a long arrow. This type of bracelet was made in the thousands by Diné artists over the last 100 years. These pieces can be distinguished as Fred Peshlakai's work even without the hallmark. *Courtesy of the Linda Kirschner collection.*

Fred Peshlakai created many forms of silver objects over the course of his long career. The vertical bar stamp on the box below is reversed to form the elliptical shape on the center of the bell, at right. The little lotus-like stamps flanking the 3/8" wingspan of the bird figure are only 3/16" long yet still have a row of three tiny dots below the main blossom.

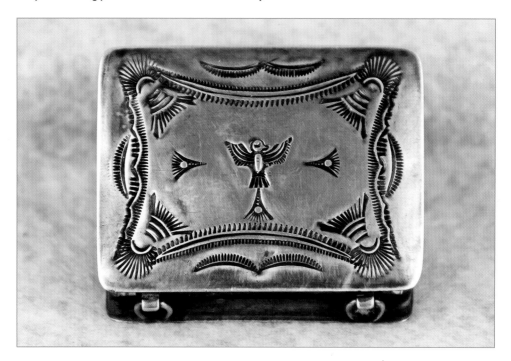

DECORATED PILL BOX. Sterling, ca. 1953. Maximum width: 2.3". Signed: FP over a long arrow. *Courtesy of the Gloria Dollar collection.*

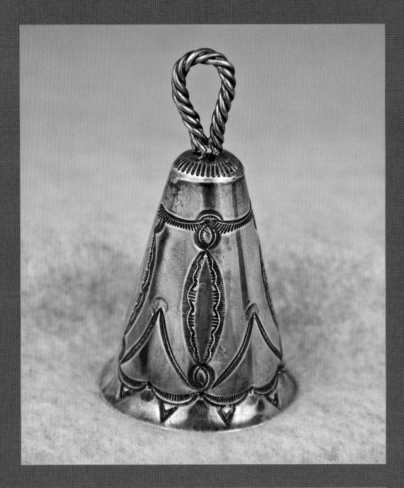

DECORATED BELL. Sterling, ca. 1953. Maximum height: 3" including handle. Signed FP over a long arrow. *Courtesy of the Gloria Dollar collection.*

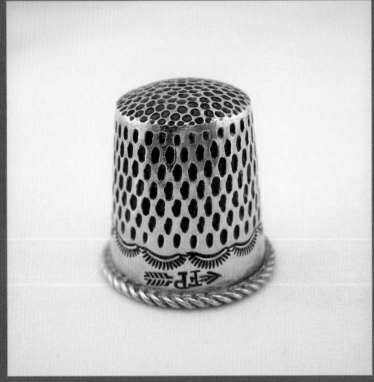

SEWING THIMBLE. Sterling silver. ca.1955. Size: 12. Maximum height: .85". Signed: FP over a long arrow. No form of object appears to have escaped Fred's capacity as is demonstrated in this unique example. Several hundred individually rendered indentations texture the surface, while scalloped stamp work and a twisted wire edge treatment add a beautiful refinement. *Courtesy of the Gloria Dollar collection.*

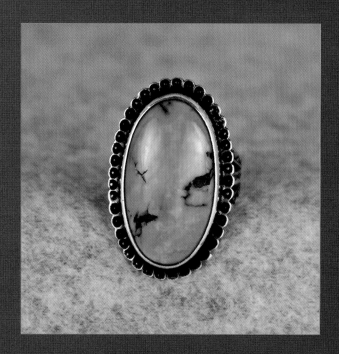

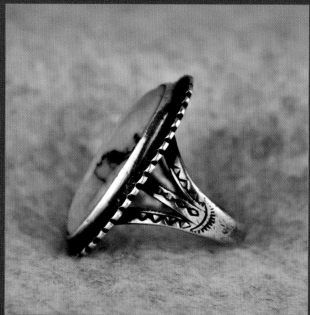

SCALLOPED RING. Blue Gem turquoise and sterling, ca. 1955.
Size: 5.75. Maximum height: 1.25". Signed: FP over a long arrow.
The 40 stamped star designs on the bezel plate of this ring are
each 1/16" in diameter. Each has tiny rays off its center and
is further notched at its rim with a hand file. *Courtesy of the
Gloria Dollar collection.*

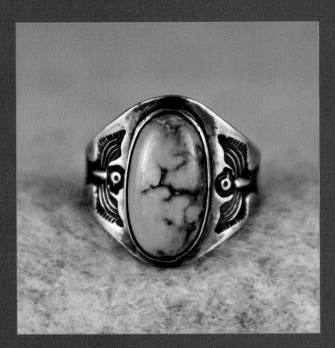
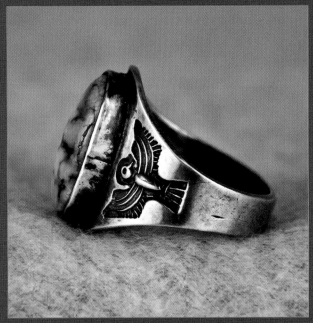

THUNDERBIRD RING. Blue Gem turquoise and sterling, ca. 1953. Size: 4.5. Signed: FP over a long arrow. This Thunderbird stamp is also present on the pill box on page 136. *Courtesy of the Gloria Dollar collection.*

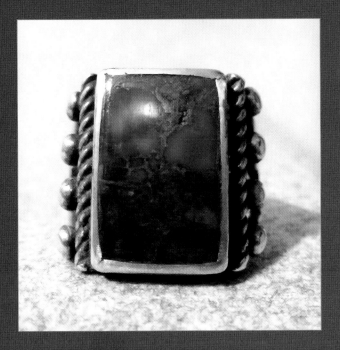
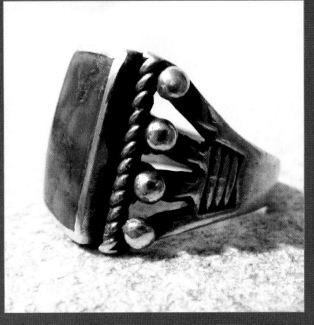

FINGER RING. Green variant Blue Gem turquoise and sterling, ca. 1954. Size: 7.5. Maximum height : .75". Signed: FP over a long arrow. Hand pulled and twisted wire bars are used as a central tier to step the rings face up and forward and rest on the vertical edge of the bezel plate. *Author's collection.*

FINGER RING. Blue Gem turquoise, onyx and sterling silver, ca. 1958. Size: 8. Maximum height: .85". Signed FP over a long arrow. This unusual and beautiful ring incorporates a center element that projects through a pierced onyx stone. *Courtesy of Martha Struever.*

Below: CAST PIN. Turquoise and sterling, ca. 1953. Maximum width: 2.25". Signed: FP over a long arrow. Pieces cast in molds are rare in Fred Peshlakai's repertoire. Here, the addition of twisted and plain wire elements at the short ends of the stone frame an otherwise fluid design creating a powerful focal point. *Courtesy: E.D. Marshall Jewelers.*

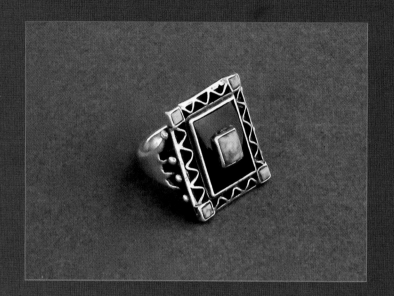

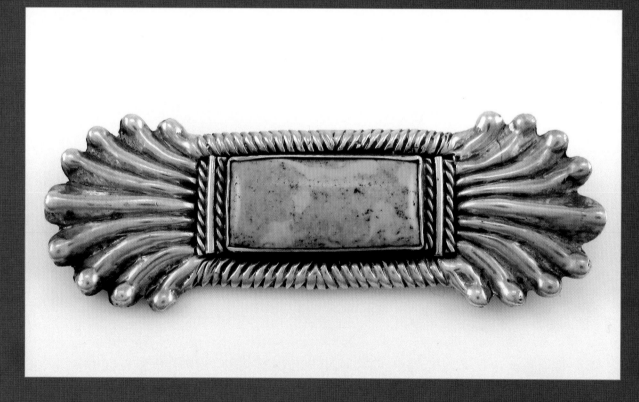

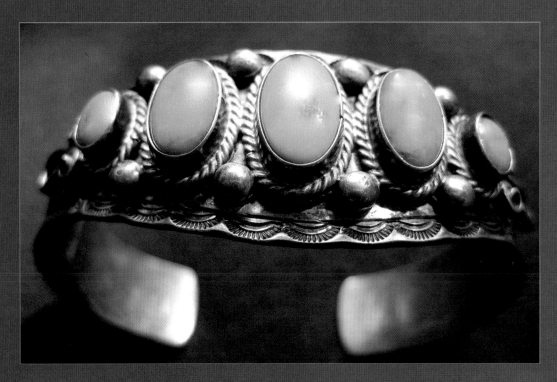

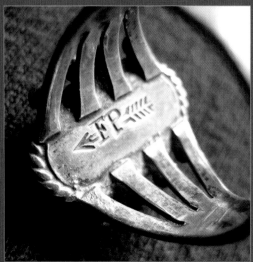

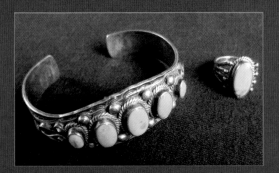

BRACELET AND RING MATCHED SET. Blue Gem turquoise and sterling, ca. 1954. Both: Size 7. Maximum height of bracelet: 1.25". Ring signed: FP over a long arrow. The very tall bezels, surrounding the spectacular stones on this set are unusual for Peshlakai. The stones' verticality lifts them clear of their complicated background, lending all of the individual features their own visual personality and a part to play in balancing the finished work. Even the curled wire on the shoulder is of ribbon form and turned on its edge to accentuate its height. *Courtesy a private collection.*

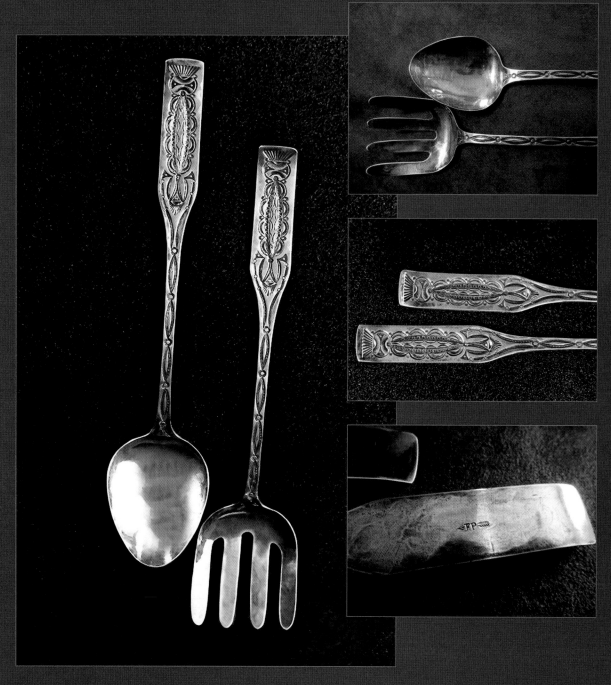

LARGE SERVING SET, STERLING. ca.1959. Maximum length: 10.5". Maximum width: 2.25". Signed: FP over a long arrow. Jeanne Bethers wrote in her 1950 article on Fred Peshlakai that he was creating large serving sets at that time. In addition, the presence of Fred's Greek Key stamp on these examples dates them from the mid 1950s to early 1960s. Fred's penchant for intricacy in his die struck stamp work often resulted in a curvilinear fluidity that, while retaining loyalty to his Diné heritage, can appear to resemble the single stroke engraved type of designs typically associated with European engraved silver. On these examples, the wider portion of the handles was made thinner by hand pounding the silver which was originally as thick as the handle midsections. The utensil sections were also hand shaped but was applied separately. Each piece was decorated with 69 individually rendered stamps which each likely would have required two hammer strikes to complete. The designs still match perfectly. *Author's collection.*

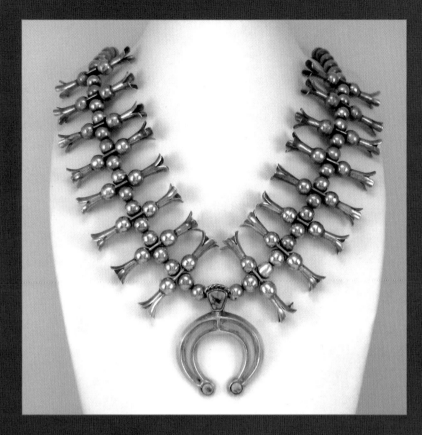

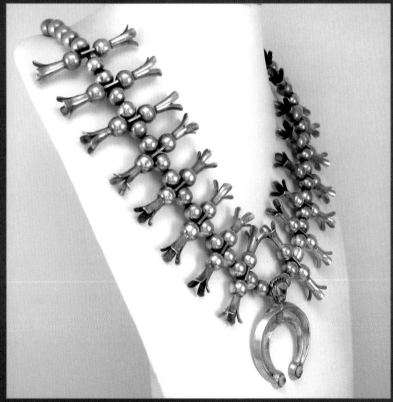

SQUASH BLOSSOM NECKLACE.
Sterling, ca. 1956. Running length
22". Maximum height of najahe: 2".
Signed: FP over a long arrow. This
double blossom design was likely
original to Fred Peshlakai's father
Slender Maker of Silver. Here, the
stems of the blossoms rest snuggly
within the curvature of the single
beads retaining their 90 degree
juxtaposition. The graduated
measurements Fred used for the
elements (1.5" wide for the pendant,
1.75" long for the blossoms, and
then 2" high) perfectly balances
shape and color and pulls the eye
to the irregularly shaped central
stone despite the complexity of the
double blossoms. The stone's simple
twisted wire crown completes the
focal point. *Courtesy of the Gloria
Dollar collection.*

*(more images continued on
following page)*

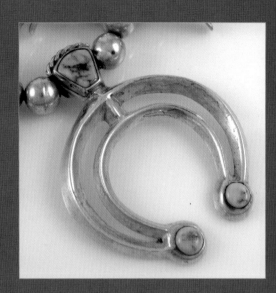

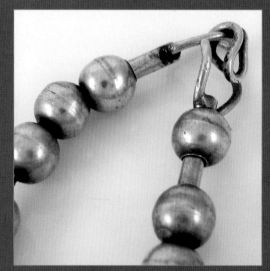

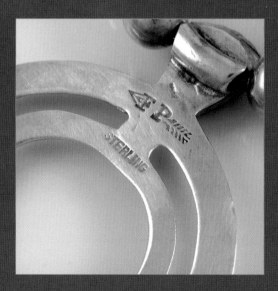

THE LAURIS PHILLIPS COLLECTION

THE STUDY OF THE ART OF FRED PESHLAKAI IS ONLY just beginning to be available in published works. However, he has for many years been admired and championed by discerning collectors and individuals interested in the evolution of the art form. The best known of these individuals had been Mrs. Lauris Phillips, who with her husband Jim, owned Fairmont Trading Company. Their home near Pasadena, California, had long been a repository for one of Lauris' main passions, the art of Fred Peshlakai, which she collected personally and discussed in her lectures on Native American art. Mrs. Phillips was pleased that this publication was being assembled on Fred Peshlakai and was kind enough to provide the following:

I became keenly interested in Old Pawn Navajo jewelry after inheriting a few pieces from my mother in the late '60s and by the '70s I'd begun collecting and trading. But I realized I needed to delve deeper into its history so as to represent it responsibly, and to make distinctions about quality and authenticity. When I began to see middle period pieces by an artist named Fred Peshlakai, I knew it would be necessary to broaden my scope. Unfortunately, Fred died before I had a chance to meet him, much to my regret, but I could clearly see how he'd taken lessons learned from his brilliant, pioneering father and applied them to his own unique and groundbreaking aesthetic.

I could also see that because Fred's work was comparatively "new" and because he had worked in Los Angeles, it didn't seem to be getting the respect it deserved. And so I happily began collecting and championing Fred's pieces at Indian shows and in talks I was giving, and the excitement about his work seemed to build, which pleased me greatly. Things reached a sort of fever pitch during the Indian jewelry craze in the 1970s and I think Fred's reputation as a great artist and innovator was sealed at that time, and it endures. I've been delighted to see the Peshlakai tradition of meticulous craftsmanship and inventive design carried forward in the work of his disciples and admirers, people like Art Tafoya and others who trace their inspiration to Fred Peshlakai. (Phillips, pers. comm.)

Sadly, Lauris passed away on June 18, 2013. Important pieces from the collection of Lauris and Jim Phillips have recently been gifted to the Wheelwright Museum in Santa Fe, New Mexico. It is with great anticipation that the public awaits the presentation of these important pieces by the Wheelwright Museum of the American Indian. The kindness of the Phillips family in making these art works available to the general public is something that surely will be appreciated by so very many people in the years to come.

Mrs. Lauris Phillips, ca. 1980. Eaton Canyon Riding Club.
Courtesy of the family of James and Lauris Phillips.

INTRODUCTION TO THE
LAURIS PHILLIPS COLLECTION

Lauris Phillips was among the first collectors to recognize Fred Peshlakai as a twentieth-century master. Lauris became interested in Navajo and Pueblo jewelry in 1968 and was aware of Peshlakai's work almost immediately. One of her biggest regrets was that she never met him, but she honored him by assembling a fine collection of his work.

The first time Lauris showed me the collection I was floored by its range, but I was equally impressed by her modesty and honesty about it. She attributed many unsigned pieces to Peshlakai, and within an hour she taught me to make the same connections that she did between those and signed or hallmarked pieces. She also acquired many unsigned pieces as Peshlakai's work but which she was not convinced were his. She referred to them as "Freddish" and hoped that serious researchers would eventually study them in comparison with pieces that were unquestionably his.

After several years of discussion, in early 2013 Lauris donated the collection to the Wheelwright Museum, just a few months before she passed away. Lauris was aware that this book was in progress, and she asked that the museum support the effort. A small selection of Peshlakai's finest pieces from Lauris' collection is included here. Many of these will be displayed in a new permanent gallery at the Wheelwright Museum that is currently under construction. We hope all of the new admirers of Fred Peshlakai's work will come see them after the gallery has opened in 2015.

Jonathan Batkin, Director
Wheelwright Museum
December 2013

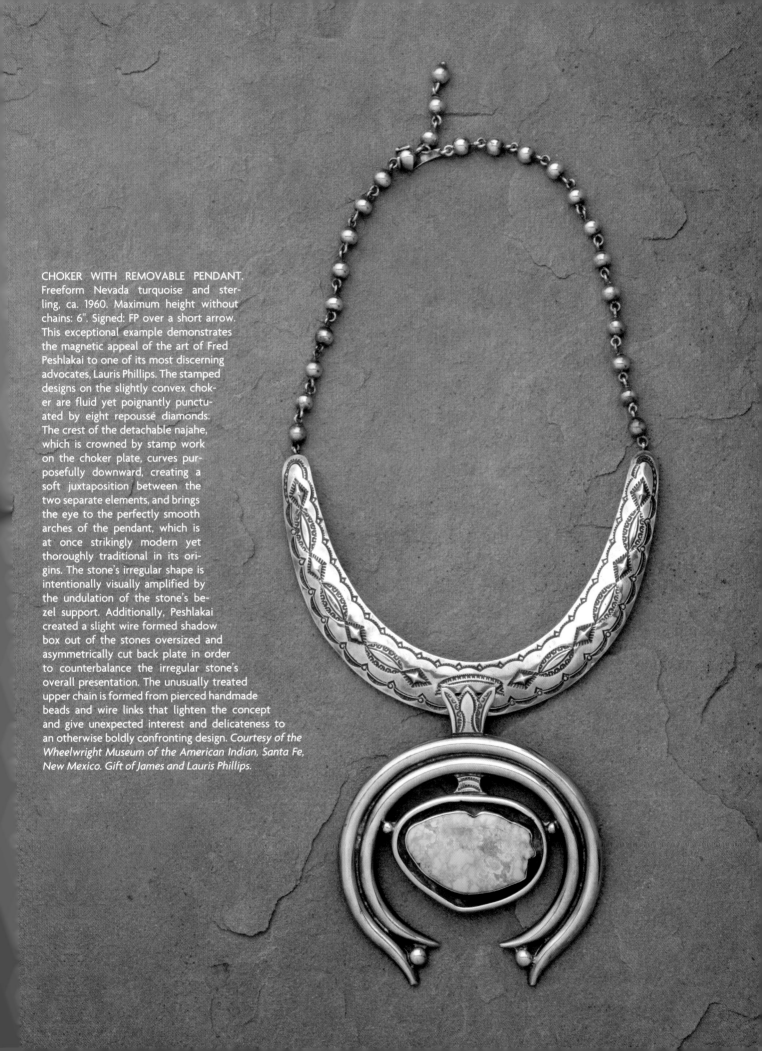

CHOKER WITH REMOVABLE PENDANT. Freeform Nevada turquoise and sterling, ca. 1960. Maximum height without chains: 6". Signed: FP over a short arrow. This exceptional example demonstrates the magnetic appeal of the art of Fred Peshlakai to one of its most discerning advocates, Lauris Phillips. The stamped designs on the slightly convex choker are fluid yet poignantly punctuated by eight repoussé diamonds. The crest of the detachable najahe, which is crowned by stamp work on the choker plate, curves purposefully downward, creating a soft juxtaposition between the two separate elements, and brings the eye to the perfectly smooth arches of the pendant, which is at once strikingly modern yet thoroughly traditional in its origins. The stone's irregular shape is intentionally visually amplified by the undulation of the stone's bezel support. Additionally, Peshlakai created a slight wire formed shadow box out of the stones oversized and asymmetrically cut back plate in order to counterbalance the irregular stone's overall presentation. The unusually treated upper chain is formed from pierced handmade beads and wire links that lighten the concept and give unexpected interest and delicateness to an otherwise boldly confronting design. *Courtesy of the Wheelwright Museum of the American Indian, Santa Fe, New Mexico. Gift of James and Lauris Phillips.*

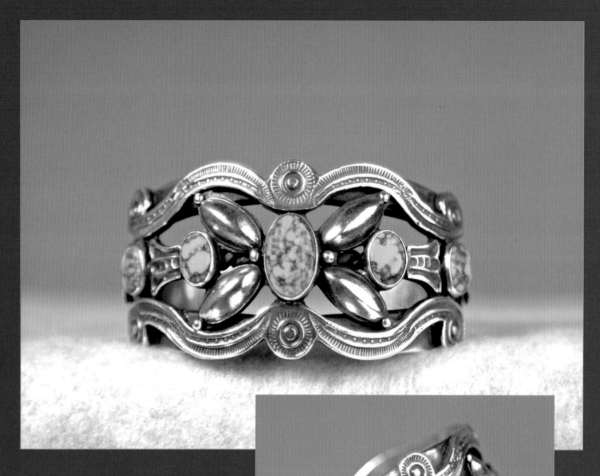

OPENWORK BRACELET. Lone Mountain turquoise and sterling, ca. 1955. Size 6.5. Maximum height: 1.8". Signed: F. Peshlakai. A masterpiece from the Phillips collection, this piece exemplifies why the silver art of Fred Peshlakai is so highly revered. A heavy flat band of silver was first hand split and then an additional twisted wire support added to the central gap. On this foundation Peshlakai has then placed a meticulously precut backplate on the bracelet's face. This supporting structure provides the foundation for the myriad of individually applied stamped and repoussé silver elements that interplay perfectly within their elegant dance. Eventually, even the original heavy band, which can still be seen through this superstructure, plays an artistic part by providing an additional frame for the artwork's central focal point. The sideband narrows abruptly to its impending terminals, providing a lightness and simple relief to the ornate fascia of the bracelet. The plethora of ornate elements present on this piece, as well as other pieces by Peshlakai that contain similar concepts, have prompted many to hypothesize as to the origins and possible influences upon the artist that could have resulted in what is consider Fred Peshlakai's personal style. Unique in comparison to other artisans of his time, this question appears pertinent until it is revealed that all the individual aspects Fred incorporated in his art can primarily be found in traditional Navajo design. *Courtesy of the Wheelwright Museum of the American Indian, Santa Fe, New Mexico. Gift of James and Lauris Phillips.*

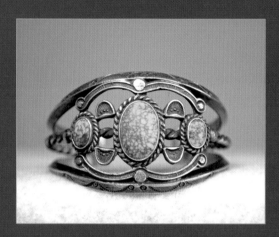
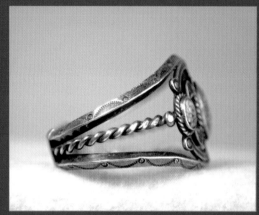

OPENWORK BRACELET. Lone Mountain turquoise and sterling, ca. 1955. Size: 6.75. Maximum height: 2.2". Signed: F.P. This beautiful piece clearly exemplifies Fred Peshlakai's mastery of cut-shaping the back plate upon which the stamped secondarily applied silver elements rest. Appearing in the final artwork to float as if suspended by their tiny solder points, these individually formed elements actually rest securely upon a larger continuous flat sheet of silver that has been pierced to mimic their individual shapes. This technique solidifies the individual artwork's construction while visually granting it a fragile airiness that is intended to last through the years. This latticework effect is amplified by the spacious layout of the sidebands and their restrained accents, all of which combine to make this example of openwork silver a masterpiece of the silversmith's craft. *Courtesy of the Wheelwright Museum of the American Indian, Santa Fe, New Mexico. Gift of James and Lauris Phillips.*

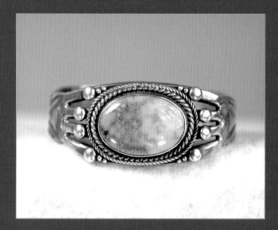
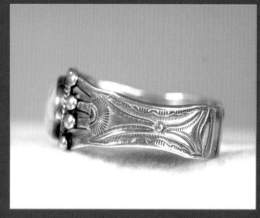

BRACELET WITH OVAL STONE. Blue Gem turquoise and sterling, ca. 1955. Size 6.25. Maximum height: 1.25". Signed: F.P. The finished result of this artwork is one of bold solidarity intended to capture the interest of the observer with its striking presentation. This visual effect typifies much of the work of Fred Peshlakai. Yet detailed analysis of these pieces reveals that the many multiples of integrated elements interplay so perfectly that the end result grows larger than the sum of its parts. Here a heavy band of silver is split into four segments that are spread to enlarge the face of the bracelet. The side band is also shaped to echo the long arcs of the intricate stamps that radiate and combine as if rendered with a single stroke engraver. The eight large raindrops are flattened into pill shapes and follow the curvature of two twisted wires of different sizes laid down in such a way as to appear braided, despite their individual application. Eight tiny raindrops create corners of framework punctuated by their two variations in sizes. All of this is highlighted by the striking focal point of the stone and its offset inclusion of matrix (contrasting material in the turquoise) that becomes an important element of the overall design. *Courtesy of the Wheelwright Museum of the American Indian, Santa Fe, New Mexico. Gift of James and Lauris Phillips.*

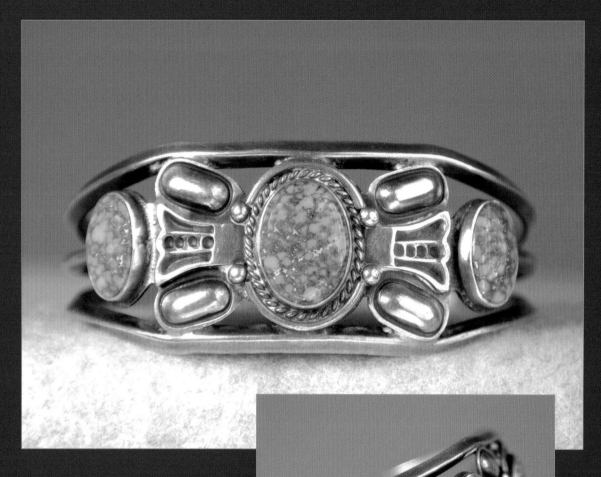

BRACELET WITH REPOUSSÉ. Lone Mountain turquoise and sterling, ca. 1956. Size: 7. Maximum height: 1.5". Signed: F.P. The absence of any stamped embellishment on the carinated outer wires, combined with their slightly bent angularity, announces their intentional simplicity. The slightly shadow-boxed repoussé-formed lozenges flanking the center stone magnify this feel of industrialization and finalizes the piece's midcentury modern style. Fred Peshlakai's delight in the many different flavors of distinctive design types is apparent in the wide scope of his art, all of which remain inherently within his denomination while always still exhibiting his singularly creative signature style. *Courtesy of the Wheelwright Museum of the American Indian, Santa Fe, New Mexico. Gift of James and Lauris Phillips.*

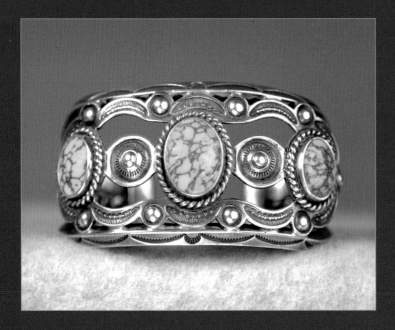
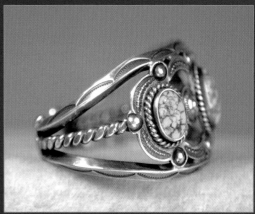

OPENWORK BRACELET WITH REPOUSSÉ BRACELET. Number Eight turquoise and sterling, ca. 1956. Size: 7. Maximum height: 2". Signed: F.P. The cut-out back plate of this spectacular bracelet includes twelve repoussé convex elements, ten of which mimic traditional raindrops that appear to perch within recessed depressions. Fred Peshlakai's knowledge of how texture is combined with line and shape to emblazon the three-dimensional form is clearly demonstrated on this spectacular example. Pushing the borders of grandiloquence, the artwork retains its masterpiece classification as the back plate itself is embellished rather than being used to support any separately applied silver elements other than the stones and their settings. The artwork is further relieved by the simply presented sidebands. The end result is something altogether remarkable due to its perfect balance and the astonishing technical dexterity exhibited in its creation. *Courtesy of the Wheelwright Museum of the American Indian, Santa Fe, New Mexico. Gift of James and Lauris Phillips.*

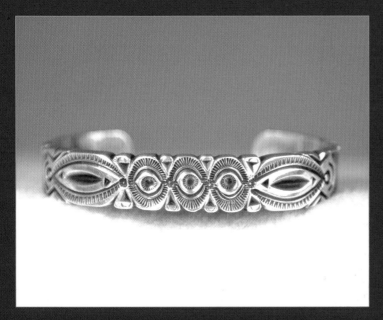
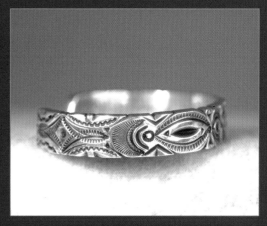

BRACELET. Sterling. ca. 1957. Size: 6.75. Maximum height: .5". Signed: FP over a long arrow. The undulating visual movement of this highly decorated example is enhanced by the slightly offset alignment of the outside arches that create the central three shapes on the bracelet's face. The band is further notched on its edges with pronounced effect. Peshlakai's penchant of combining single impressions in order to create secondary forms is clearly demonstrated on this piece, some of which even intertwine in order to generate their unique motif. *Courtesy of the Wheelwright Museum of the American Indian, Santa Fe, New Mexico. Gift of James and Lauris Phillips.*

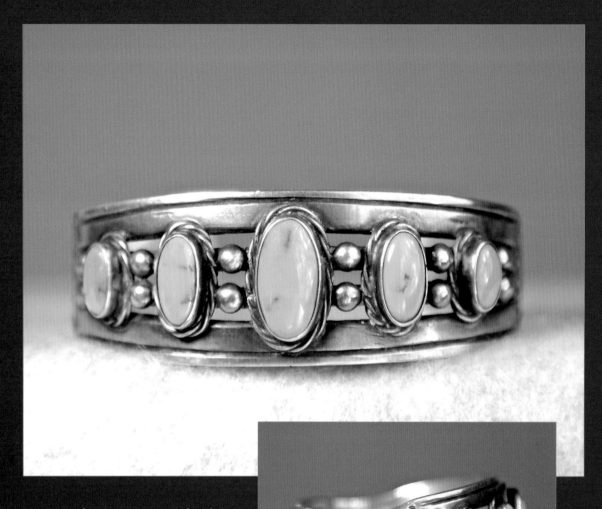

BRACELET. Blue Gem turquoise and sterling, ca. 1957. Size: 6.75. Maximum height: 1.2". Signed: FP over a long arrow. The face of this impressive bracelet is purposefully straightforward in its no-nonsense message. Linear grooves and raindrops that seem to simulate small ball bearings appear to move the oval stones along their streamlined and gear-like mounts. Even the wires surrounding the stones are unusually loose in their relative twists. This theme is abruptly broken by the decoration of the sidebands, which appear to intentionally present the face of the bracelet forward in order to better display its unique statement. *Courtesy of the Wheelwright Museum of the American Indian, Santa Fe, New Mexico. Gift of James and Lauris Phillips.*

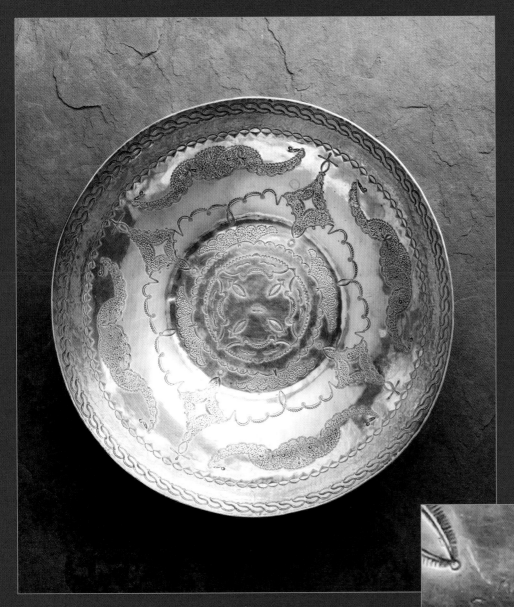

LARGE SERVING BOWL. Sterling, ca. 1958. Maximum diameter 12.25". Signed FP over a right-facing arrow and the words: Trade Mark." The rarity of this impressive bowl, along with its unusual signature suggests the probability that this piece was prepared for an exhibition. The tiny stippling inside the cloud-like figures was created with individually impressed points. These shapes then combine with the hundreds of additional figures on the face of the bowl that were all rendered by the use of approximately thirty differently shaped dies. The hammer strikes required to decorate this beautiful piece total well into the several thousands. The highly unusual signature incorporates an arrow that faces to the right in its horizontal bisecting of the artist's initials. This is the only known example examined for this study that incorporates this right-facing arrow, yet the presence of verified dies used elsewhere on the piece confirm Fred Peshlakai as its maker. Those verifications seem a redundancy on a piece so clearly indicative of Peshlakai's personal artistic style. *Courtesy of the Wheelwright Museum of the American Indian, Santa Fe, New Mexico. Gift of James and Lauris Phillips.*

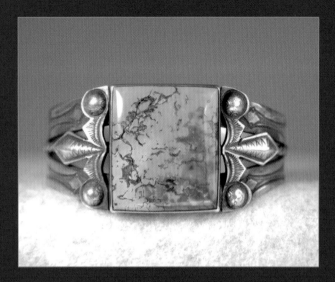
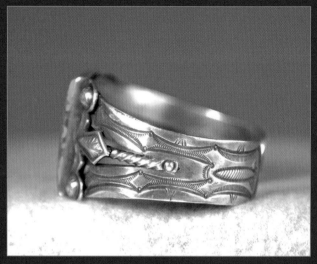

BRACELET. Blue Gem turquoise and sterling, ca. 1938 (?). Size: 6.75. Maximum height: 1.75". Signed: FP over a long arrow. Arthur Woodward remarked that Fred Peshlakai was using an FP over an arrow (likely the long arrow version) signature as early as 1938, yet the use of similar hallmarks by Peshlakai appear to have continued well into the late 1950s. The art deco influence on this example prompts the hypothesis that this could possibly be one of the early examples mentioned by Woodward. However it should be remembered that Peshlakai's art varied widely over the entire course of his long career, influenced by personal predilection as well as his accommodation of individual client requests. *Courtesy of the Wheelwright Museum of the American Indian, Santa Fe, New Mexico. Gift of James and Lauris Phillips.*

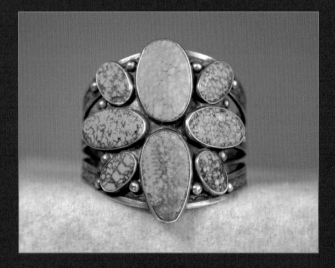
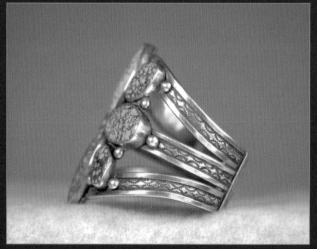

BRACELET. Lone Mountain turquoise and sterling, ca. 1962. Size: 6.75. Maximum height: 2.8". Signed: FP over a short arrow. The design intention of this spectacular bracelet is clear in the riveting visual presence of its beautiful stones. The heavy silver work amplifies the dynamic stones and is accompanied by Peshlakai's rare reveal of an uninterrupted back plate that further solidifies the boldly substantial quality of this impeccable piece. *Courtesy of the Wheelwright Museum of the American Indian, Santa Fe, New Mexico. Gift of James and Lauris Phillips.*

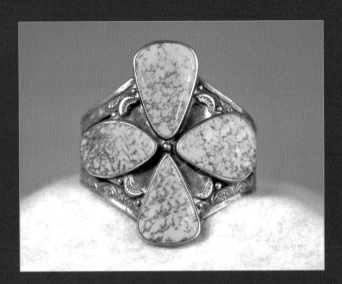
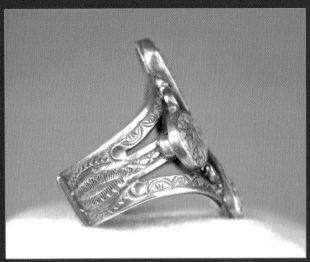

BRACELET. Lone Mountain turquoise and sterling, ca. 1962. Size 6.5. Maximum height: 2.25". Signed: FP over a short arrow. Fred Peshlakai's ingenious use of shape and form is demonstrated on this beautiful example. Here, the teardrop shaped stones all point inward in an unexpected arrangement with the largest stones set vertically to maximize their impact. The back plate is incorporated into the design and the visual shape it creates between the stones is enhanced by the addition of cut out appliqués at the crowns of these shapes that add dimension and power to the intentional negative space. This treatment demonstrates once again that everything within Peshlakai's art was intentional and played a part in the overall composition. Complex stamp work embellishes the side bands, further endorsing the reasoning behind the center of the bracelet's calm repose. *Courtesy of the Wheelwright Museum of the American Indian, Santa Fe, New Mexico. Gift of James and Lauris Phillips.*

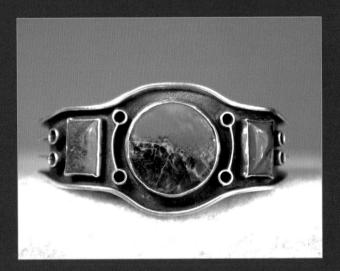
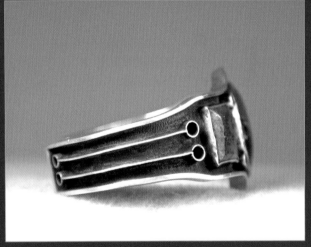

BRACELET. Malachite blended chrysocolla and sterling, ca. 1964. Size: 7. Maximum height: 1.65". Signed: FP over a short arrow. This beautiful bracelet transitions the art deco and midcentury modern styles while remaining firmly seated within the Fred Peshlakai catalogue. Flat wires, mounted on their edges, create a shadow box effect by being placed on the bracelet band's edges as well as by their interior placement, a treatment that doubles to create the band's interior designs. The dark recessed area of the shadow box's viewable surface is intentionally roughed with a subtle texture that absorbs the light augmenting the polished silver of the stone's bezel and the decorative edges of the silver work. *Courtesy of the Wheelwright Museum of the American Indian, Santa Fe, New Mexico. Gift of James and Lauris Phillips.*

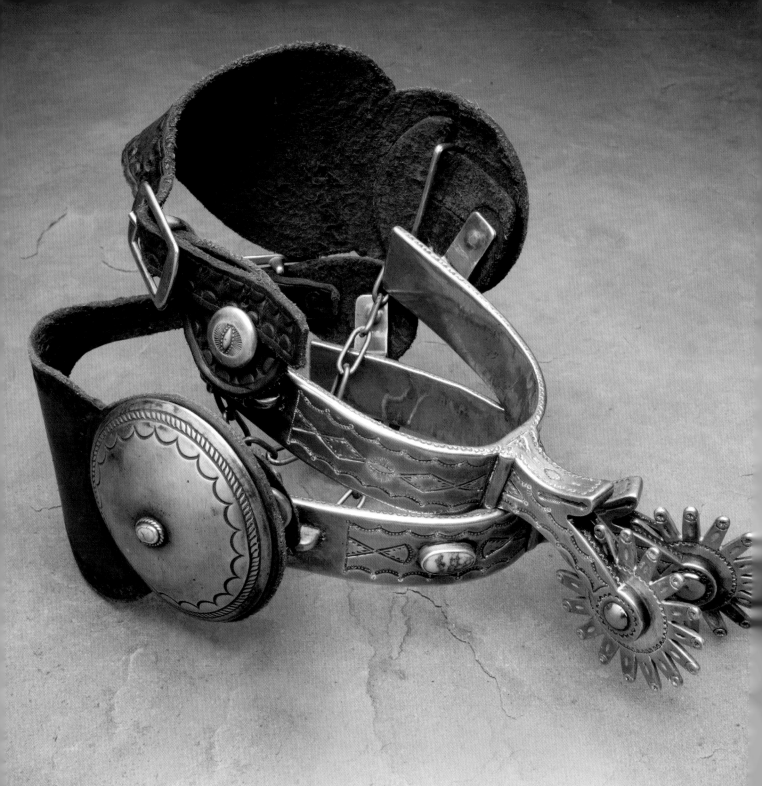

PAIR OF SILVER SPURS. Nevada turquoise and sterling. Maximum length without spur strap: 7". Signed: Fred Peshlakai. This beautiful pair of boot spurs demonstrates Fred Peshlakai's scope of artistry very clearly. Heavily cast and formed, they take an otherwise typical object and elevate it into pure art. The large conchas on the spur straps as well as the heel yokes show considerable restraint, yet the embellishment on the rowels proves that all the different aspects have interplay of intention. The small flame-like stamps inside their triangles present on the heel yokes appear to indicate an earlier date of manufacture for these objects. But, as with much of Peshlakai's art, that suggestion remains unsubstantiated. There is a somewhat blurred image, in the archives of Mr. Art Tafoya, which depicts a horse's headstall made by Fred Peshlakai. Although provenance does not indicate these regalia are companions, it tantalizes the imagination regarding the breadth of artworks that may eventually be revealed as originating from the hands of Fred Peshlakai. *Courtesy of the Wheelwright Museum of the American Indian, Santa Fe, New Mexico. Gift of James and Lauris Phillips.*

WORKS OF ART SIGNED:
FP OVER A SHORT ARROW

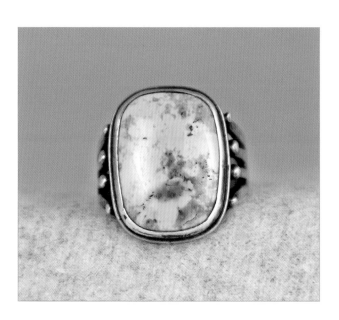

CURRENTLY, THE EARLIEST FULLY DOCUMENTED PIECE of jewelry by Fred Peshlakai that exhibits the short arrow version of Fred's hallmark is the ring shown here. Purchased in September of 1960 by John Bonner Strong, this ring represents a clear example of the final evolution of Fred's mark of an FP over a left-facing arrow. It is believed that Fred was using this mark for some time prior to Mr. Strong's purchase of the piece and indicates that pieces bearing this particular mark likely began sometime in the latter half of the 1950s. Mr. Strong would continue to purchase forty-one custom orders from Fred over the next twelve years and all of these documented pieces, which bear a hallmark, are marked with this particular cipher, except one. The consistency of the use of this short-arrow mark during that period is a key to being able to begin chronologically dating Fred Peshlakai's art during the last fifteen years of the artist's life.

MAN'S RING. Blue Gem turquoise and sterling. September, 1960. Size 8.5. Maximum height: .75". Signed: FP over a short arrow. The addition of a flat ribbon wire, cleanly soldered along the vertical edge of the bezel's back plate, creates a slight shadow box around the bezel's base and celebrates the artist's technical prowess. Graduated raindrop spheres at the outside apexes of the split bands achieve visual balance by accentuating the center pair. From the John Bonner Strong Collection; #JS2. *Author's collection.*

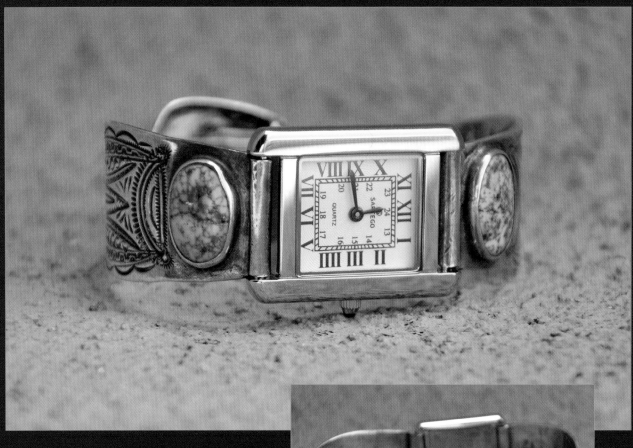

WOMAN'S FOUR-PART WATCH BAND. Nevada turquoise and sterling, ca. 1964. Size: 6.25. Maximum height: 1.16". Signed: FP over a short arrow. Beautiful silver work and complicated construction highlight this example of Peshlakai's art. The adaptable functioning buckle and hinged pin attachments demonstrate Fred's ingenuity. Fine and intricate die rendered stamp work echo silver engraving, which is a trait common to Fred Peshlakai's stamped designs. *Courtesy of the Beverly Twitchell collection.*

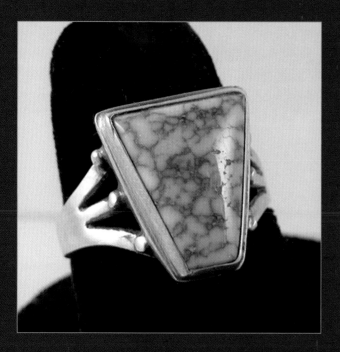

TRAPEZOID STONE RING. Lone Mountain turquoise and sterling, ca. 1964. Size: 7.5. Maximum height: .85". Signed: FP over a short arrow. Trapezoid stones from this mine are relatively common in Fred's work during this period. The back plate is done in a shallow shadow box lending a graceful surround that belies the complicated technical requirements for this uncluttered design. *Courtesy of Turkey Mountain Traders, Scottsdale, Arizona.*

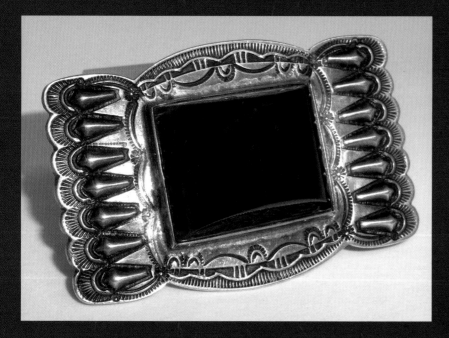

BEVELED STONE PIN. Jet or onyx and sterling, ca. 1963. Maximum width: 2.3". Signed: FP over a short arrow. Fred Peshlakai often combined his individual stamps to create unique interplay between their associated forms. The high domed and beveled stone appears to be draped in two-dimensional fabric, but the stage's side-flanges reach outward, each with their seven parallel, crowned and repoussé eagle tail feathers that seem to hint of impending flight. *Courtesy of the Art Tafoya collection.*

This historically important set (shown on pages 160 and 161) was made in the late 1950s or early 1960s and incorporates stones attributed to the famous Zuni fetish carver, Leekya Deyuse. Silver stamp work, which resembles Pueblo cloud symbols with falling rain, embellishes the water plant leaf shapes of the enlarged back plates on which most of the frogs perch. Fred Peshlakai often created individual dies to accommodate the required stamps, as is demonstrated on

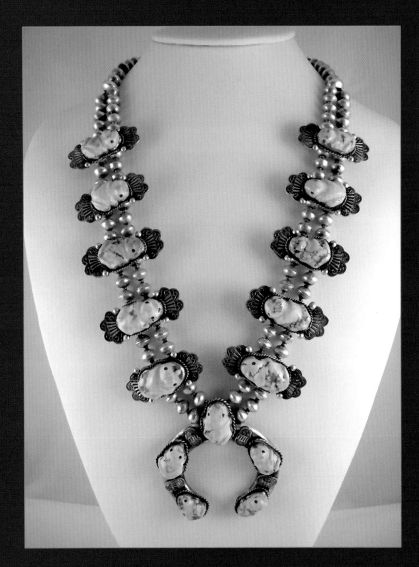

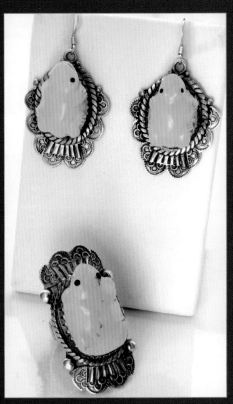

this piece. Likely a custom order by a client, there remains, however, a possibility that Fred purchased these stones directly from the carver. Deyuse lived until 1966 and Fred was known to visit his daughter, Dorothy, in Arizona during this same period. It remains a rare collaborative masterpiece combining two of the most famous figures in the history of American Southwest art.

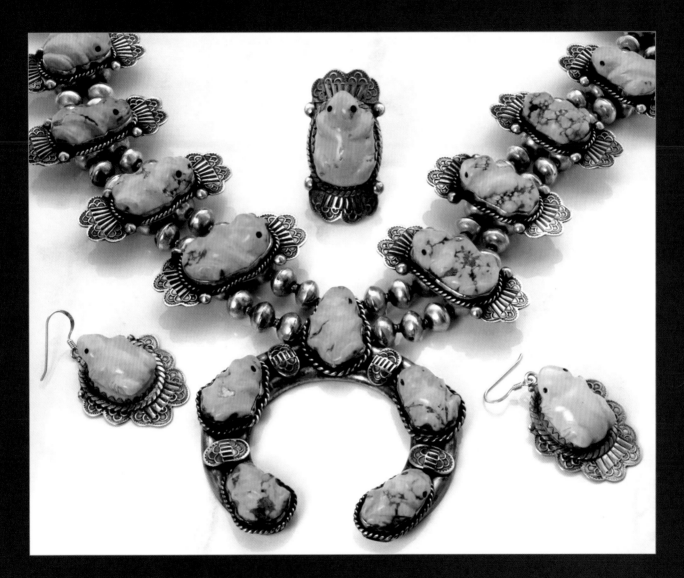

Fred Peshlakai and Leekya Deyuse FROG FETISH FOUR-PIECE SET. Carved turquoise and sterling. ca. 1960. Overall length: 24". Maximum diameter of najahe: 2.75". Largest fetish maximum: 1.12". Ring: Size 7. Earrings: Maximum height: 1.5". Necklace signed: FP over a short arrow. *Courtesy of the Gloria Dollar collection.*

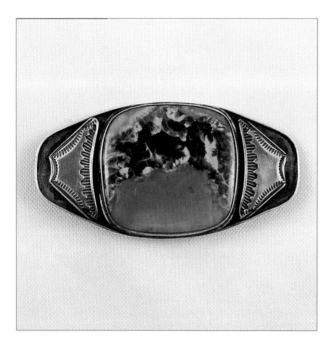
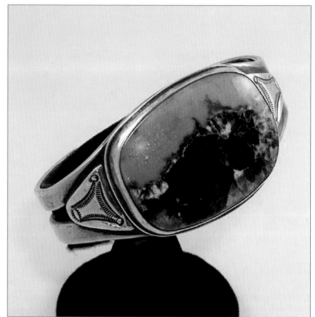

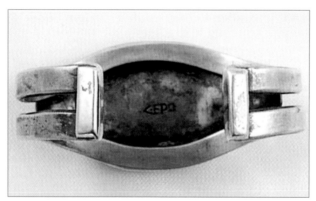

BRACELET AND PIN SET. Malachite blended chrysocolla and sterling, ca. 1964. Bracelet size: 7. Maximum height: 1.7". Maximum width of pin: 3". Signed: FP over a short arrow. Fred Peshlakai was passionate about using beautiful stones as is demonstrated in these spectacular examples. Heavy flattened silver bands on the bracelet offer a robust presentation for the stone's slightly incurved and shadow-boxed back plate, which is also present on the brooch. The applied side elements appear simple at first, but their carefully formed incurving at the stone's edge and sharply angled approach to their terminals balances the pieces while creating visual movement. *Both courtesy of the R.F. Koda collection.*

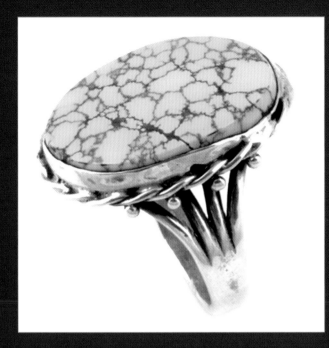

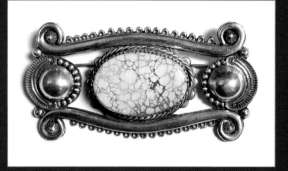

OPEN-WORK PIN AND RING SET. Number 8 turquoise and sterling. Pin's maximum width: 2.75". Ring size: 9.75. Maximum height: 1". Signed: FP over a short arrow. Familial stones and complicated silver work highlight this set. Fluidly shaped elongated wires, each studded with 17 pierced raindrops, are meticulously balanced with 17 separate elements on both ends of this complicated pin. Braided hand-pulled wire and a rare serrated bezel augment the stone's matrix. The ring, which calms the ensemble, makes pertinent use of the same size of tiny raindrops that were used on the inner edge of the larger domes of the pin. The ring's more loosely twisted wire, cantilevers off the rim of the stone's vertical bezel, adding to its lighter presentation. *Both courtesy of Waddell Trading, Scottsdale, Arizona.*

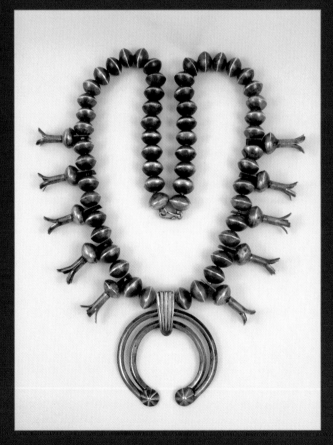

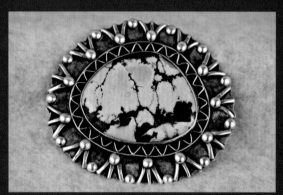

FALLING WATER PIN. Bisbee turquoise and sterling, ca. 1964. Maximum width: 2.65". Signed: FP over a short arrow. Raindrops with tails, which gravitate toward the beautiful stone, are all arranged on a back plate that is cut to mimic the stone's shape. The stone is surrounded by a continuous flat ribbon wire that is stood on its edge in a zigzagged arrangement of waves. The back plate is crosshatched on its surface face, which provides a matte backdrop for the polished appliqués. Water and its mythical association to turquoise is clearly the theme of this perfectly balanced example. *Author's collection.*

OLD STYLE SQUASH BLOSSOM NECKLACE. Sterling, ca. 1966. Maximum diameter of najahe: 2.5". Signed: FP over a short arrow. Fred Peshlakai was not adverse to simpler forms as is demonstrated in this traditional-style necklace that mirrors an early twentieth-century style. Created entirely by hand and using traditional methods of doming the separate halves of the bead elements, the lozenge-shaped beads are combined with the carinated arched portions of the pendant to complete its nineteenth-century presentation. This example shows that John Strong was quite right in stating that he felt Fred appeared to become increasingly Navajo in his later days. *Courtesy of the Gloria Dollar collection.*

This spectacular belt was purchased by the Williams family in the mid 1960s during their association with Fred on Olvera Street in Los Angeles. Although it is not documented as a custom order, John Strong relates that almost all of Fred's output was custom-ordered during the last ten years of Fred's life. Although other Diné artists have made this traditional design of belt, Fred's intrinsic expression of quality reverberates clearly throughout the artwork. First Phase-style triangular centers, which are in-framed with a straight line inside the stamped arches surrounding the cut opening, are offset by the deep black of the leather, which provides a striking contrast to the lyrically stamped conchas.

Perfectly matched clear blue stones sparkle from their serrated bezels, while tiny stamped raindrops perch at the terminals of each exterior arched stamp. The concha's scalloped outer edges echo across the separate elements with a convergence of unified and perfect symmetry.

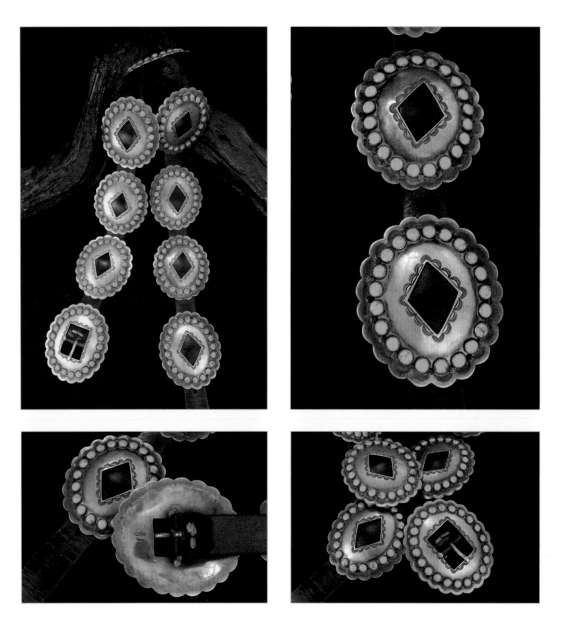

CONCHA BELT. Blue Gem turquoise and sterling, ca. 1964. Maximum width of buckle: 3.25". Signed: FP over a short arrow. *Courtesy of a private collection; Brown's Trading Company, purveyor.*

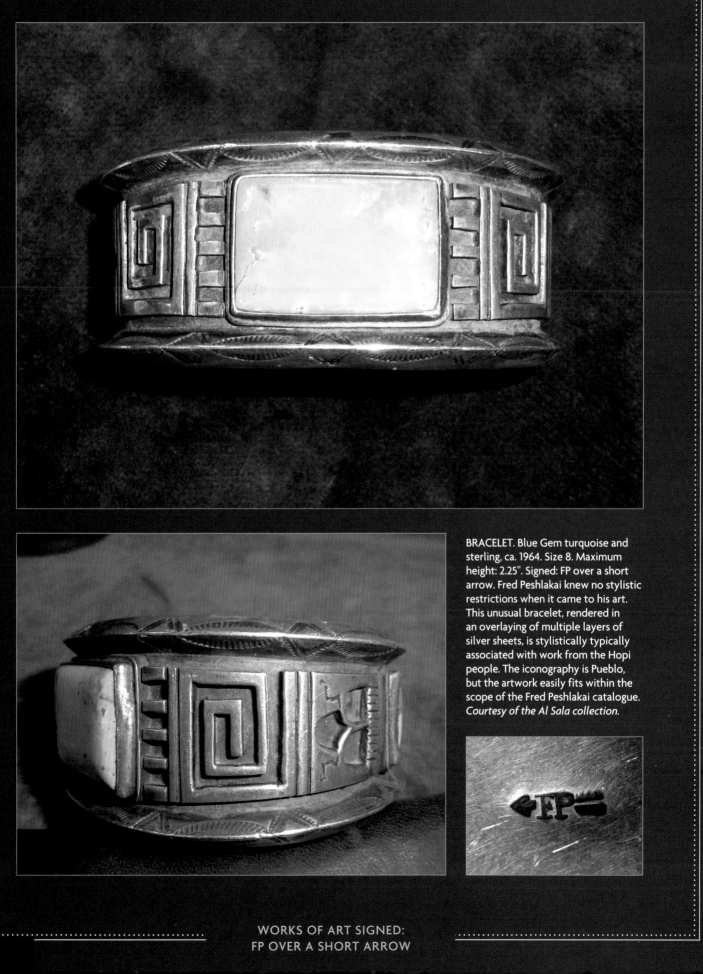

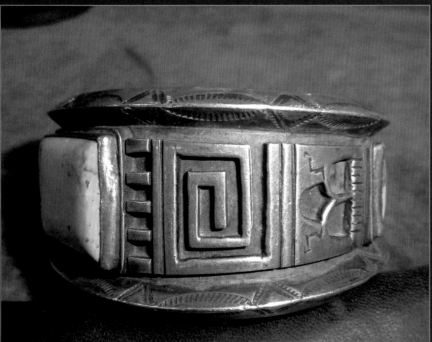

BRACELET. Blue Gem turquoise and sterling, ca. 1964. Size 8. Maximum height: 2.25". Signed: FP over a short arrow. Fred Peshlakai knew no stylistic restrictions when it came to his art. This unusual bracelet, rendered in an overlaying of multiple layers of silver sheets, is stylistically typically associated with work from the Hopi people. The iconography is Pueblo, but the artwork easily fits within the scope of the Fred Peshlakai catalogue. *Courtesy of the Al Sala collection.*

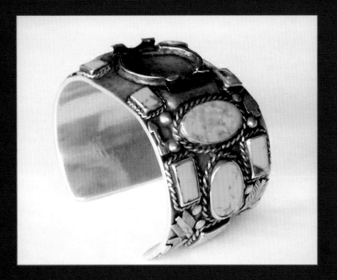
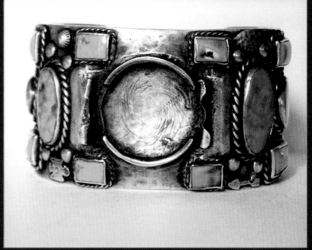
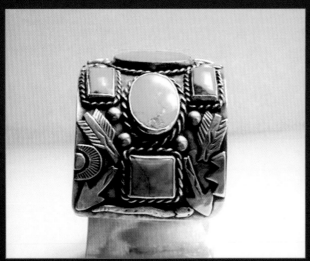
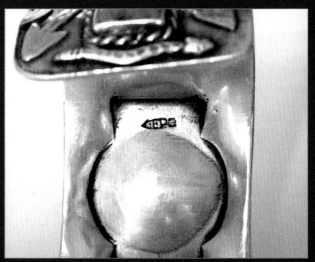

MAN'S WATCH CUFF. Blue Gem turquoise and sterling, ca. 1964. Blue Gem turquoise and sterling. Size: 7.5. Maximum width: 1.75". Signed: FP over a short arrow. Fred Peshlakai had a very well developed sense of humor as is demonstrated by this whimsical design. Patterned after the Fred Harvey Era tourists style of the early twentieth century, Peshlakai used broken arrows, snakes, arrowheads, and thunderbirds, all of which were individually applied, in order to duplicate that particular style. The atypical arrangement of variably shaped stones and the heavy silver work remain quintessentially Fred Peshlakai's. Those familiar with the work of Mr. Peshlakai almost always view this piece quizzically at first until they see the hallmark. It's certainly worth the smile Fred was hoping for. *Courtesy of the Martin and Lisa Monti collection.*

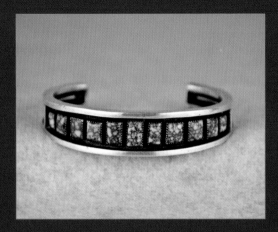
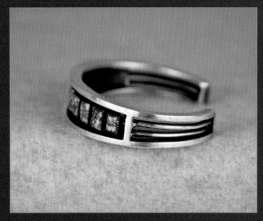

MODERNIST BRACELET WITH ELEVEN STONES. Lone Mountain turquoise and sterling, ca. 1961. Size: 6.75. Maximum height: .6". Signed: FP over a short arrow. From traditional to modern, Fred Peshlakai's mastery of design knew no bounds. This riveting example, and its incorporation of nine differently sized stones, transcends any barriers of creative captivity. Its simplicity disguises the perfect angularity of the seamless silver work that causes the eye to visit each of the stones individually, a feat that is further provoked by each stone's surrounding dots of reflected light that are created by the addition of Fred's rarely used serrated bezels. *Courtesy of the Gloria Dollar collection.*

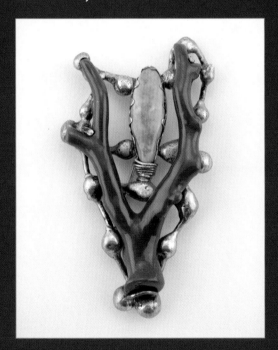
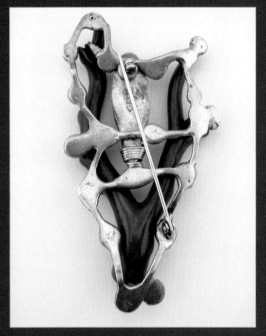

FREEFORM PIN. Mediterranean red coral, turquoise and sterling, ca. 1965. Maximum height: 3.75". Signed FP over a short arrow. Fred Peshlakai's innovations continued over the entire course of his career as is demonstrated with this striking and exceedingly rare example. The silver in the setting was shaped by dipping the ends of short wire segments into molten silver before being assembled, which allows the slumped silver mounts to retain an overall liquefied appearance. This format of wateriness perfectly complements the only known example of Mediterranean branch coral currently catalogued within Fred's repertoire. Casually wrapped wire at the base of the turquoise stone and rounded undulating bezel teeth repeat the oceanic feel of the artwork's theme. *Courtesy of the Gloria Dollar collection.*

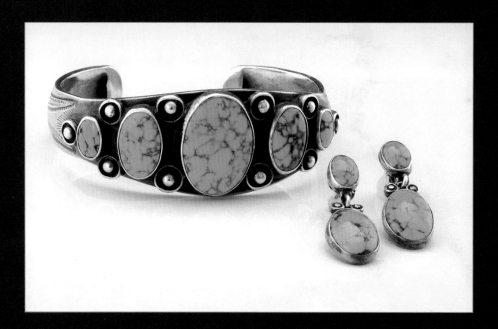

BRACELET AND EARRING SET. Number Eight mine turquoise and sterling, ca. 1962. Size: 7. Maximum height: 1.2". Signed: FP over a short arrow. Although only the bracelet is hallmarked n this set, the wires that encircle the raindrops and the matched turquoise stones tie the ensemble together. Signing only one piece in a suite could be considered typical of Fred Peshlakai. *Courtesy of the Gloria Dollar Collection.*

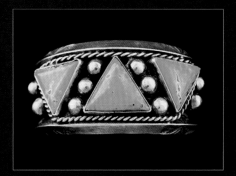

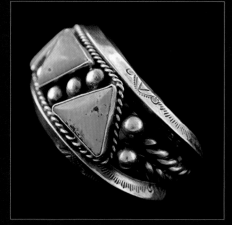

TRIANGULAR STONE BRACELET. Burnham turquoise and sterling. Size 7. Maximum height: 1.65". Signed: FP over a short arrow. The arrangement of triangular stones is brought into balance by the use of ten large repoussé raindrops accompanied by the hand pulled and twisted wire framework that surrounds the stones. The pairs of raindrops on each flanking side of the bracelet's face are placed outside the twisted wire, where they also become the terminals of the upward spiraling and heavier midbody twisted elements. Their duality of purpose provides fluidity to this otherwise angular stone positioning. Delicate stamp work softens and refines the artwork. *Courtesy of the Linda Kennedy-Baden collection.*

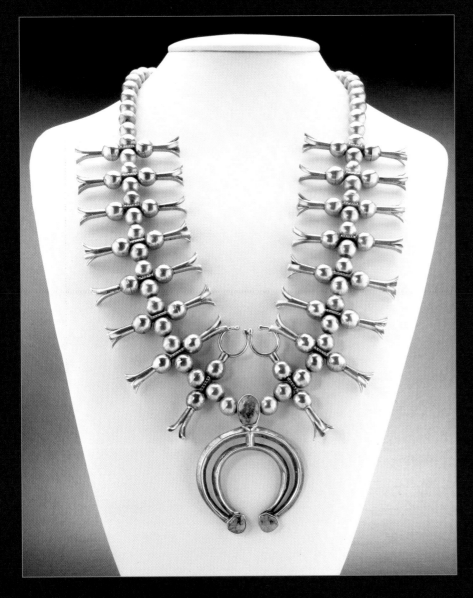

SQUASH BLOSSOM NECKLACE. Blue Gem turquoise and sterling, ca. 1963. Maximum horizontal width of najaje pendant: 2.25". Signed: FP over a short arrow. This brilliant necklace is fashioned after a similar necklace that was created by Fred's father, Slender Maker of Silver, for the noted Diné tribal leader Chee Dodge which is shown on page 49. Although it is not known if this design was a special commission for a discerning client or rendered by Fred out of personal nostalgia, the importance of the piece for its historical continuity within the art form is clearly evident. *Courtesy of the Gloria Dollar collection.*

FOUR WINDS BELT BUCKLE. Blue Gem turquoise and sterling, ca. 1972. Maximum measurements: 2.75" x 1.8". Signed: FP over a left-facing arrow. This buckle is among the last pieces of silver art ever produced by Fred Peshlakai. As documented, Fred had purchased an electric engraver in 1972, with which he likely signed only a very few pieces during the last year of his producing silver. The design

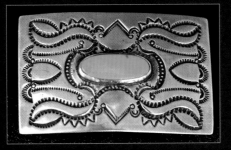

on the face of this piece, and its execution, is obviously of Fred's manufacture. Further, the particular stamp used on the four elliptically shaped Four Winds elements can be found elsewhere surrounding the smaller center repoussé elements at both ends of the piece shown on page 182. Here Fred has signed his art using his electric engraver in what can only be considered an endearing fashion to those who loved him and those who now have come to love his art. Fred was seventy-six years old when he produced this brilliant creation, leaving no doubt that he would still be at his forge to this day if his body had allowed. He's with his ancestors now, and doubtless they hold him in a place of honor as one of the most, if not the most, influential Diné artisan to impact the evolution of Diné silver art during the twentieth century. *Courtesy of a private collection.*

WORKS OF ART SIGNED:
FP OVER A SHORT ARROW

THE JOHN BONNER STRONG COLLECTION

IN AUGUST OF 1960, TWELVE-year-old John Bonner Strong peered over a chain that barred the entrance to an Indian silversmith's shop on Olvera Street in Los Angeles. Inside, working at his bench, was Fred Peshlakai. This was the beginning of a great friendship between the two men. John ultimately purchased more than forty pieces of Fred's work, twenty-seven of which are represented here. Mr. Strong's enormous contributions to this study of Fred's art cannot be underappreciated. He may very well be the only surviving person who knew Fred personally, and he also studied silversmithing from Fred for thirteen years. Mr. Strong has a remarkable memory, and as such, much of the biographical information regarding Fred's character in this book was obtained during lengthy recorded interviews with Mr. Strong between 2009 and 2012. Further, as a silversmith himself, his insights into the art have been integral to the discussions presented here.

It's easy to imagine the quizzically amused look on Fred's face regarding this young boy who could discuss the nuances of Native cultures at such a young age. John became a regular fixture at Fred's shop, spending long hours in quiet observation and excited banter about the technical aspects involved in creating silver objects and their often spiritually symbolic designs.

John remembers Fred as being an amazing man. When asked what was important to him to have included in this book, John replied, "What I'd like everyone to know about Fred is how highly intelligent and articulate he was. He was the kindest and most gently spoken person I have ever known,

not ever having a bad word to say about anyone. Fred was always truly happy and smiled all the time."

Regarding Fred's silver artwork John remarked, "Fred Peshlakai was the Master. Every piece Fred made was perfect. If there was a way to produce a design, Fred always seemed to use elements that were ten times harder to execute. Intricacies and nuances in the tiniest details are traits that Fred used as a matter of course in the pieces he created. They are quietly elegant and seem effortlessly made, but the skill required to make them was incredibly evolved, requiring deep knowledge of the silversmith's art and years of practical experience and an innate ability. Fred seemed to just know how to do things with silver. Knowing how difficult it was for those art pieces to be executed, especially using the tools and techniques that Fred used, is a never-ending source of inspiration. His skill was a natural born talent he possessed. He was easily the most influential Navajo silversmith of the twentieth century. I'm grateful that people are getting a better chance to know just how brilliant and wonderful an artist Fred was. It's been something I've wished for all my life" (Strong, 2012, CD No. 3).

One has only to review the pieces of silver Fred Peshlakai made for Mr. Strong to recognize the impact Fred had on John's life. Masterpieces in the collection were made for him when John was sixteen and seventeen years old and give insight into the technical complexity of their educational exchange.

John also met his own wife at seventeen, and they were involved with the Native American community in Los Angeles and other activities typical of a young couple. However, John

John Strong. 2012.

found time to visit Fred and endlessly discuss Fred's current creations as well as the state of the world and international events. John recalls arriving at Fred's shop one day and Fred rushing back out into the street to see if he could catch his brother, Frank Peshlakai, who had just been visiting with him. Although Frank was not to be found, John was able to purchase several rings of Frank's manufacture that he had left with Fred that day.

John Strong purchased his last piece of silver from Fred in 1972. This interesting anomalous example was a custom order that had been rejected by a different client. Fred's source for stones, Doc Wilson, had passed away, and Fred was struggling to obtain his usual materials. Also, at seventy-six years old, Fred was extremely ill, a truth that was possibly finally beginning to reveal itself within Fred's art. Fred was excited, however, and signed the piece for John Strong using Fred's most recent purchase, an electric engraver, with which he laughingly signed with a flourish what would turn out to be the last transaction between these two great friends. Mr. Strong now lives in New Mexico, up in the pinyon pine forest not far from Zuni Pueblo. He acquired his peaceful home after parting with his Fred Peshlakai collection, which he had kept for more than forty years. He believes Fred likely would have wanted it that way.

The individual art pieces contributed from the Strong collection are important. Primarily, they add rare dating sequences for known material from Fred Peshlakai's catalogue. Secondarily, they refute the notion that Peshlakai's work had become overtly Mexicanized in its design style due to his tenure on Olvera Street in Los Angeles. Mr. Strong mentioned repeatedly in interviews for this study that, if anything, Fred only became more traditionally Navajo during the course of his long career. The pieces in the Strong collection demonstrate that truth very clearly. Lastly, they refute the suggestion that Fred Peshlakai's work suffered in his later years, except perhaps during the last six months of Fred's residency at Olvera Street. The collection presents several examples that will undoubtedly persist among the pinnacle masterpieces of this brilliant world-class artist.

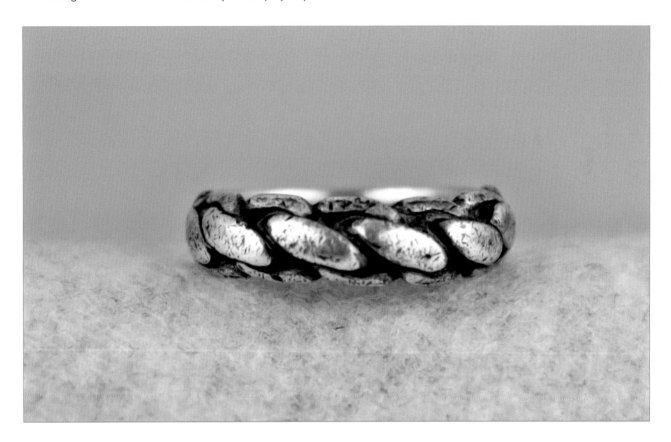

JBS #1. BRAIDED, HAND-PULLED WIRE RING. Sterling. Purchased in August, 1960, on the first meeting between Fred Peshlakai and John Strong when John was twelve years old. Size: 8.5. Maximum height: .35". Unsigned. This particular ring appears simply wrought but was assembled in two sections. The braided face as well as the larger wire verso were both preliminarily flattened into their half-round forms within a groove on Fred's anvil before being assembled, leaving the palm side smooth and only the top with a braided reveal. *Author's collection.*

THE JOHN BONNER STRONG
COLLECTION

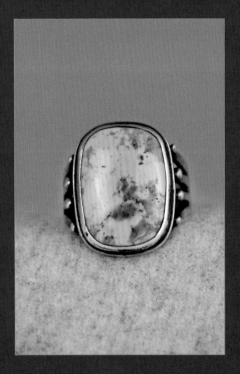
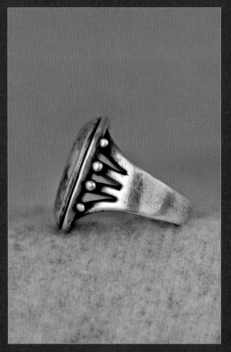

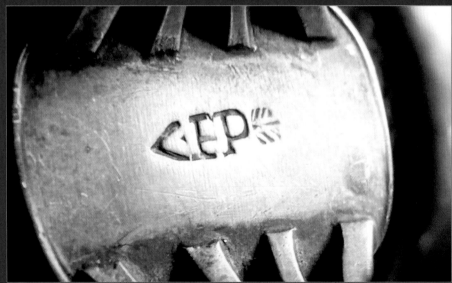

JBS #2. RING. Blue Gem turquoise and sterling. Purchased: September, 1960. Size 10.5. Maximum height: 1". Signed: FP over a short arrow. *Author's collection.*

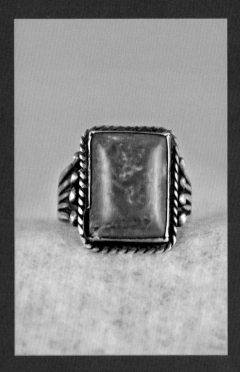
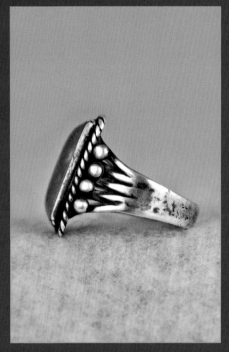

JBS #3. RING. Green Blue Gem turquoise and sterling. Purchased: November, 1960. Size: 10. Maximum height: 1". Unsigned. Fred Peshlakai often used the extremely difficult technique of cantilevering the hand pulled and twisted wire to the bezel plate surrounds on pieces of his manufacture. This technique requires considerable finesse since the edge for the plate is typically very thin; this is rarely accomplished without the solder being visible and is a feat not often exhibited by any other artist. *Courtesy of the John L. Skinner collection.*

JBS #4. CUSTOM WATCH BAND. Battle
Mountain and Tonopah turquoise and
sterling. Size: 7. Maximum height: 1.5".
Purchased: January, 1961. Signed: FP over
a short arrow. This beautiful example
clearly demonstrates a soft stippling in
the field between the stamp work on the
bracelet's sides. This texturing technique is
more difficult than it appears, requiring a
gentle touch to avoid an over-impression
of the individual die strikes. The long, 1.65"
arched stamps on the band's outside edges
are classic creations of Fred Peshlakai.
Courtesy of a private collection.

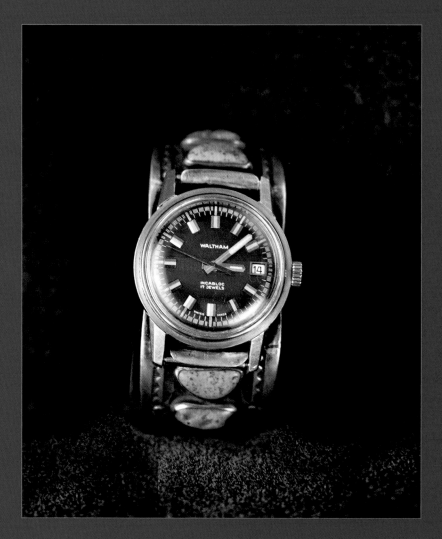

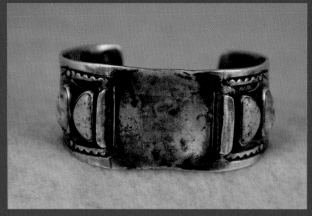

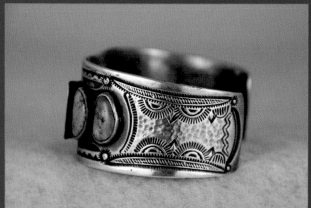

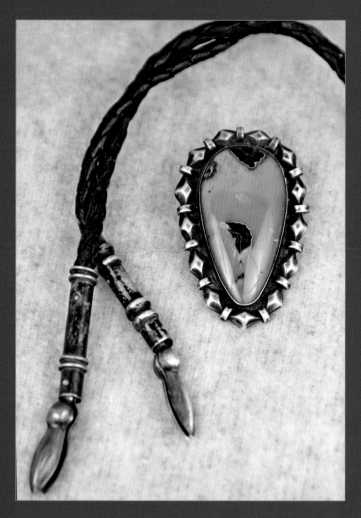

JBS #6. INVERTED TEARDROP BOLO TIE. Gem Crysocholla and sterling. Purchased: Summer, 1962. Maximum height: 2". Signed: FP over a short arrow. Fred Peshlakai described this design as "Diamonds and Rainbows" in reference to the twenty-six individual applied repoussé elements that surround the striking stone. Peshlakai's unique terminal elements for this bolo tie are hollow, each with a pair of repoussé clappers that move independently inside their mounts. *Courtesy of the John L. Skinner collection.*

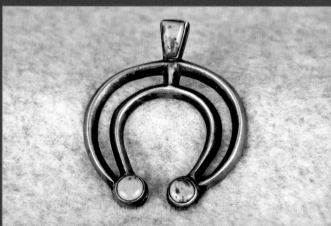

JBS #5. CUSTOM NAJAHE. Blue Gem turquoise and sterling. Purchased: April, 1961. Maximum height: 2.16". Unsigned. Although appearing as pounded carinated wire, this pendant is actually sand cast. *Courtesy of the John L. Skinner collection.*

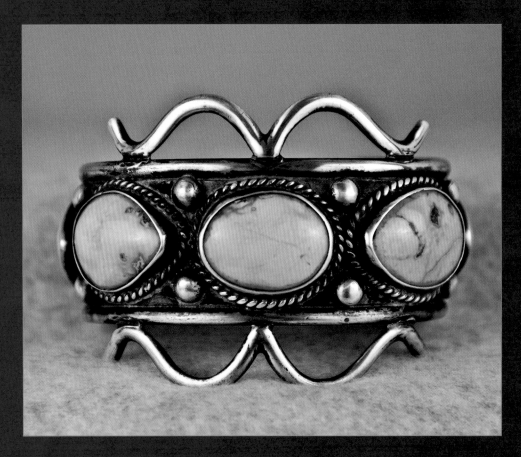

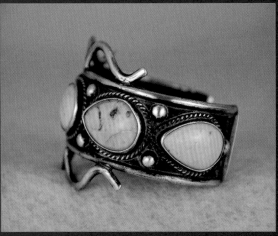

JBS #7. UTAH VERISCITE AND STERLING. Purchased: December, 1962. Size: 7. Maximum height: 2". Fred Peshlakai loved beautiful stones, as is shown again in this beautiful custom order for the fourteen-year-old John Strong, who had provided them to Fred for this particular piece. The outside stones are inverted from the typical with their narrow ends pointed inward, maximizing the focal point of the center stone. This unexpected arrangement of the stones appears on many of Fred's creations. The smooth .16" wires with their flat-backed larger size are painstaking applied to the band's outer edges creating a shallow shadow-box effect. The large individual raindrops were repoussé created. The resulting visual simplicity of the design again belies the technical prowess required for its creation, a trait typical of so many of Fred Peshlakai's artistic masterpieces. *Courtesy of a private collection.*

Fred Peshlakai was able to demonstrate his personal style while staying inside traditional forms, a trait that few other artists have accomplished. The intricacies of the individual dies he created, combined with unique embellishments of traditional Diné design layouts, converge to uplift the art form to new heights of possibilities. Fred was among the first to demonstrate this quality and was producing such works as early as the 1930s, far outreaching the counsel of the traders who were attempting to steer the genre for the mutual benefit of those concerned. Fred's imaginations for the pieces he created also far outpaced his contemporaries in innovating what was possible during the entire length of his career. He was, however, always willing to teach and help others, which he continually did. Echoes of his influence on the art form are still discernable today in the work of other artisans, whether they realize its source or not.

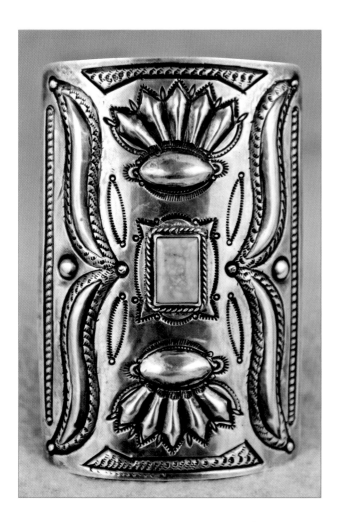 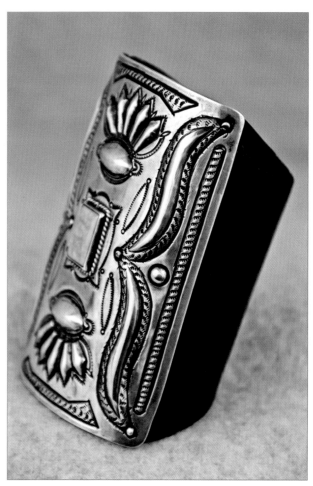

JBS #8. SINGLE STONE KETOH OR BOW GUARD. Blue Gem turquoise and sterling. Purchased: May, 1963. Maximum height of faceplate: 4". Signed: FP over a short arrow. Fred Peshlakai and John Strong's friendship was strengthened by their mutual love of traditional Navajo designs as is exemplified in this custom arm guard based on a nineteenth-century Diné form. Endless hours were shared discussing the nuances of each creation. The large elliptic repoussé elements are Four Winds designs found in ancient Diné sand paintings and later also found in modified versions of classic Storm Pattern Navajo weavings. Lozenge repoussé elements are crowned by pointed repoussé elements that represent Eagle Tails and celebrate the sun's journey inside the cosmos. The center stone represents the wearer's place inside the natural order of all things, perfectly in balance with his Hozho. Silver artwork must be decoratively stamped prior to being repoussé domed, making their individual planning essential to the finished artwork. The stamped design shown on this spectacular example required approximately 435 individual hammer strikes to create. *Courtesy of the John L. Skinner collection.*

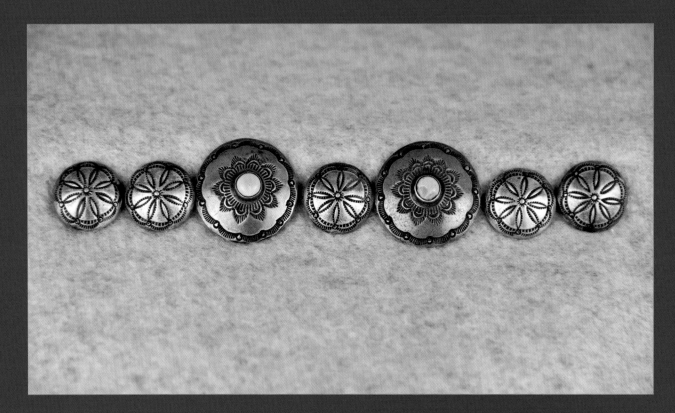

JBS #9. TWO MOCCASIN BUTTONS AND FIVE SHIRT BUTTONS. Blue Gem turquoise and sterling. Purchased December, 1964. Maximum diameter: 1.016". Unsigned. The detail on these buttons is surprising due on their small size. The fine, closely spaced teeth evident on most of the iron dies made by Fred Peshlakai defy explanation when it's considered that Fred's tools were entirely handmade. *Author's collection.*

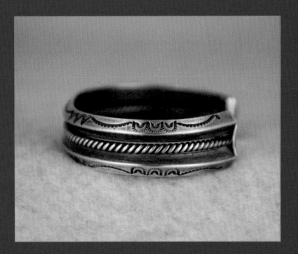 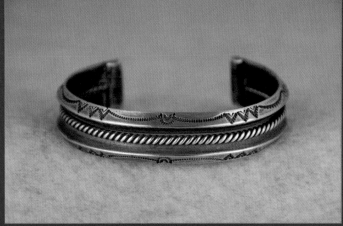

JBS #10. DOUBLE CARINATED BRACELET. Purchased: December, 1964. Size 6.75. Maximum height: 1". Unsigned. Although similar to bracelets made by other artisans who used this traditional form, the intricacies in Fred's stamp work make his creations stand alone. *Author's collection.*

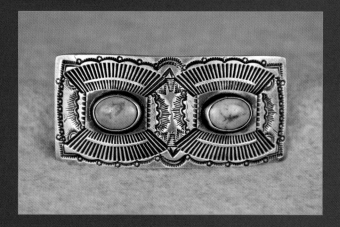

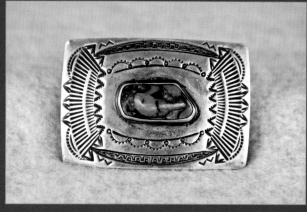

JBS #11. BELT BUCKLE WITH FOUR EAGLE TAILS. Blue Gem turquoise and sterling. Purchased: January, 1965. Maximum width: 3". Signed: FP over a short arrow. Fred delighted in the interplay of negative and positive shapes that occurred when stamps combined together on the surface of a piece he was designing. This fascinating example clearly shows Fred's use of multiple iconic stamps from his catalogue to create a subliminal secondary theme. *Courtesy of the John L. Skinner collection.*

JBS #12. DOUBLE EAGLE TAIL BELT BUCKLE. Freeform Bisbee turquoise and sterling. Purchased: April, 1965. Maximum width: 2.35". Signed: FP over a short arrow. This buckle has a cosmological association in its traditional Diné design. *Courtesy of the John L. Skinner collection.*

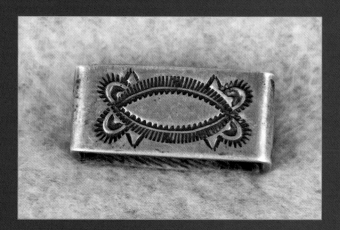

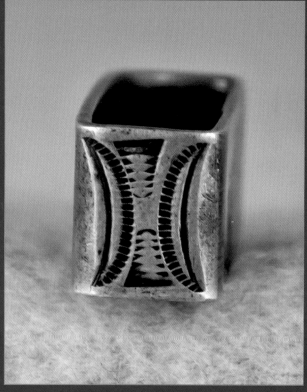

JBS #13. BELT KEEPER. Sterling. Purchased: March, 1965. Maximum width: 1.5". Unsigned. Even the mundane received special attention from Fred Peshlakai. *Courtesy of the John L. Skinner collection.*

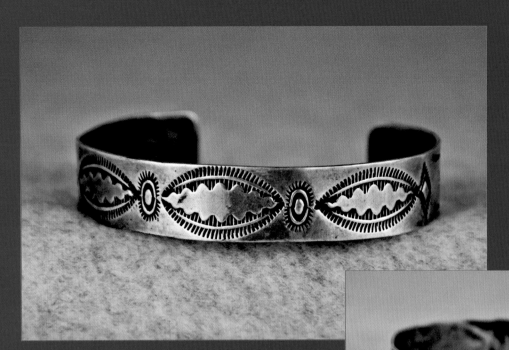

JBS #14. STAMPED CUFF. Sterling. Purchased: June, 1965. Maximum height: .5". Unsigned. John Strong was seventeen years old and poor yet still collected Fred's art work during this period. Simple silver bands were custom ordered and discussed between the two artists as Strong's education in the silversmith's art continued. *Courtesy of the John L. Skinner collection.*

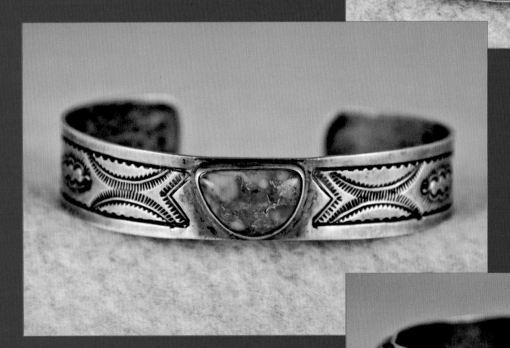

JBS #15. STAMPED CUFF. Blue Gem turquoise and silver. Maximum height: .5". Purchased: June, 1965. Unsigned. John Strong purchased a Ketoh that preceded the creation of this piece and had broken and lost half of its original stone. Fred reset the remaining portion in this cuff. This piece shows the use of several of Fred's iconic stamps, including the notched border stamp, the finely rayed arches and an undulating rayed arch which, when joined, create a cloud symbol. *Courtesy of the John L. Skinner collection.*

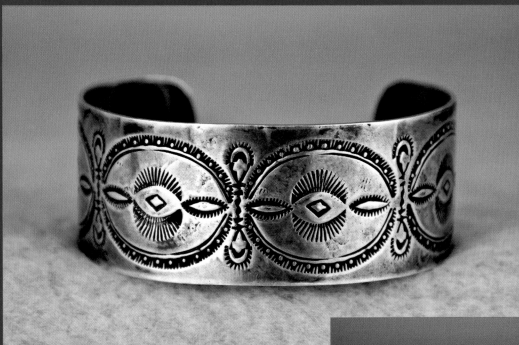

JBS #16. STAMPED BRACELET. Sterling. Maximum height: 1".
Purchased: August, 1965. Unsigned. Beautifully balanced and
designed, this wonderful example clearly demonstrates why
Fred Peshlakai created the dazzling array of different dies to
create his artwork. Endless combinations of forms and figures
entertain the eye, yet always emit the impression of solidity
within the character of each piece. *Author's collection.*

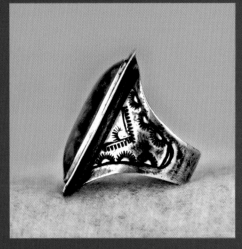

JBS #17. SHADOW BOX RING. Sterling and Canadian Jade. Purchased September, 1965. Size: 10.5.
Maximum height: 1". Unsigned. Although the stone is slightly trapezoid-shaped, Fred was able
to create a seamless back plate for the stone that curves slightly inward producing a shallow
shadow-box effect. Fine stamp work on the band dramatizes the clearly intended restraint in the
presentation of the ring's face. *Courtesy of a private collection.*

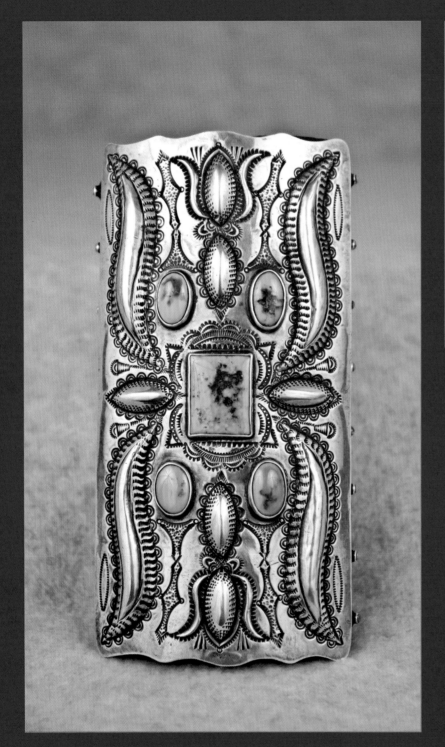

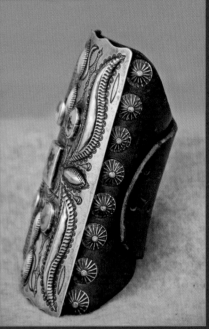

JBS #18. KETOH. Blue Gem turquoise and sterling. Purchased: December, 1965. Maximum face plate measurements: 5.5" x 3". Hallmarked twice: FP over a short arrow. A masterpiece from the career of Fred Peshlakai, this peerless example of Diné silver art was purchased by Mr. Strong when John was seventeen years old. In the Strong interviews for this book, John states that Fred wanted to wow his student when he made this custom order for his pupil. He succeeded. Hours could be, and were, spent discussing the nuances of what is obviously one of the finest pieces of traditional Diné silver art ever created. It required approximately 1280 individual hammer strikes to at least twenty-five different dies to complete. Further, this near estimate does not take into account the time it took to prepare the original design, cut the scalloped plate, set the stones, or create the side buttons. *Courtesy of a private collection.*

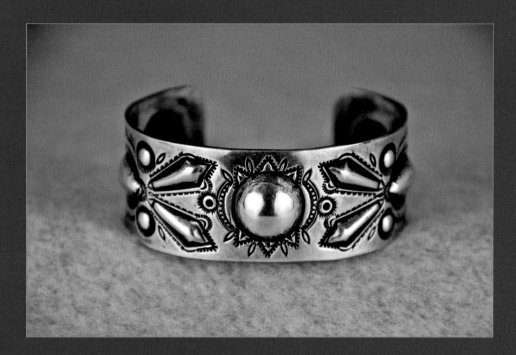

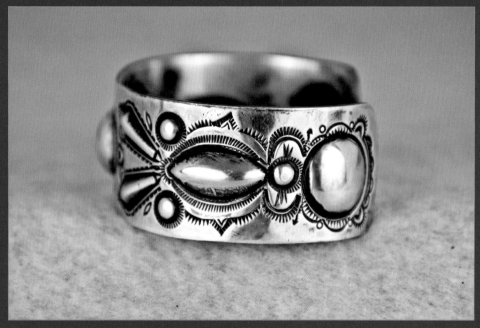

JBS #19. REPOUSSÉ BRACELET. Sterling. Purchased: February, 1966. Size: 7. Maximum height: 1".
Signed: FP over a short arrow. The distinctive signature of Fred Peshlakai's design style is clearly
exhibited on this beautiful example. Tiny elements within the stamps, combined with the fluidity
of engraving-like lines, dance across the surface. The use of many different dies dazzle in their
combinations, leaving a result anything but static, yet the complete work is still perfectly in
balance. *Author's collection.*

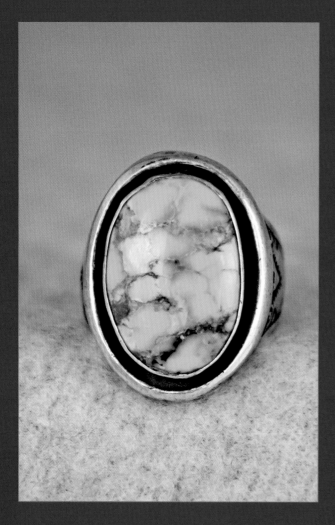 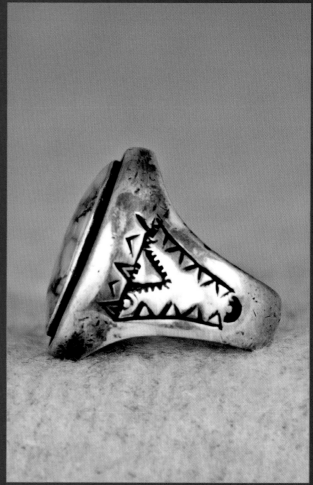

JBS #20. SAND CAST RING. Nevada turquoise and sterling. Purchased: May, 1966. Size 7. Maximum height: 1.15". Signed: FP over a short arrow. Sand cast pieces do occur in the artist's catalogue although they are relatively rare. The stone is set inside a shadow box surround that accentuates its bold nature. The piece is meant to be heavily forceful and anything but subtle. *Courtesy of the John L. Skinner collection.*

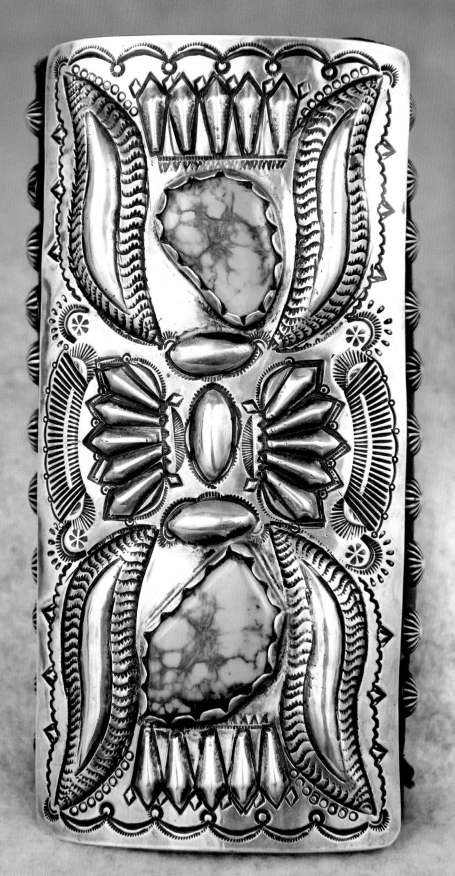

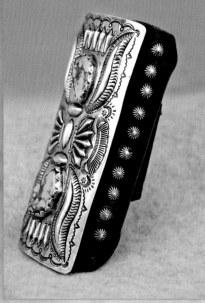

JBS #21. REPOUSSÉ KETOH. Freeform Bisbee turquoise and sterling. Purchased: December, 1966. Maximum plate measurements: 6" x 3". Unsigned. A tour de force of the silversmith's art, this spectacular example represents a century-long culmination in Diné traditional silver art. Rendered within a Four Winds design layout are six modified Eagle Tail representations aligned with the cardinal directions. The eternal movement of the natural world is strongly communicated inside a place that proves that harmony, achieved through staying in balance within natural order, articulates itself as an energetic presence. This state of being results in an expression of beauty and is portrayed purposefully inside the highest forms of traditional Diné art. *Courtesy of a private collection.*

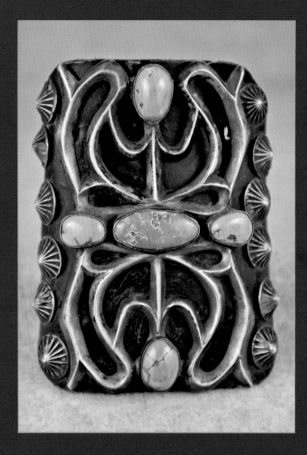

JBS #24. SAND CAST KETOH. Blue Gem turquoise and sterling. Purchased: December, 1967. Cast element measures: 4" x 2.5". Unsigned. The impressions in the sand, into which the liquid silver was poured, were produced by first creating the lead cast master, also shown here. *Courtesy of a private collection.*

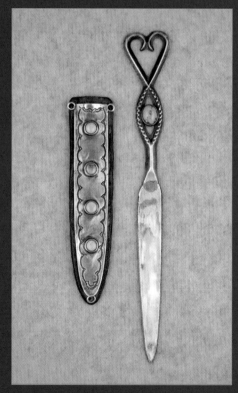

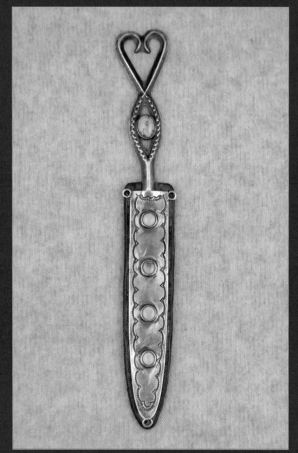

JBS #22. BOOT KNIFE AND SHEATH. Blue Gem turquoise and sterling. Purchased: May, 1966. Overall maximum length: 7.5". Unsigned. Fred made this custom order for the eighteen-year-old John Strong as an accessory to his street apparel. The sand cast knife itself was provided by John to Fred Peshlakai, who modified it by setting the stone on its haft. Fred then created the leather sheath with its decorative plate, complete with small circlets for the boot knife's lacings. *Courtesy of the John L. Skinner collection.*

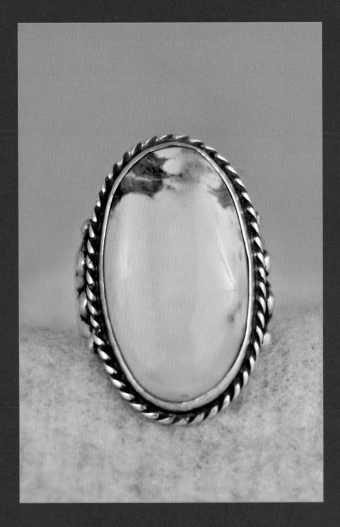
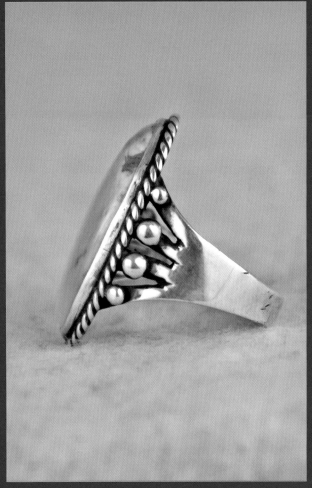

JS #25. OVAL STONE RING. Blue Gem turquoise and sterling. Purchased: May, 1971. Size: 10.5. Maximum height: 1.15". Unsigned. The cantilevered twisted wire surround and graduated raindrops on the shoulder speak to Fred's discernment. *Courtesy of the John L. Skinner collection.*

JBS #23. CONCHA BELT. Blue Gem turquoise and sterling. Purchased: May 1967. Seven oval conchas, eight butterflies and buckle. Maximum measurements: Buckle: 3" x 2.5". Conchas: 3" x 2.5". Butterflies: 2" x 1". Signed on the buckle: FP over a short arrow. Concha belts were not uncommon within the artist's production although few have surfaced in recent years. John Strong related that he never used the installment method when purchasing from Fred Peshlakai. He recalls Fred having a concha belt in his case (a rarity for anything at any time during their friendship) and John had saved every available dollar he could in order to purchase it without revealing his intent to Fred. When the princely sum of $100.00 was finally compiled, John went to Olvera Street only to find his conquest sold. Fred only laughed at John incredulously and informed him he would make one for him. The beautiful result is shown here. Although traditional forms were incorporated, the elements remain quintessentially in Fred's signature style. Finely made and unique stamps, rendered in complicated symmetry with fine repoussé elements, make this piece stand out as being made by the hand of the master. Fred's knowledge of John Strong's appreciation for traditionalism was incorporated into a timeless design, yet the piece still reverberates as "Peshlakai" to any proselyte of this great artist. The unique buckle is an intellectual break from the normal, yet still it could be considered traditional in every sense of the word. *Courtesy of a private collection.*

(Continued on following pages)

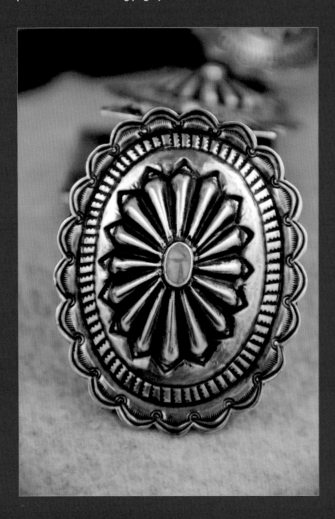

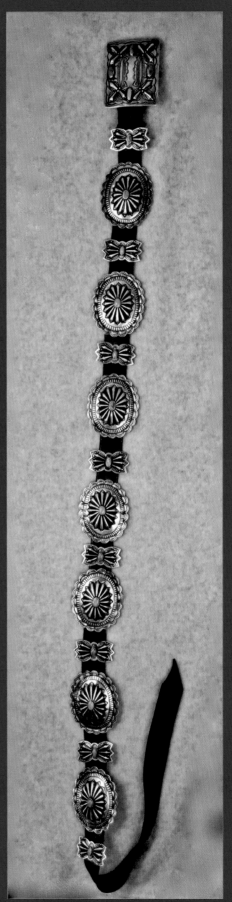

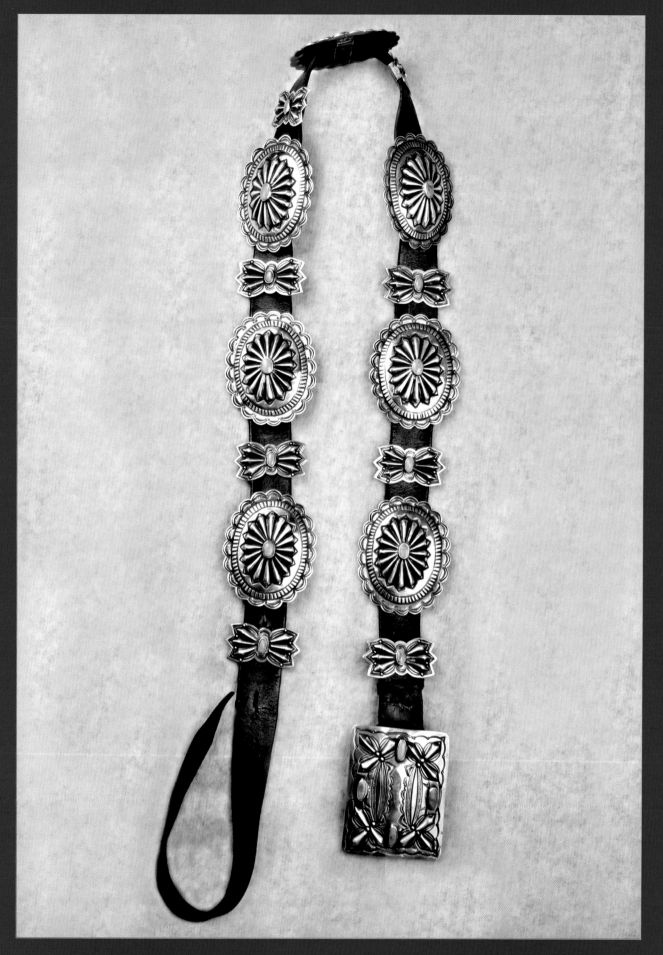

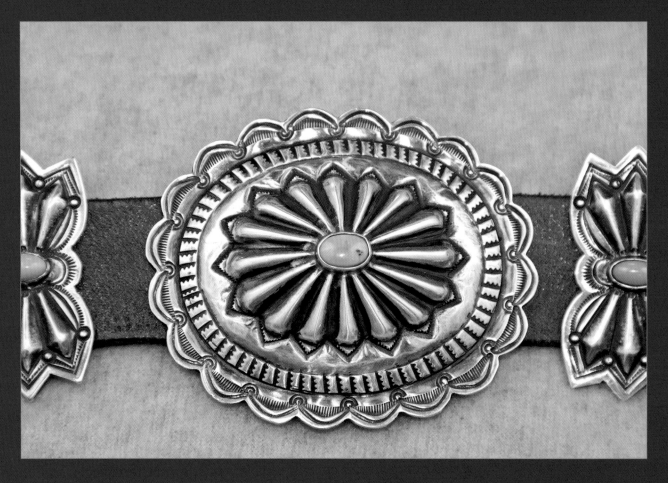

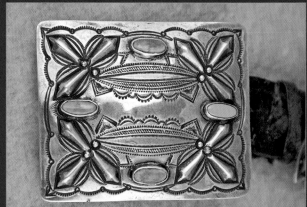

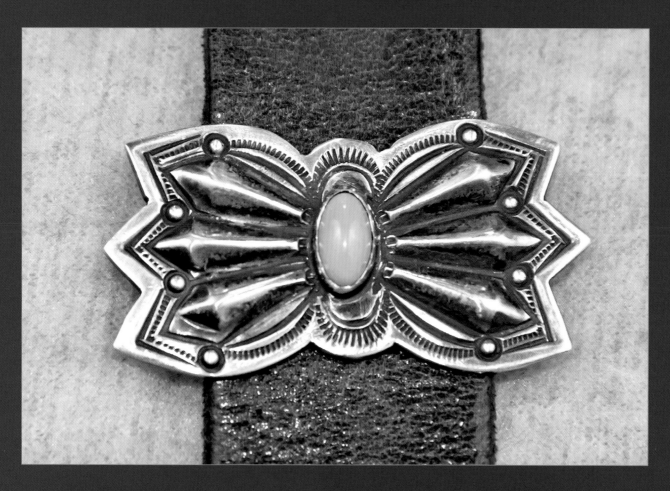

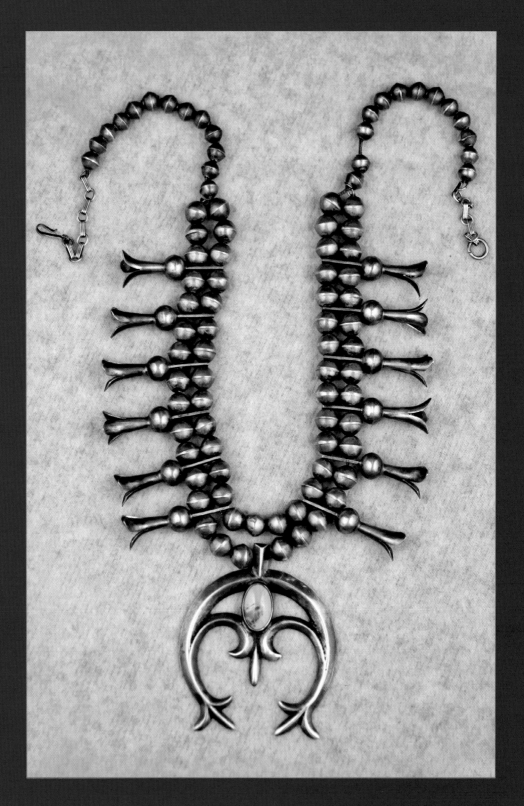

JBS #28. TRADITIONAL SQUASH BLOSSOM NECKLACE. Blue Gem turquoise and sterling. Maximum width of najahe: 3.25". Unsigned. Fred Peshlakai did not make this necklace, but he did mount the stone at the request of Mr. Strong, which demonstrates the absence of any restrictive ego in the character of Fred Peshlakai. The elegant shape of the najahe pendant is Tufa cast and completed in what is considered a standard layout of the beads and pomegranate blossoms typical of many similar pieces inside the artistic repertoire of the Diné. The striking Blue Gem turquoise stone uplifts this example into the unique sphere of Fred Peshlakai's caliber. *Author's collection.*

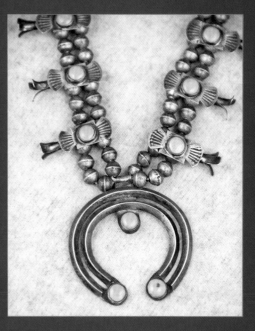

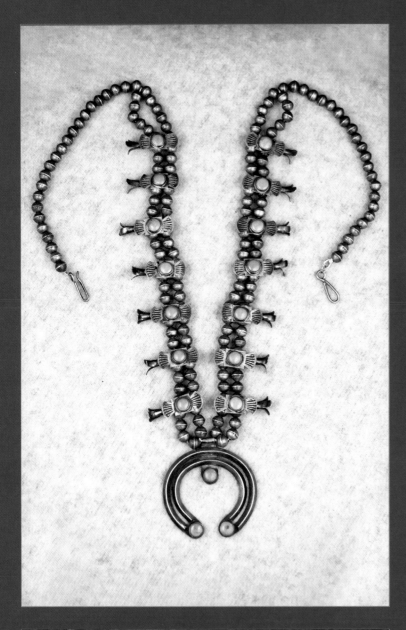

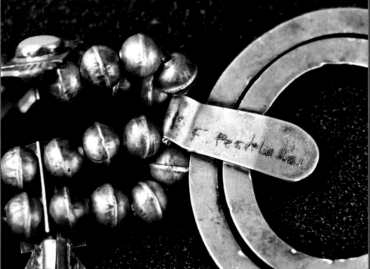

JBS # 26. BOX AND BOW NECKLACE. Blue Gem turquoise and sterling. Purchased: 1972. Maximum diameter of najahe: 3". Signed: F. Peshlakai. This was the last piece Strong ever purchased from Fred Peshlakai. Rejected by the client that had ordered it from Fred, John relates that he was subsequently able to acquire the piece from Fred and requested that Fred sign it. Fred laughingly produced his newest acquisition: an electric engraver, with which he signed this atypical example. Doc Wilson, from whom Fred had always acquired most of his stunning stones, had passed away and Strong feels this may be part of the reason for the ordering client's dissatisfaction with this thoroughly traditionally designed necklace. Certainly without the impeccable provenance that accompanies this piece, and the practically unknown fact that Fred did indeed sign a very few pieces with an electric engraver at the end of his career, this piece could easily have become lost among the hundreds of similarly designed examples that had been made frequently by many other Diné artists. All typical indicators that this is the work of Fred Peshlakai appear to be absent, leaving scholars to wonder at what events could precipitate in this surprising departure within Fred's art. It begs consideration that Fred's shop on Olvera Street would be abandoned within the year as Fred's health was declining rapidly, a sad truth that perhaps could be discerned in this piece. Fred's friend and indubitable advocate, John Strong, suggests that the overtly traditional form of the piece may have been requested by the patron, rather than indicating any demise in the artistry of his great friend. The end of an era was fast approaching. John Strong only saw Fred a few times after this piece was purchased. *Courtesy of a private collection.*

IN PASSIONATE PURSUIT OF PESHLAKAI

A DISCUSSION AND COLLECTORS' GUIDE

TODAY, IT IS GENERALLY ACCEPTED THAT FRED Peshlakai did, in fact, not sign all of his artwork.

It is suggested by those who knew him that, as an artist in love with the art-form, it became an inconvenience to have to plan the signing of his pieces in the formative portion of their design. Further, his innate humility and disdain of being considered famous seems to have prompted Fred to turn away from any requirement that his art-pieces always be signed. It is further hypothesized that this penchant increased as he got older, and that later in his career, he signed as few as twenty percent of the pieces he produced, and then only at the request of his clients. Based on the relative dearth of signed works known to exist, it appears that Fred's inclination to omit his signature could possibly have spanned most of his career.

A consensus taken among living silversmiths compiled for this study suggests that an artisan of the caliber of Fred Peshlakai, working full time, could easily have produced an annually rounded down figure of 200 pieces of silver art per year. Fred became a full-time silversmith sometime during 1929 and continued as such until sometime in 1971 when his health caused his output to diminish. His forty-two year career then suggests an overall catalogue of a staggering 8,400 pieces of jewelry completed during his lifetime.

With that figure in mind, consideration needs to be given to the fact that Navajo jewelry did not always retain its perceived value or popularity during the middle years of the twentieth century. This prompted an additional consensus, that perhaps fully as much as one half of Fred's jewelry was lost, broken, repurposed, or scrapped over the years, leaving a conservative possible remainder of 4,200 pieces. This hypothetical mathematical model is only suggested here as a point of interest. It will be many years before the entire catalogue of Fred Peshlakai can be assembled with any finality and there will always be the possibility of pieces being misidentified or omitted. Of further interest, too, is the disclosure that the many years of research for this book's particular study have revealed fewer than 500 signed examples of the work of Fred Peshlakai and allowed an inspection of an additional 200 pieces that had the potential to possibly be attributed to the artist. These figures are culminated out of the thousands of pieces reviewed overall and include those contributed by other contemporary scholars, collectors, knowledgable gallery owners, and curators alike. Although admittedly not likely even remotely final, the pieces currently recognized may indicate a smaller survival rate than the 4,200 pieces the above model suggests.

Fortunately, Fred Peshlakai had a unique perceived style to his art. The Hopi potter, Nampeyo of Hano, is another example of a great Native American artist who never signed any of her art, but her pottery has become almost instantly recognizable thanks to the large amount of study dedicated to her and her stylistic expression. Hopefully the following section of this book begins a similar dedication—one that will be added to for the future appreciation of the consummate art of Fred Peshlakai.

 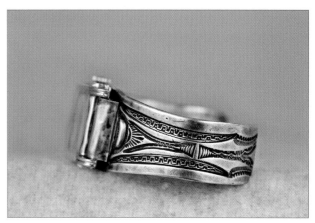

STAMPED WATCH BAND. Sterling, ca. 1965. Size: 7. Maximum height: 1". Unsigned. This beautiful piece could be considered a "chestnut" in its ability to be attributed to Fred Peshlakai. Here, the identification of the individual stamps used is made easy by their presence on well-documented, chronologically dated, and hallmarked examples of Fred Peshlakai's work. Although the provenance is lost, there is so little doubt that Fred was the creator of this piece that it could be argued it belongs in a different section of his catalogue. However, being unsigned, it remains technically "attributed". *Author's collection.*

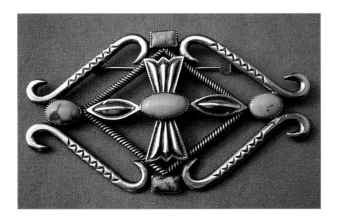 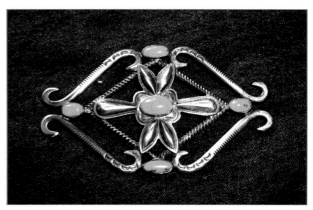

FOUR WAY OR FOUR WINDS PINS. Blue Gem turquoise and sterling. Maximum width: 3". Maximum height: 2". Unsigned. Considered iconic within the Fred Peshlakai repertoire, this design was a favorite of Fred's based on the relative abundance of examples known to be in collections. The sacred geometry reminiscent inside Diné tapestries and sand paintings is here represented by openwork motifs inside the elliptical heavy Four Ways stamped wires that give the pieces their unique shape. All examples vary somewhat in their embellishments, but all ultimately adhere to their cosmological tradition. Example with four separate repoussé center elements: *Courtesy of the Karen Sires Collection.* Example with six repoussé center elements: *Courtesy of the Nancy Conner Collection.*

The prospect of attributing unsigned art to any particular artist is a precarious adventure. Silver art could be considered especially so since there are few chemical analyses or age-related testing indicators that could be clearly associated with any particular artist. As such, it is wise to acknowledge that caution is recommended, especially in the face of prevalent skepticism. That is not to say that attributing work to someone like Fred Peshlakai is not possible, but it should be remembered that experts are just people after all and that without hard science to substantiate a claim, the field is subject to variable opinions that may or may not be spotless. However, getting these opinions in writing from a reputable authority is helpful to any future considerations.

Several factors help in the attribution process. One is that signing or hallmarking did not become the norm until sometime around 1970. Almost all contemporary silversmiths today hallmark their work. This eliminates a large section of contemporary artists from being the possible creator of much unsigned jewelry. Certainly any artist with the abilities to create pieces of the caliber of Fred Peshlakai would be signing their work unless they were engaged in questionable behavior. Evidence of age or wear also contribute, but is not always absolute since pieces were not always worn. However, the signs of some age certainly help when evaluating the piece being considered.

The best indicator is the presence of a unique stamped image on a piece of silver that can clearly be associated with the work of Fred Peshlakai. Fred Peshlakai made all of his silver dies by hand and they are generally very distinctive in their construct and are not easily reproduced. However, Fred is known to have gifted or sold his dies to people he liked and so other attributing factors must be considered.

It needs to be remembered that Fred was working in a time when few if any other Diné artists were producing at the level of pure individualized design that Fred was. This period is considered the Middle Phase in the evolution of the art form and was complicated by factors such as increased tool quality and availability of semi-processed supplies. Also, Anglo aesthetics were strongly dictating the type of jewelry being produced by most Diné silversmiths trying to make a living at their craft. These types of designs were what was robustly selling, and most of the Diné silversmiths of the time period were producing works directed toward that consumer.

After leaving the Charles Burke School at Fort Wingate in 1935, Fred was no longer restricted by the dictates of oversight by others. His last non-independent job at a production shop appears to have been at Vaughn's in Los Angeles in the late 1930s, and the Vaughn's management was primarily interested in offering high-quality work to their customers, and they were targeting a more art-minded patron of Diné silver. It was in this liberated spirit for innovation that Fred Peshlakai would affirm his intentions for being a unique and progressive artist, a temperament that he would adhere to for the rest of his life.

The layout of the overall design is another very strong indicator of the work of Fred Peshlakai. His arrangement of stamp work, stones, and overall shapes was never random. All of Fred's pieces were thoroughly planned out in advance and were sometimes sketched out prior to their being initiated. Fred was thoroughly familiar with the individual dies he possessed, but he was also known to make dies in order to accomplish a design he had imagined on paper (Art Tafoya, pers. comm.). His capacity for combinations of multiple finely made stamps enabled Fred to embellish a piece as if it were decorated with a fine-tipped engraver. A curvilinear fluidity is a marker for much of Fred Peshlakai's art. Few other Diné artists have ever been able to accomplish this feat. It is not fully understood how Fred could make such intricate and often minuscule detailed dies since he did not ever use machine assistance in their manufacture. These dies were made of very hard iron, and the sensitivity accomplished by Fred in their production often defies explanation. Close examination of some of Fred's pieces do reveal the use of a single-stroke engraver to complete the details for the design, but these are limited to small, single feathering strokes at intersections of certain elements that he felt needed refining.

Another indicator for the work of Fred Peshlakai is

Enlargement of a unique single-stamped design by Fred Peshlakai. Maximum width: 1.25". This iconic example of a large stamp by Fred Peshlakai is unique to the artist. Fred's stamps ranged from 1/16th of an inch to as large as 2" in length. Source: JS # 11. *Courtesy of the John L. Skinner collection.*

Part II: A Legacy of Art

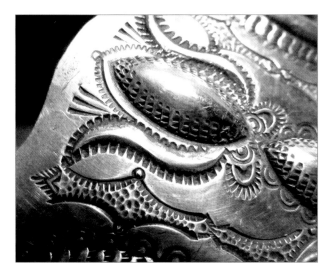

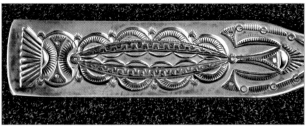

beauty of stones Fred used in his work. That period was exceeding brief and includes only very few examples of Fred's overall output.

Fred's favorite turquoise was Blue Gem (Strong, pers. comm.). The wonderful, clear blue color of this relatively hard type of turquoise is often highlighted by swirled, curved inclusions that appealed to Fred's sense of elegance. Fred did, however, use many other types of turquoise, although they appear to have all originated predominantly from the mines of central Nevada.

Sleeping Beauty or Kingman mine stones from Arizona were not present in any of the pieces examined for this study. Pieces incorporating turquoise from the Bisbee mine in southern Arizona do exist but are also few in numbers and suggest that they were custom-ordered, possibly using stones provided by the patron. Carico Lake and other green turquoises are also not well represented. Fred Peshlakai's association with Doc Wilson, who owned at various times the Lone Mountain, Number Eight, and Blue Gem mines in Nevada, spanned over thirty years and is documented by Fred's use of him as a personal reference on his draft card in 1942 (National Archives, National Personnel Records). Their collaboration appears to dominate the type of stones used by Fred Peshlakai.

his famous reputation for using only beautiful stones in his artwork. These stones, when examined individually often appear as works of art in their own regard and could stand alone without their setting. Fred used many varieties of stone material over the course of his career, which indicates that he selected them based on their intrinsic beauty rather than any inclination toward only adding monetary value to his pieces. Turquoise was not elevated to its semi-precious classification by gemologists until just after the middle of the twentieth century, yet Fred Peshlakai predominantly adhered to its use over the entire course of his career, an indication that he considered himself first and foremost a Diné artist. His choice to use stunning specimen types of stones attests to his predilection for impeccable taste in the materials he worked with. Attributing a piece of jewelry to Fred Peshlakai that does not somehow also incorporate beautiful stones (if stones are present at all) would rarely be considered possible. It wasn't until the very late 1960s, when his primary source for stones, Doc Wilson, had passed away, that there is any discernible decline in the

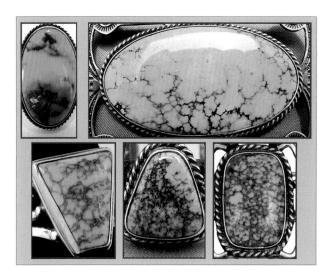

Details of stones used by Fred Peshlakai. Presented previously in sections of this book, these examples clearly demonstrate Fred Peshlakai's taste for stones from the turquoise mines of Central Nevada. The types shown here dominated Fred's preferences and include Blue Gem, Lone Mountain, and Number Eight mines. Dendrite examples and beautiful matrixes typify Fred's choices. Each stone is a thing of beauty entirely on its own and in combination with Fred's exemplary silver work, the artwork is carried to new heights. All images are from hallmarked examples. From top, clockwise, see full images of the works on pages 126, 125, 129, 132, and 159.

Two examples of intricately laid out designs using a multiplicity of die forms and sizes. The use of negative space to create an additional design shape is prevalent in much of Fred Peshlakai's work. All the individual dies shown here are unique to Fred Peshlakai, although it is believed by some that the repoussé dies may have been inherited from his father, Slender Maker of Silver. Details from pages 182 and 142.

Documented provenance from specific collectors is another excellent way to obtain absolute attributions for the work of Fred Peshlakai. Unfortunately, pieces with well-recorded history are few in number and are limited to collections formed by John Strong, Mrs. Lauris Phillips, or previously published photographs such as those from the Tanner Indian Arts Collection, which was published on page 11 of the 1975 *Arizona Highways* magazine and titled *Turquoise Blue Book*.

Again, obtaining written attribution from living authorities who have long studied the work of Fred Peshlakai is also recommended. Several professional persons who have contributed to this book are well known for their expertise in attributing the work of Fred Peshlakai and obtaining written documentation from them is currently possible.

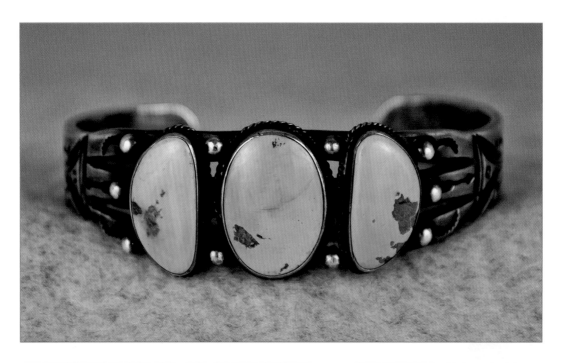

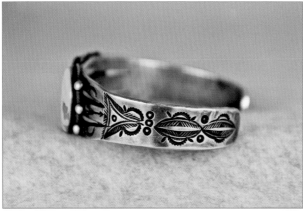

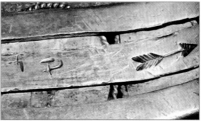

BLUE GEM TURQUOISE AND STERLING BRACELET, ca. 1945. Size 7. Maximum height: 1". Anomalous signature. It is know that Fred Peshlakai had several transitional periods when he was developing new versions of his hallmark. The fine distinctive stamp work and difficult cantilever to the twisted wires surrounding the bezels possibly suggests this piece belongs in the Peshlakai catalogue. The brilliant blue stones are plain bezel set. Although the initials are worn and the arrow is detached and incorporates the rare right-facing direction, this example could be discussed as possibly attributed to Fred's mid-1940s period, but not without its share of critics. *Courtesy of a private collection.*

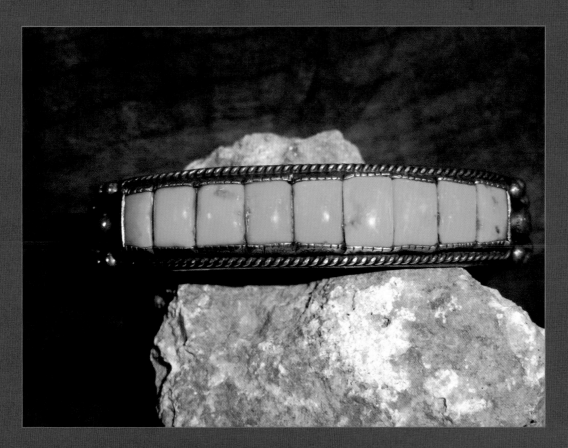

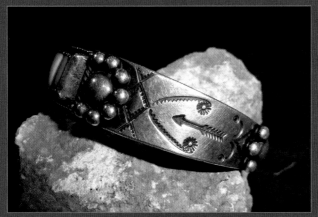

FLUSH-MOUNTED TURQUOISE AND STERLING BRACELET. Blue Gem turquoise and sterling. Size: 6.5. Maximum height: .5". Signed: F.P. inside a cartouche. Several examples of this particular design are known to exist and some bear the alternate version of Fred's signature as: F. Peshlakai. The stamp work appears to clearly echo Fred's early stamps. Despite the persistent presence of an atypical treatment of a long serrated bezel, which results in a slightly uncomfortable undulation to its presentation, the design is generally associated with the work of Peshlakai despite the signature's cartouche surround. *Courtesy of Harriet Callahan, Frontier Plunder Antiques.*

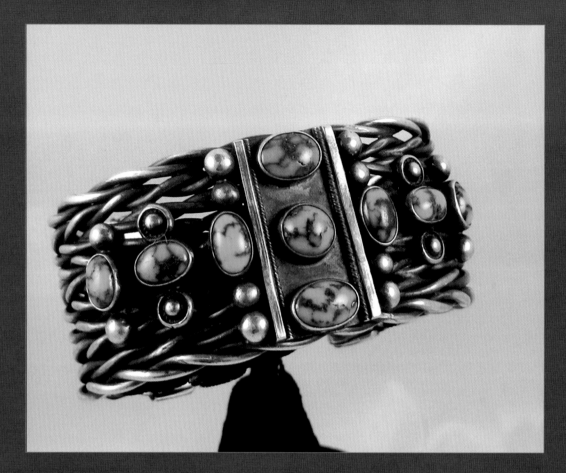

FIVE-STRAND BRAIDED WIRE BRACELET. Burnham turquoise and sterling, ca. 1955. Size 7. Maximum height: 1.5". Unsigned. This example demonstrates a piece attributed to Fred Peshlakai by Mrs. Lauris Phillips. Mrs. Phillips was very well known as an authority on the work of Fred Peshlakai as she was an avid collector and advocate for his work for more than forty years. Her extensive collection could be considered among the most important collections ever assembled of the art of Fred Peshlakai based on its sheer volume alone. Important pieces from Mrs. Phillips' collection have recently been donated to the Wheelwright Museum of the American Indian in Santa Fe where they will be gratefully appreciated by many. *Courtesy of The Mrs. Deborah Begner collection, Turkey Mountain Traders.*

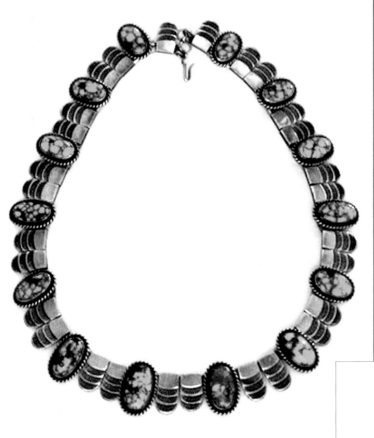

TAB NECKLACE. Central Nevada turquoise and sterling. Overall length: 22". Maximum height: 1.15". Unsigned. Fred Peshlakai was a pioneer in design for his era. This beautiful necklace clearly shows Fred's ability to merge current fashion within his art while retaining a purely Diné modality. Here, spectacular stones and traditional stamp work yield a midcentury modern design that transcends into a classic when created with the use of multiple stair-stepped tabs. Fourteen stones and twenty eight tabs give a nod to Fred Peshlakai's profound sense of sacred geometry used in order to achieve balance and harmony. *Courtesy of the Lisa and Martin Monti Collection.*

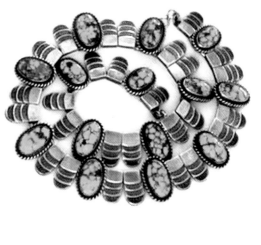

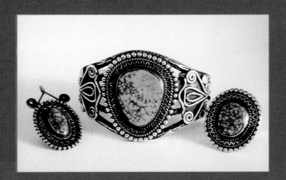

THREE-PIECE DEMI-PARURE. Number Eight mine turquoise and sterling. Bracelet: size 7. Maximum height: about 2". Unsigned. Fred's hand in this three-piece suite is clear by its incorporation of spectacular turquoise and dazzling silver work. This set is a tour de force in its exhibition of wire work types, while the intentionally blackened back plate of the bracelet's side elements, here left atypically exposed, gives rest and balance from the intensity of the focal points. *Courtesy of the Lisa and Martin Monti Collection.*

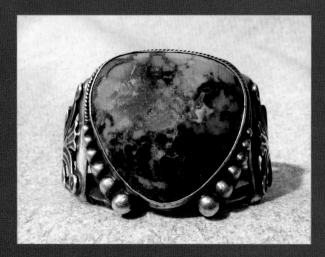
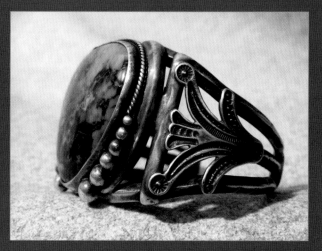

BRACELET WITH APPLIQUÉS. Battle Mountain, Nevada, turquoise and sterling, c. 1945. Size 6. Maximum height: 1.75". Unsigned. This exceptional example is easily attributable to the hand of Fred Peshlakai by the use of identical die stamps that are present on the signed brooch on page 125. Additionally the presence of the expressive ambiance present upon Fred's artwork becomes increasingly clear to the scholars of his distinctive style, much in the same way as the designs of the brilliant Hopi potter Nampeyo of Hano become irrefutable evident on her universally unsigned masterpieces. *Author's collection.*

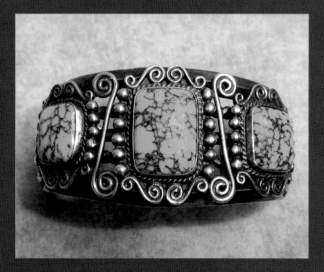
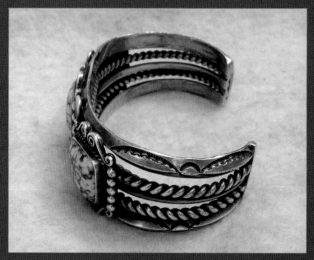

BRACELET. Lone Mountain turquoise and sterling. Size: 7. Maximum height:1.25". Unsigned. The many complexities of the silver work on this beautiful example augment the tall-set, spider webbed stones. Rather than distracting from each other, all the differently formed elements balance themselves inside their beautifully combined alliances while retaining their individual distinctions. This intrinsic harmony, combined with Fred's superior designs, is why Fred Peshlakai's art is so highly revered and also intuitively attributable. *Author's collection.*

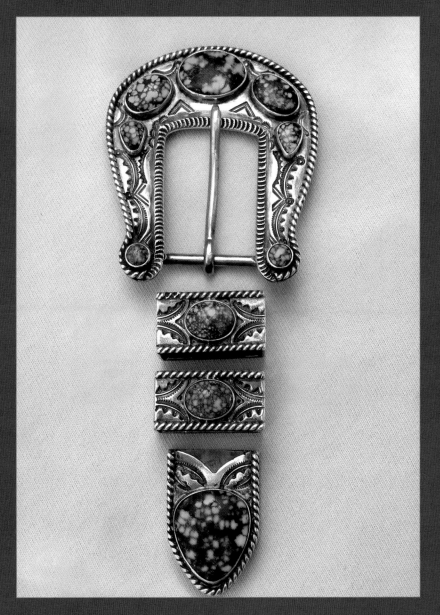

RANGER SET BELT BUCKLE. Lone Mountain turquoise and sterling. Maximum length of buckle: 2.25". Unsigned. The use of such extraordinary stones, combined with stamp work that can be considered distinctive to Fred Peshlakai, render a signature on this piece almost unnecessary. Having the piece vetted by a gallery with an impeccable reputation doesn't hurt either, as this piece was by Turkey Mountain Traders in Scottsdale, Arizona. The ridged surround on the interior of the buckle prevents the metal tongue from scratching the smooth surface while framing the design into its traditional shape. *Author's collection.*

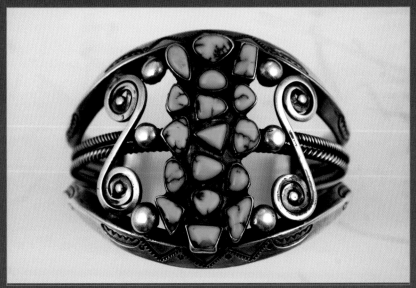

FREEFORM BRACELET. Central Nevada area turquoise and sterling. Size: 7. Maximum height: 2.5". Unsigned. Few if any other Diné artists were using the high caliber turquoise that Fred Peshlakai used during the same time period. These stone types, accompanied by designs with a strong visual momentum and perfectly balanced intentional silver-work, are powerful indicators of the work of Fred Peshlakai. *Courtesy of the Lisa and Martin Monti Collection.*

TRIANGULAR STONE BRACELET. Lone Mountain turquoise and sterling. Size: 7. Maximum height: 1". nsigned. *Courtesy of Waddell Trading Company.*

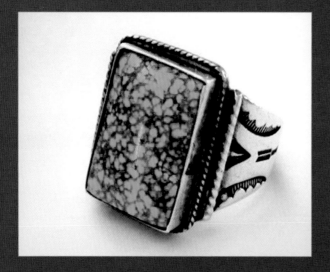
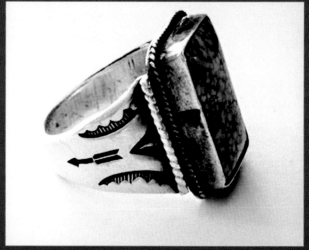

MAN'S RING. Number Eight mine turquoise and sterling. Size: 10. Maximum height: 1". Unsigned. *Courtesy of the Lisa and Martin Monti Collection.*

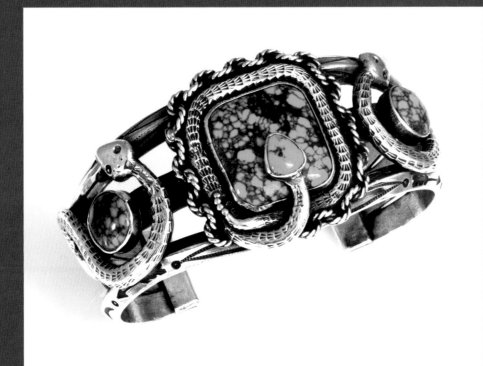

SNAKE BRACELET. Lone Mountain turquoise and sterling. Size: 7. Maximum height: about 1.6". Unsigned. Even though figural motifs in the Peshlakai catalogue are very rare the exemplary silver work and spectacular stones leave no doubt Fred Peshlakai was the creator of this piece. *Courtesy of a private collection.*

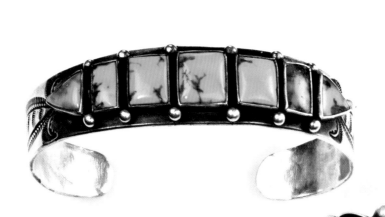

SEVEN-STONE BRACELET. Central Nevada mined turquoise and sterling. Size: 7. Maximum height: .75". Beautiful stones of varying shapes combined with distinctive stamp work make the attribution of this piece to Fred Peshlakai clear. *Courtesy of the Jeff and Carol Katz Collection.*

SCROLLWORK PIN. Lone Mountain turquoise and sterling. Maximum diameter: 1.75". Although unsigned, the uniqueness of this example combined with its companions from the same old collection solidifies its attribution to the hand of Fred Peshlakai. *Courtesy of a private collection.*

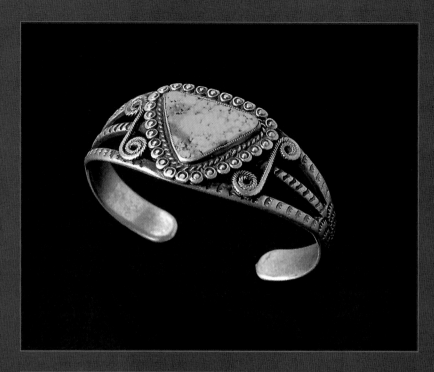

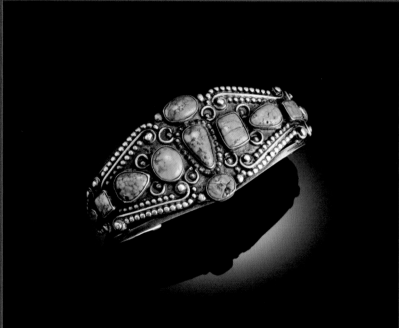

TRIANGULAR STONE BRACELET. Number Eight mine turquoise and sterling. Size: about 6.75". Maximum height: 1.75". Unsigned. Also shown: bracelet wtih APPLIQUÉS. Blue Gem turquoise and sterling. Size: 7. Maximum height: 1.65". Signed: "FP" scratched into the verso. Much of the attributed work of Fred Peshlakai likely resides in the collections of institutions. Identification of those works will someday add greatly to the recognized catalogue of Fred Peshlakai. The spectacular examples shown on this page have already previously been attributed, and it tantalizes the imagination regarding what is yet to be discovered in the repertoire of Fred Peshlakai. These institutions are the perfect stewards for Fred's artwork as they steadily are making them available for the enjoyment and appreciation of the many interested people in the work of this legendary artist. *Courtesy of the Heard Museum, Phoenix, Arizona. Photograph by Craig Smith.*

THE INDIVIDUAL STAMPS
OF FRED PESHLAKAI

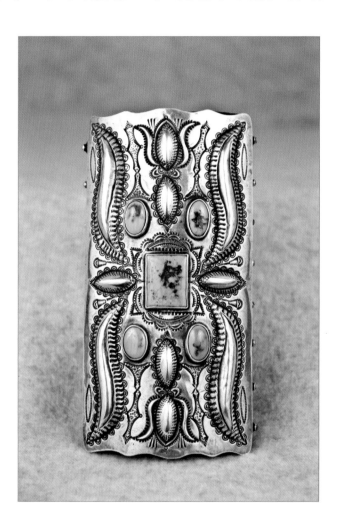

THE FOLLOWING PAGES ARE PRESENTED AS A QUICK reference to some of the individual stamps from dies made by Fred Peshlakai. Those interested in attributing the art of Peshlakai will find that Fred often reused dies he had made on subsequent pieces of jewelry of his manufacture. All of the examples shown are selected from pieces of his signed, hallmarked, or irrefutably attributed work only.

It should be remembered that this is only a small sampling of the many hundreds of individual dies Fred Peshlakai made over his lifetime and is in no way suggested as an entire inventory. This archive of die stamped designs is only a beginning to which others will hopefully be added to over time.

Fred's stamp work is considered very distinctive. Often, that distinction is brought about by combinations of several otherwise simple designs. It should also be borne in mind that other artists may have created similar stamps. However, the following images should prove enlightening and be an aid in eventually bringing the entire remaining catalogue of Fred's art into clearer focus.

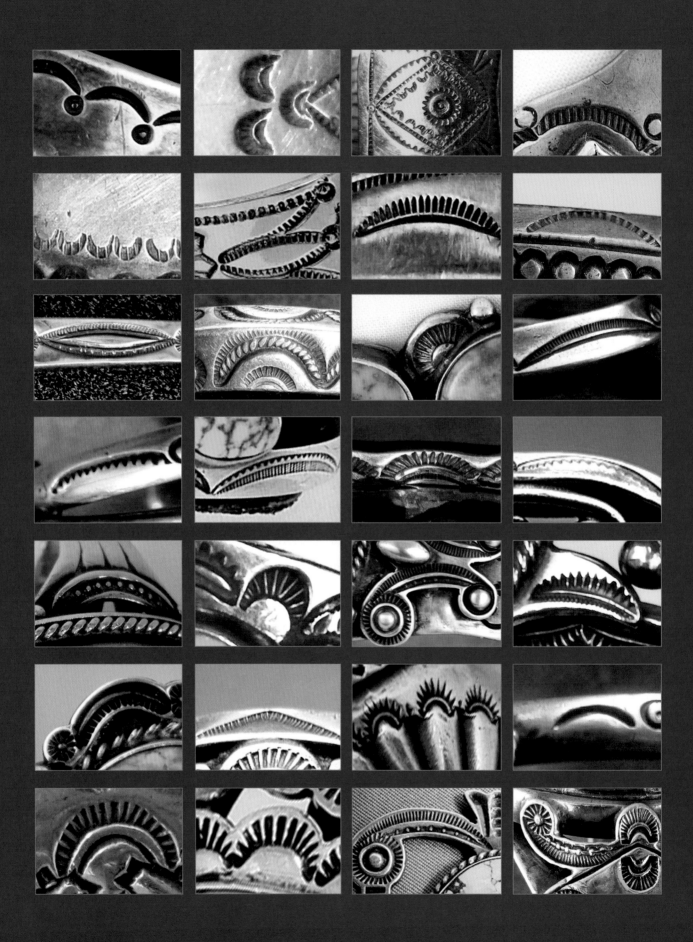

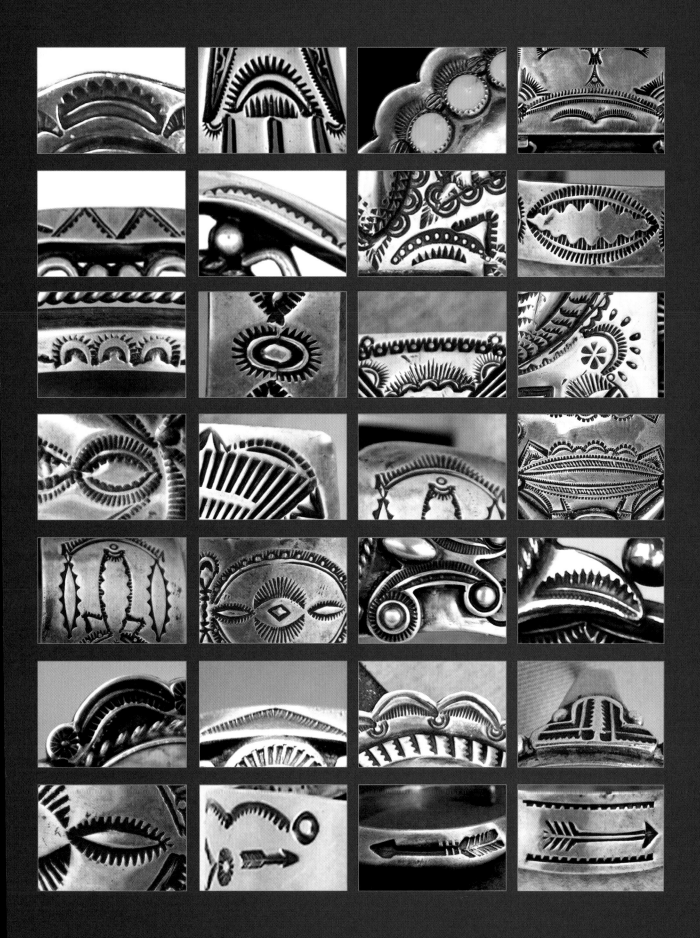

THE INDIVIDUAL STAMPS
OF FRED PESHLAKAI

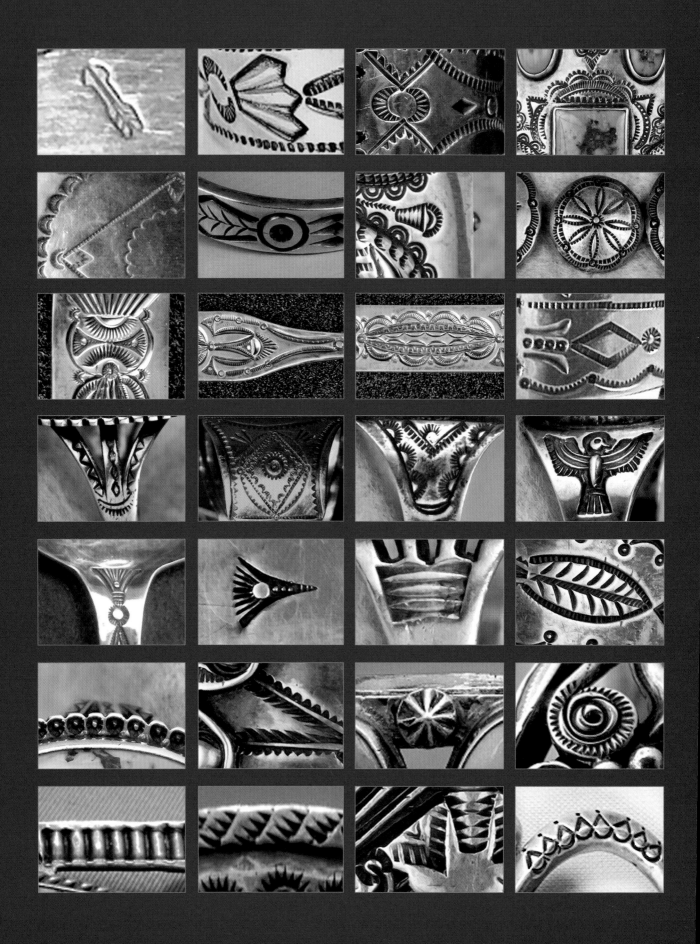

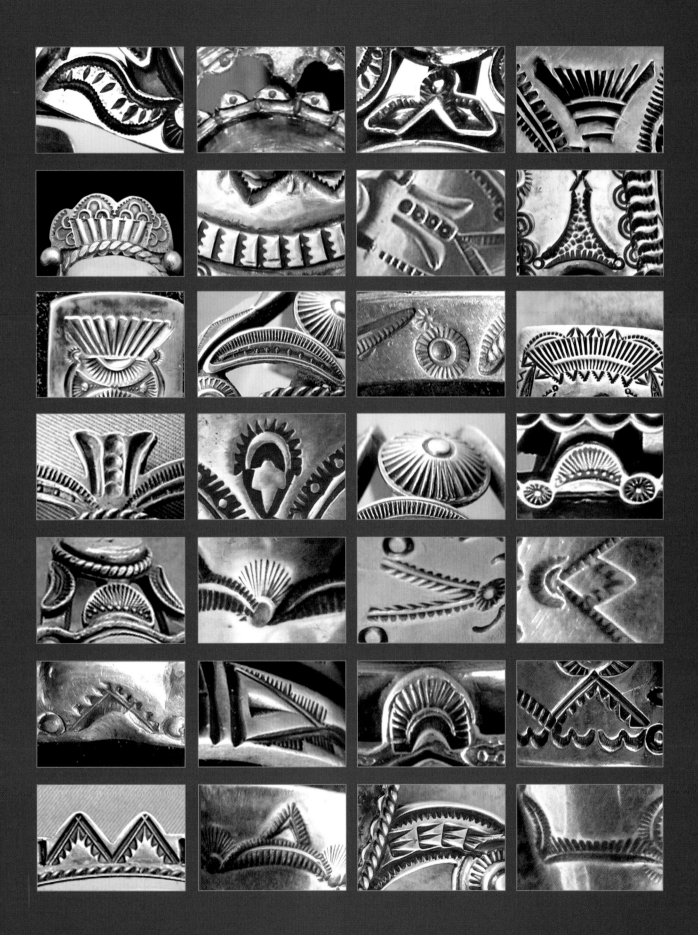

THE INDIVIDUAL STAMPS
OF FRED PESHLAKAI

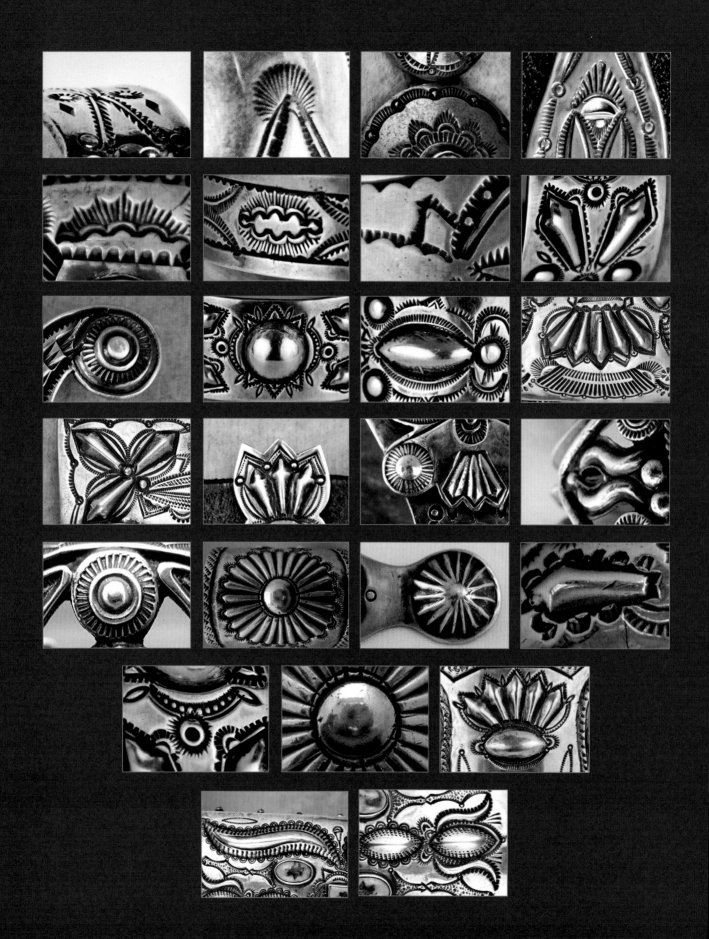

Resources

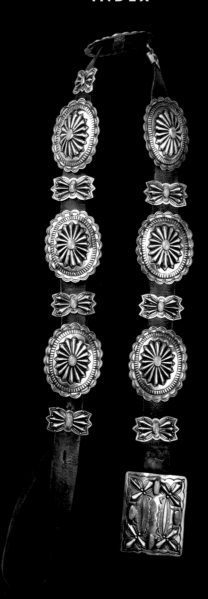

Appendix A:
TERMINOLOGY

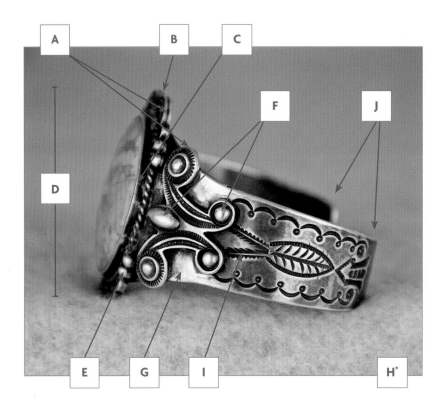

A. APPLIQUÉ: A secondary element that has been separately applied.

B. BACK-PLATE: Also sometimes referred to as the "bezel plate", this term refers to an appliquéd support plate which under carries all the final fascia elements.

C. BEZEL: The flat, vertical, ribbon-wire which secures the stone to the back-plate.

D. HEIGHT: Term used to standardize a directional measure for this study.

E. RAINDROP: A half-spherical element which is typically individually appliquéd.

F. REPOUSSÉ: A convexly domed element accomplished by placing the silver sheet between a matched pair of silver working dies.

G. SHOULDER: Term used to describe the upper region of the encircling band.

H*. SIZE: Determined using an inner circumference. Bracelets = Total inner circumference in inches. Rings = Total inner circumference in millimeters.

I. STAMP-WORK: Variable concave designs which have been impressed into the silver's surface by the use of individual silver working dies.

J. TERMINALS: The place where the silver terminates at both ends of a bracelet's bands.

Appendix B:
ART TAFOYA

A TRIBUTE TO FRED PESHLAKAI

IN ALBUQUERQUE, NEW MEXICO, is a silversmith who has long been recognized as an advocate and student of the art of Fred Peshlakai. Art Tafoya was born in California of Yaqui Indian and Spanish descent. He learned the basics in silversmithing at the age of twelve from a blacksmith who worked at a riding stable near his home. He remembers being fascinated with Navajo silver jewelry and its beautiful stamp work.

In 1972, Tafoya met the Mescalero Apache silversmith Carlos White Eagle. At that first meeting of what would evolve into a great friendship, the conversation turned to Fred Peshlakai, whom Carlos had met when Carlos was a young boy. Art Tafoya relates:

Carlos said he had watched Fred make his silver on Olvera Street and had always remembered the experience. Carlos White Eagle taught me everything: how to make a pattern, make stamps and dies, how to anneal the small files for lines and how to handle the metal. Most smiths today buy their stamps, so you see the same pattern over and over. Look at bracelets and boxes from the '20s, '30s and '40s and you will see fine stamps, intricate in design, sometimes made by blacksmiths.

Art Tafoya worked at Knott's Berry Farm as a silversmith for many years. He has spent countless hours studying the individual dies made by Fred Peshlakai, which he considers the most worthy due to their consummate skill and scope of their manufacture. Fred's artistic design abilities have inspired Tafoya throughout his own career. Today, Art Tafoya's silver creations reflect that inspiration. His work is clearly his own, but his admiration for Fred Peshlakai and Peshlakai's insistence for unique combinations of impressions made by personally created dies is echoed in Tafoya's art. He emphatically acknowledges that the development of his personal style was only made possible thanks to Mrs. Lauris Phillips, who allowed him to study her Fred Peshlakai collection beginning in 1973.

Art Tafoya's studio is in the historic Old Town section of Albuquerque, New Mexico. He is recognized as a brilliant artisan, and in 2012, he won a Blue Ribbon at Santa Fe's Spanish Market for a silver and inlaid stone hummingbird pin with its accompanying stand. His own art pieces are collected by many devoted admirers who recognize his unique abilities and highly prize his intrinsic sense of beauty. Although the art form certainly found its beginnings within the capabilities and expressions of the Diné, it has evolved rapidly in the twentieth century and today can be appreciated for its noble origins while still being embraced by great silversmiths who handle it purely like Art Tafoya does.

Certainly Fred Peshlakai, who was decidedly cosmopolitan, would have approved of his second-generation student and the legacy that Art Tafoya strives to advocate. Tafoya is certainly an artist to watch in the twenty-first century.

Art Tafoya, ca. 1999. Knott's Berry Farm, California. *Courtesy of Art Tafoya Studio.*

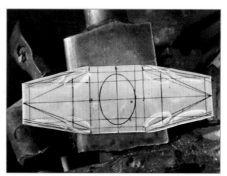
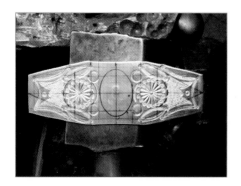
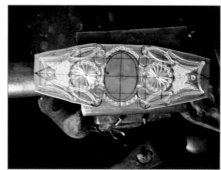
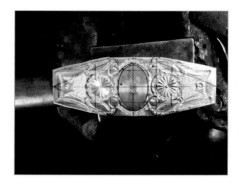
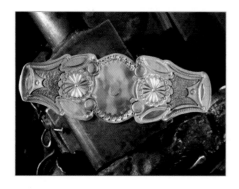
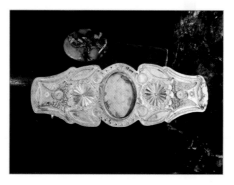

BRACELET IN PRODUCTION WITH ACCOMPANYING SCHEMATIC DRAWINGS. Art Tafoya. 2012. Art Tafoya draws out his designs accurately to scale as a preliminary step to creating any particular jewelry design. The fascinating use of these design templates being implemented is demonstrated here. The original design is sometimes first rendered on heavy cardstock and impressed with the individual stamps. This design map is then used to reference the measurements as well as the placement of the individual elements that are meticulously indicated on the silver rough in advance of their being worked. *Courtesy of Art Tafoya Studio.*

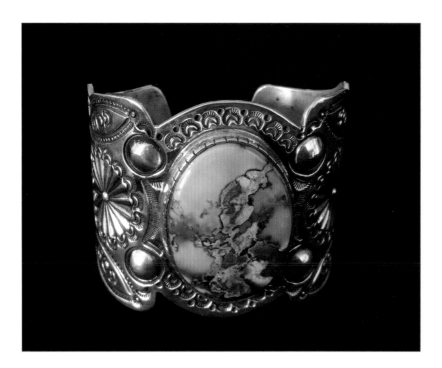

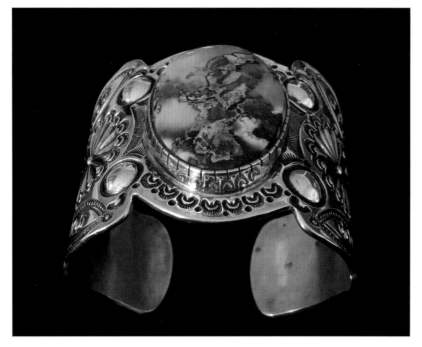

FINISHED BRACELET. Pilot Mountain turquoise and sterling. Size: 6.5. Maximum height: 2.3". Signed: Art Tafoya hallmark. The finished product of Art Tafoya's artistic endeavors represents a tour de force in the silversmith's skills. Multiple repoussé elements combine with heavy stamp work to uplift the stone within a dazzling presentation. It's easy to see why Art Tafoya's work is so highly prized by collectors. *Courtesy of Pat Messick and Brook Myers collection.*

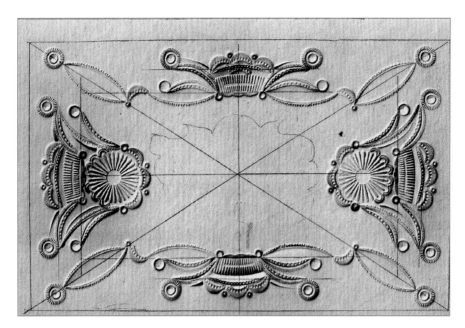

Cardboard templates for "Tribute to Fred Peshlakai" box. 2013. Art Tafoya draws out his designs and then creates preliminary stamped renderings on thin cardboard stock prior to commencing with the manufacturing of the artwork. *Courtesy of Art Tafoya Studio.*

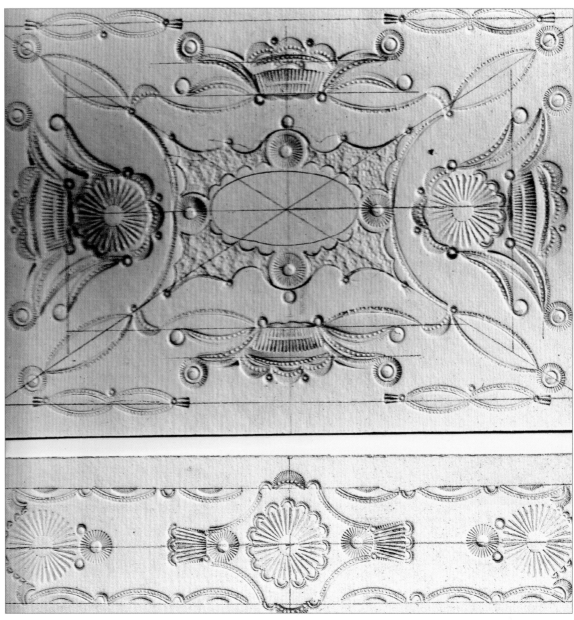

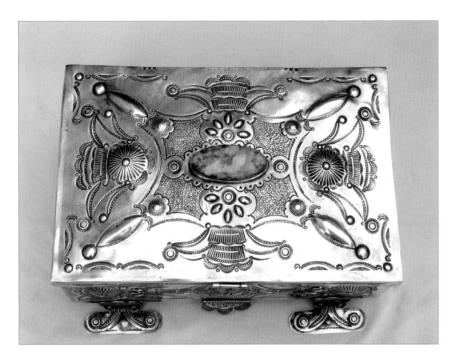

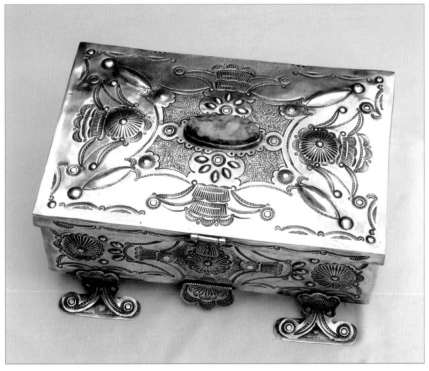

"A TRIBUTE TO FRED PESHLAKAI." Large silver box. 1930s mined Pilot Mountain turquoise and sterling. Maximum dimensions: 9" w. x 6" d. x 3.5" h. Hallmarked: Art Tafoya. Fred Peshlakai's distinction grew largely from his personal philosophy that his creations were works of art, not just novelties for tourists like the overwhelming majority of Southwest silver art being created during his lifetime. Fred championed his art form, much like his contemporaries Maria Martinez, Hosteen Klah, and other great Old Masters did. Fred taught that philosophy, along with the necessary skills, to his students. He didn't require that his students be Diné, only that they loved the art form and were true to its integrity. This masterpiece by Art Tafoya exemplifies everything Fred could have hoped for in a legacy of Beauty to have been passed along to the world by teaching those students. That distinction in contemporary Southwest silver art is still evident today in the difference between the true artist and the mundane. Art Tafoya is certainly the kind of artist Fred Peshlakai championed. Fred Peshlakai's legacy represents a form of world art that honors not only his brilliant heritage and his noble people but also all true artists everywhere. *Author's collection.*

SOURCES CITED

Ackerly, Neal W. 1998. *A Navajo Diaspora: The Long Walk to Hwe'eldi.* Dos Rios Consultants, Inc.

Adair, John. 1944. *The Navajo and Pueblo Silversmiths.* Norman, OK: University of Oklahoma Press.

Batkin, Jonathan. 2008. *The Native American Curio Trade in New Mexico.* Santa Fe: Wheelwright Museum of the American Indian.

Bedinger, Margery. 1973. *Indian Silver.* Albuquerque: University of New Mexico Press.

Bethers, Jeanne. 1950. "Peshlakai. Master Silversmith." *Deseret News Magazine* (Aug. 27).

Chang, Marjorie A., Dr. 2012. Personal communication.

Diné Education Web. "Manuelito," San Juan Heritage. http://dine.sanjuan.k12.ut.us/heritage/people/dine/biographies/manuelito.htm

Greenberg. Henry and Georgia. 1996. *Power of a Navajo: Carl Gorman, the Man and His Life.* Santa Fe: Clear Light Publishing.

Horgan, Paul. 1954. *The Rio Grande in North American History,* vols. 1 and 2. New York: Reinhardt and Company, Inc

Independent. Gallup Independent Co. Gallup, New Mexico.

Indian Census Records. National Archives and Records Administration, College Park, Maryland.

Klah, Hasteen. "Navajo Creation Myth." Recorded by Mary C. Wheelwright, Santa Fe, 1942. http://darcheogology.com/texts/wheelwright.introduction.html

Lapahie, Harrison, Jr. Accessed 2011. "Navajo Clans," http://www.lapahie.com/dine_clans.cfm.

Lourie, Peter. 1991. *Sweat of the Sun, Tears of the Moon.* New York: Atheneum.

The National Archives, National Personnel Records Center, St. Louis, Missouri, Federal Service Records, 1933-1935, (Charles Burke School, Fort Wingate, New Mexico, 1933-1935).

Navajo Nation Museum exhibition. 2012. Hwéldi Baa Hane' (the Long Walk). Manuelito Wheeler, curator. Jennifer Nez Denetdale, guest curator. Window Rock, Arizona.

Navajo Times. January 1975. Window Rock, AZ: Navajo Times Publishing Company.

Newcomb, Franc Johnson. 1965. *Hosteen Klah: Navajo Medicine Man and Sand Painter.* Norman, OK: University of Oklahoma Press.

O'Sullivan, John L. 1845. "Annexation," *United States Magazine and Democratic Review,* 17 (July-Aug.): 5-10.

Pardue, Diana. 2005. "Native American Silversmiths of the Southwest." *American Indian Art Magazine.* Los Vegas: Creel Printing and Publishing.

Phillips, Lauris. 2013. Personal communication.

Rosenzweig, Jay. 2012. Personal communications regarding investigative report of Fred Peshlakai civil records in Los Angeles, California.

Schaaf, Dr. Gregory. 2013. *American Indian Jewelry III: M-Z.* Ciac Pr.

Strong, John Bonner. 2009-2013. Personal communications.

Strong, John Bonner and Fred Peshlakai. 2012. Compact discs. Recorded digital archive of Steven Curtis.

Tafoya, Art. 2010-2013. Personal communications.

Tsosie, William B., "Moving Across the Landscape. The Diné of T'iistosoh Sikaa." http://www.woodscanyon.net/Navajo/People/Clans.html

Union Pacific Magazine. June 1932. Omaha: Union Pacific System.

U.S. Bureau of the Census. 1909. *A Century of Population Growth from the First Census of the United States to the Twelfth, 1790-1900.* Washington, D.C.: Government Printing Office.

Woodward, Arthur. 1938. *A Brief History of Navajo Silversmithing.* Flagstaff, AZ: Northern Arizona Society of Science and Art.

ADDITIONAL BIBLIOGRAPHY

Arizona State Board of Health Vital Records, 1928-1940. Arizona State Archives, Phoenix.

Begay, Aaron. Interview with author, 2005.

Century of Progress archives, 1933, 1934. Chicago Historical Society, Chicago

Denetdale, Jennifer Nez. *Reclaiming Diné History*. Tuscan: Museum of Arizona Press, 2007.

Douthitt, Kenneth, Ganado Mission Photographic Essay and Oral History Project, vols. 1-4. 1993. Unpublished digital archive. Yakima, Washington.

Estrada, William D., *Los Angeles's Olvera Street,* Chicago: Arcadia Publishing, 2006.

Falkenstein-Doyle, Cheri. *Turquoise in Mexico and North America.* London: Archetype Books, 2012.

Harris, Stephen L., "Archaeology and Volcanism," in *Encyclopedia of Volcanoes*, Haraldur Sigurdsson, Bruce Houghton, Hazel Rymer, John Stix and Steve McNutt. Academic Press, 1999: 1301-1314. Accessed online at www.elsevierdirect.com.

Howard, Kathleen L. and Diana F Pardue. *Inventing the Southwest*. Flagstaff, AZ: Northland Publishing, 1996.

Johanson, Donald C. "Origins of Modern Humans: Multiregional or Out of Africa?" *BioScience* journal on the website of the American Institute of Biological Sciences. 2001.

Kidder, Alfred V. "Southwestern Archaeological Conference," *Science* magazine 66, no. 1716 (Nov. 18, 1927): 489-91.

Lapahie, Harrison, Jr. "The Navajo Creation Story." Personal website. http://www.lapahie.com/creation.cfm.

Mera, Harry P. *Indian Silverwork of the Southwest*. Globe, Arizona: Dale Stuart King, 1959.

Phillips, Lauris J. "History and Development of Navajo Indian Silversmithing." Unpublished article, 1990.

Sides, Hampton. *Blood and Thunder.* New York: Doubleday, 2006.

Turquoise Blue Book. *Arizona Highways.* 1975.

Wheelwright, Mary C., *Navajo Creation Myth.* Whitefish, MT: Kessinger Publishing, 2006.

INDEX

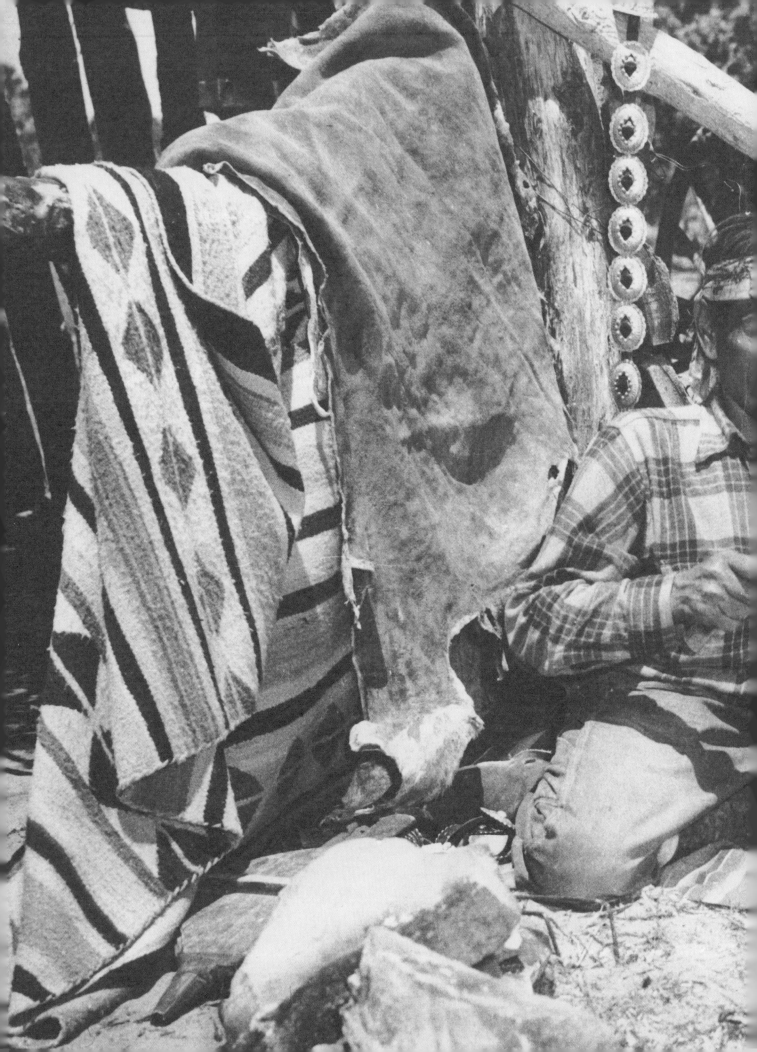